IMAGES
of America

Jewish Pioneers of the
Black Hills Gold Rush

IMAGES
of America

JEWISH PIONEERS OF THE BLACK HILLS GOLD RUSH

Ann Haber Stanton

ARCADIA
PUBLISHING

Published by Arcadia Publishing
Charleston, South Carolina

Library of Congress Control Number: 2009943873

For all general information, please contact Arcadia Publishing:
Telephone 843-853-2070
Fax 843-853-0044
E-mail sales@arcadiapublishing.com
For customer service and orders:
Toll-Free 1-888-313-2665

Visit us on the Internet at www.arcadiapublishing.com

I dedicate this book to my family, those who came before and those who will follow, and most especially, to the blessed memory of my parents, Joseph Joshua Haber and Cecelia Minkoff Haber, who instilled in us an appreciation for the beauty and value of our heritage.

CONTENTS

ACKNOWLEDGMENTS

In many ways, this book represents an exercise in patience, both on my part and that of those around me. Looking back over the past 15 or more years to when this research began in earnest, countless people have assisted in some way, whether through sharing photographs and information, offering suggestions, recommending new contacts, or simply remembering.

Among those to whom I owe the most are the folks in the Black Hills who share my love of local history. Foremost among these people is Dr. Watson Parker, eminent author of local history and professor emeritus of history at the University of Wisconsin. Dr. Parker and his dear wife, Olga, introduced me to their world. Thank you to David Strain, historian and author of the seminal *Black Hills Hay Camp*, which was my abiding inspiration. Thanks goes to the incredibly obliging staff of the Adams Museum and House, including Jerry Bryant, Arlette Hanson, Darrel Nelson, Anne Rogers, and Rose Speirs, under the direction of the formidable Mary Kopco. The staff of the Deadwood Public Library has helped me spin through countless hours of historical newspapers on microfilm. Eka Parkison's memory and immense collection of Rapid City's historical minutiae constitutes a local encyclopedia. Reid Riner, the amazing director of the Minnilusa Historical Association at the thriving young Journey Museum; Carol Evan Saunders; and Ray Summers, who always made time for me, are special stars in my firmament.

The following good people, some of whom are no longer with us, have all contributed in some significant way to the effort that underlies this book: Ita Adelstein; Stanford Adelstein; Al Alschuler; Sarah Neiderman Alschuler; Charles Anderson; Elizabeth Benusis; Marion Hattenbach Bernstein; Charlotte Hattenbach; Sue Teller; Ellen Bishop; Lynda Clark; Dick Dunwiddie; Russel Frink; Prof. David Gradwohl; Florence Blumenthal Hawki; Nate and Ruth Horwitz; Frieda Hosen; Mary Ingram; Irma Klock; Bob Lee; George Moses; Georgette Ohayon; Etta Fay Orkin; Diane Sinykin Small; Janet Rathbun; Myron and Sarah Rivkin; Linda Mack Schloff; Bill Swanson; Glenn Swanson; Bill Walsh; Rena Webb; Diane Weber; Marc Aldrich; Peggy Mahler, Faye Gitter, Lance Gitter, Linda Velder, of the Newell Museum; and Dr. David Wolff. Jerry Klinger, president and CEO of the Jewish American Society for Historic Preservation (JASHP), deserves special recognition for his generosity and his tireless efforts throughout the United States, and in Europe and Israel, on behalf of preserving our American Jewish history.

Special thanks go to my three sons, David, Joshua, and Daniel Stanton, all similarly afflicted with the "history bug." Daniel has made recordings, taken hikes, driven us on adventures, and made friends with my own "history friends," enough to write books of his own, a rara avis indeed. Thanks goes to my sister, Diana Hirsch, lifelong friend who shares my memories, for putting up with my obsessions and coming to the rescue when she is needed most. My endless love and gratitude to you all.

Last, but hardly least, my heartfelt appreciation to Anna Wilson and John Pearson of Arcadia Publishing for guiding me through the mysteries of assembling this book. If I missed anyone, I am truly sorry, you know who you are. My sincere thanks to all of you.

Unless otherwise noted, all images are courtesy of the Adams Museum.

INTRODUCTION

This story needs telling. It was hiding in plain sight for many years, yet no one could see it. That was because no one had stitched it together before. It has been my privilege to find it and bring it into daylight.

In 1959, I was a young bride, newly arrived in South Dakota. Deadwood was picturesque, but an undeniably decaying remnant of what appeared to once have been a vital town. Deadwood's streets were steeped in history and legend; it was impossible to tell where history left off and legend began. Wild Bill Hickok's name was everywhere; he appeared to have been shot in just about every saloon on Main Street, and there were quite a few. Wild Bill was either a hero or a villain, depending upon the prevailing point of view. Everyone seemed to agree that he had been shot in the back of the head on August 2, 1876, while sitting at the poker table with his back to the door. Jack McCall was arrested and paid the price for the crime, which he avowed was in revenge for Wild Bill shooting his brother. The "dead man's hand," pairs of black aces and eights at the card table, made people around here just a little nervous. Calamity Jane, also surrounded by local lore, was right there beside him, not only in story, but also in her grave beside his in Mount Moriah Historic Cemetery. It was easy to imagine her in life, squinty-eyed, foul-mouthed, buckskinned, jauntily blowing smoke off the end of her six-shooter. Her reputation ranged from rough whore to kind nurturer of victims of rampant typhoid fever, not that those were mutually exclusive.

But it was Goldberg's Grocery Store that had stopped me in my tracks. Could a man with the clearly Jewish name of Jacob Goldberg have been within elbow-rubbing distance of these infamous denizens of these streets?

Newly married, on my way to begin a new life, this was no time to pursue legends, but the questions would linger. An old fascination arising from a deep and ancient well compelled me to ask who these people were. I knew that someday I would return to probe Deadwood's Jewish secrets.

Fast forward to 1989. Deadwood had changed radically—30 years can do that. Buildings and shops that once catered to local needs had morphed into hotels, casinos, restaurants, and gift shops. Where the old Phoenix Building had arisen from the ashes, still in my memory the site of the fashionable New York Store, a grand new restoration was under way, funded by none other than Kevin Costner of *Dances with Wolves* fame. Other store signs had disappeared, replaced by glitzy neon invitations to try your luck at the slots and poker tables. Gambling was now legal and thriving in South Dakota.

This endangered town, faced with the choice between survival and extinction, had prudently chosen to provide for its future by capitalizing on its flamboyant past. Charismatic little Deadwood had returned to its roots and become a mecca for gambling. But behind the gambling, I learned, was a genuine effort to preserve its fabled history.

It was time to pursue the Jewish place in Black Hills' history. As questions crystallized, I asked who they were, where they came from, how they got there, and what they did here. Did they have a synagogue? Did they have a Torah? How long did their community last? Who were their leaders? How did they maintain their Jewish identity? How did they fit into the larger community? What did they contribute? Where did they go, and what did they leave behind?

I visited the Mount Zion section, the eastward-facing Jewish section high atop Mount Moriah Historic Cemetery, and found some clues in the beautiful old Hebrew engravings on the gravestones. Cemetery records showed that there were 86 Jewish burials here. Surely, there had been a substantial Jewish population once upon a time. I soon learned that those 86 burials told only a small part of the story. I learned that "hundreds of Jewish pioneers" lived here, but only a small number of them are buried in Mount Zion, the only cemetery specifically for Jews in the Black Hills at that time.

I was learning the names of families, their children, their occupations, their interests, and the places they held in the community. I read about their celebrations and their tragedies. The glue that bound them then, as now, was their Jewish heritage. Deadwood held the first, and only, Jewish congregation, organized when South Dakota was still part of Dakota Territory. Like all nascent Jewish communities, one of their earliest acts was to organize a burial society and purchase cemetery land. They had a Torah and the benefit of skilled lay rabbinical leadership. Newspapers reported glowing descriptions of Jewish weddings. They even had a mohel, a tailor by trade, who traveled the distance from Rapid City to perform the occasional necessary ritual of circumcision.

Information from historical newspapers, photographs, yellowed history books, and interviews—odd fragments—were forming a surprising mosaic that included all of western South Dakota. In 1874, a prospector named Moses Aarons had traveled into the Black Hills with a clandestine party of prospectors and settlers. A soldier only identified as Goldstein had served at the military station at the Cheyenne River Indian Agency in 1874, the year of Custer's expedition into the Black Hills. A hospital steward named Oscar Pollack was found dead among the Indians after the Wounded Knee massacre in 1890. Historical records claimed that these men were Jews.

I learned that there were Jewish homesteaders on the prairie in the years before statehood. While Dakota was still in its territorial infancy, Jews from Eastern Europe had formed settlements, developed farms and ranches, and even built towns and agricultural colonies. They fought fire and flood, insects and harsh weather. They also faced the wrath of hostile Indians, understandably perturbed, after broken treaties with the US government, which allowed the white man to invade their land and intrude on their way of life.

There were Jewish cattlemen and bankers, watchmakers and innkeepers, purveyors of cigars and whiskey, and suppliers of hardware, boots, and bread in the Black Hills. They were mayors and judges, firemen and miners. The shopkeepers knew that those who came for the gold needed provisions of every kind. What they could not produce themselves had to be brought in by wagon trains pulled by mules or oxen, a costly and risky endeavor. Some carried on businesses and were vital participants in civic life, some raised crops, and some raised families, and they all helped to bring stability and social order to the frontier and cause it to flourish.

By no means did the Black Hills fulfill every promise. There were plenty who tried their luck and failed. And there was the occasional *schlemiel* and even the out-and-out crook . . . and a small piece of real estate on Boot Hill for the most ignominious among them. But then, as now, Deadwood was a gamble worth taking.

This book focuses on photographs and images that tell a story. In many cases, however, family photographs were simply not available. Such was the case with the brilliantly successful Martinsky/Adelstein family of Rapid City, or the Kaufman family, formerly of Deadwood and now of Peoria. Their ancestors played a large part in this story, and this does not discount their contributions in any way.

The book tries to confine itself to the first 50 years following the gold rush (1876–1926). For the most part it does that, but inescapably, there will be spillover. There are still a handful of descendants of the Jewish pioneers in the Black Hills. Some are Jewish, others not. But they all demonstrate that same remarkable talent and vigor that allowed their predecessors to flourish. Those ancestors were durable people with courage and initiative. We can take pride in what they accomplished, in helping to open and stabilize this, the last frontier in the lower 48, in what is now South Dakota.

One

THE SCENE

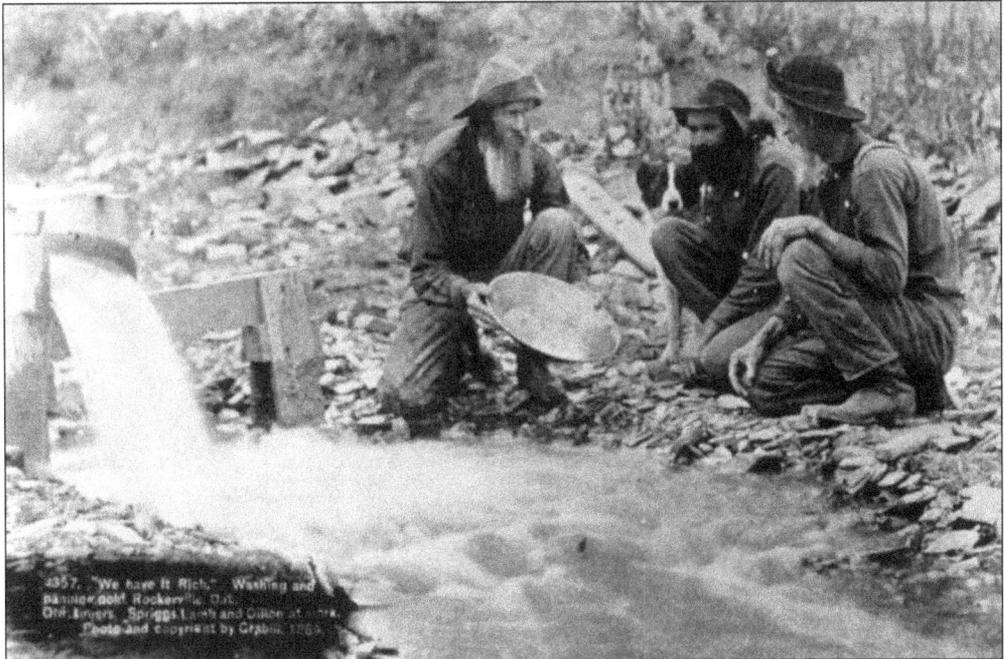

Here men are panning for "colors" in the Black Hills of the Dakota Territory. To the Lakota Indians, the area is referred to as *Paha Sapa* (Hills Black). It was 1876, and the news of gold was out. Traffic of all kinds, good and bad, will come stampeding into the Black Hills, especially into Lead and Deadwood, creating a wild and lawless scene. Early Deadwood is just a series of gold camps, which will later merge and become a town. (Courtesy Minnilusa Historical Association.)

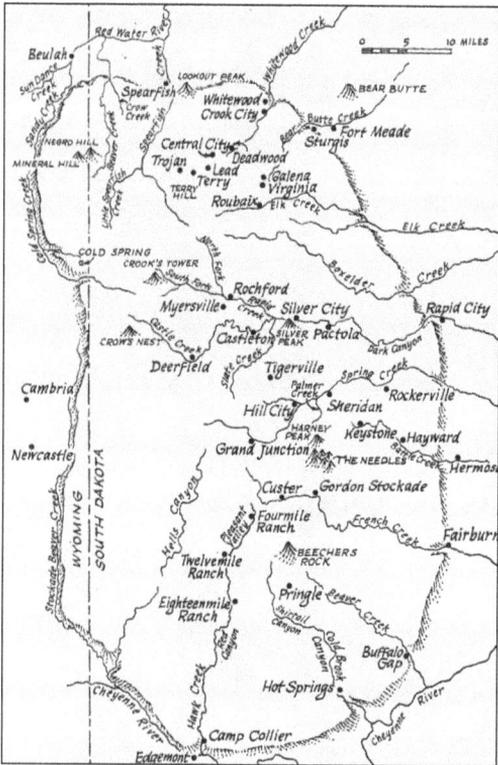

This is a map of the Black Hills of South Dakota during the gold rush. (Courtesy Dr. Watson Parker.)

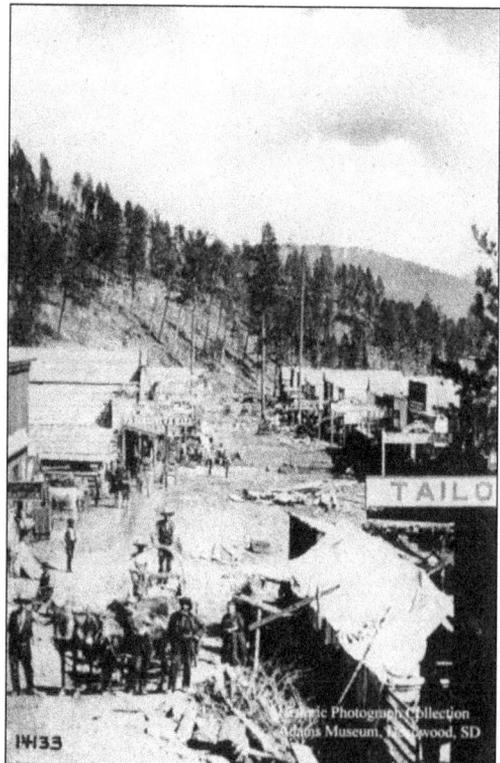

Mining claims were established in the middle of the trail, which later became Deadwood's Main Street. There are a few more-or-less permanent structures, but there are still many tents. Prospectors, merchants, gamblers, road agents, oxen, mules, and horses, all travel over the same routes that will some day become main streets. With mining claims in the middle of the trail, miners took no chances—all claims were well guarded. (Courtesy Adams Museum.)

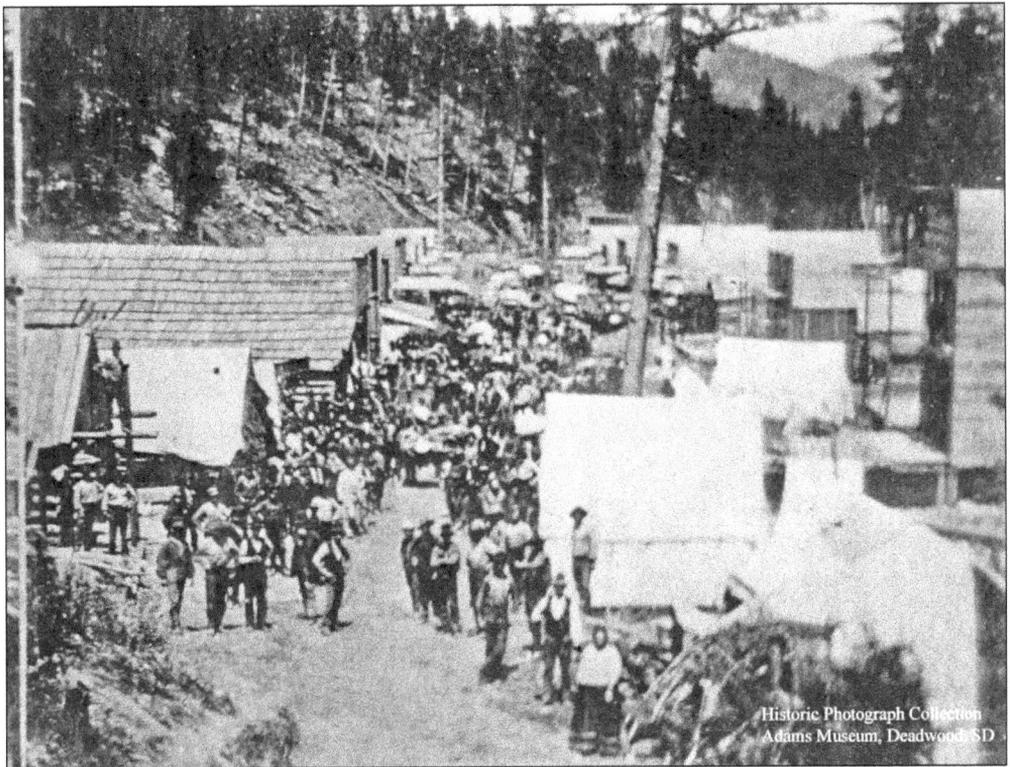

Entering Deadwood Gulch, throngs are on the move. Disorder and slap-dash construction prevail. Most are coming for the promise that a gold strike holds—some for the mineral treasure and some for the more reliable treasure to be found in commerce. There are also a few scalawags, rogues, gamblers, gunfighters, robbers, and soiled doves (prostitutes) in the mix. Interesting times, to be sure. (Courtesy Adams Museum.)

Oxen pulling heavy-duty wagons, the long-haul trucks of their day, rest beside the trail. The trail is mired in mucky, slimy mud in wet weather and dung and dust in dry weather. The board sidewalks help, but one must descend into the mess while trying to cross. Imagine the lady in her long dress trying to shop for a new hat. Now a few small houses dot the hillside to the west. (Courtesy Adams Museum.)

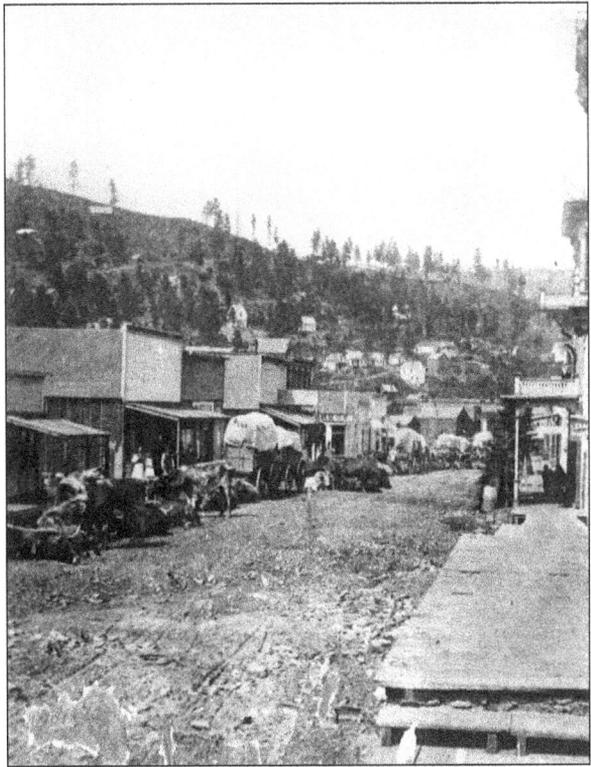

11

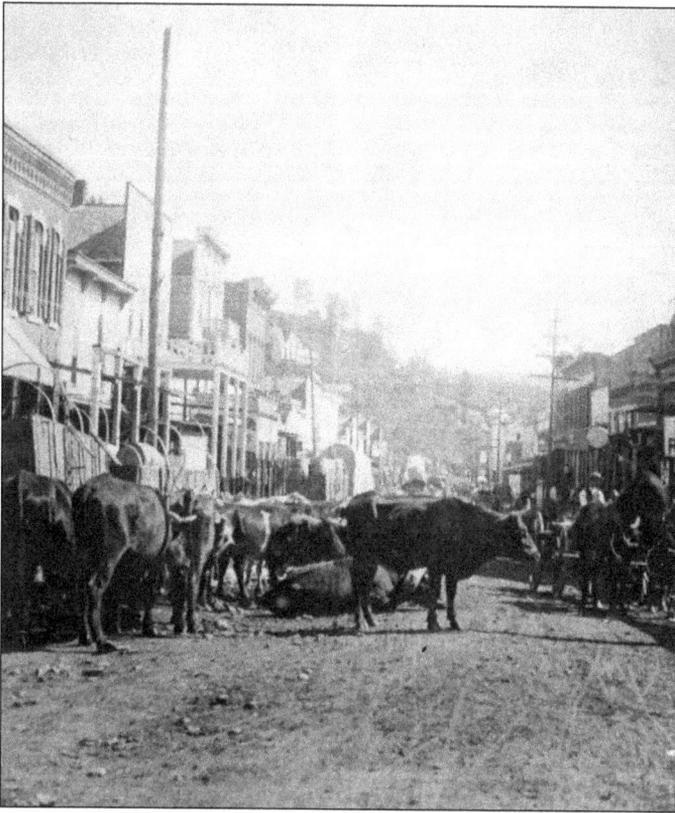

Ox teams crowd the street. Technology is improving. Electricity has come to Deadwood, but the ox team is still the main method of transporting goods. (Courtesy Minnilusa Historical Association.)

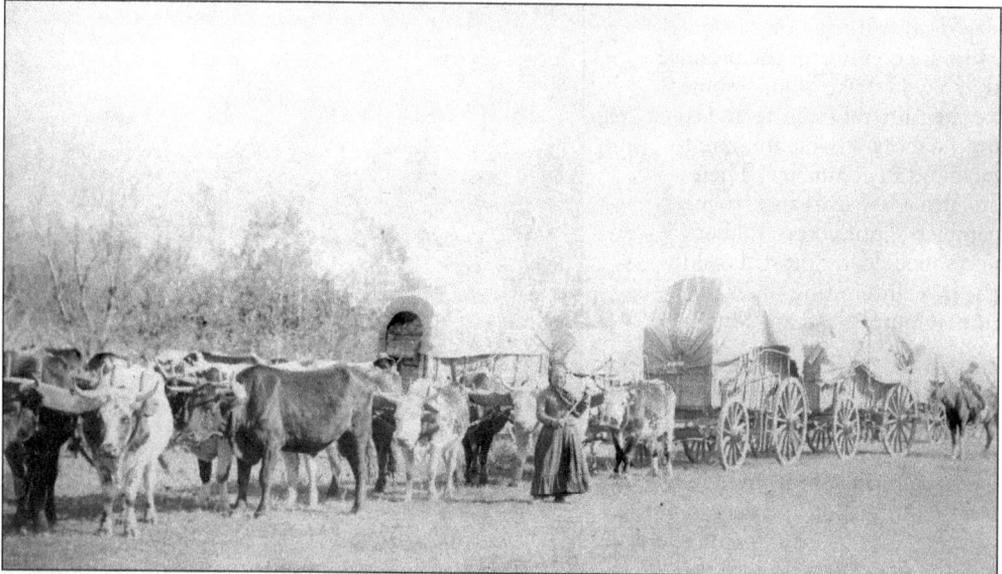

When Mr. Knutson died, Ingeborg Botne (Mrs. Knutson, neither of them were Jewish) picked up the bullwhip and stepped right into his shoes. Here is a scene on St. Joseph Street in Rapid City. One might not expect to see a woman driving a team of oxen down St. Joseph Street, near Fifth Street, in Rapid City. Ingeborg Knutson was known as the "bullwhackeress." (Courtesy Minnilusa Historical Association.)

Real pay dirt was struck in the spring of 1876, when the Manuel brothers, Fred (left) and Moses, and fellow prospectors, Lloyd Tevis and James B. Haggin, discovered a "ledge," a lead (pronounced leed) of gold, near what would come to be the city of Lead. None of these gentlemen were Jewish. (Courtesy Adams Museum.)

Historic Photograph Collection
Adams Museum, Deadwood, SD
Not for reuse or resale

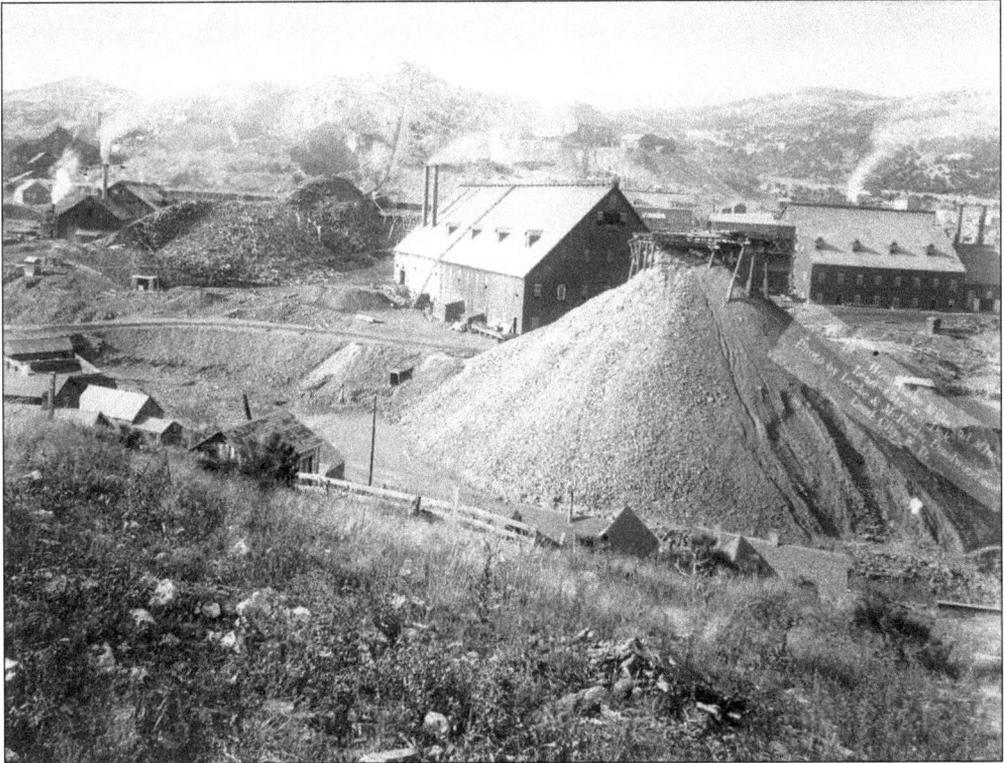

The lead was the mother lode from which arose the free gold in streams running down Deadwood Gulch. George Hearst, a San Francisco newspaper magnate and the father of William Randolph Hearst, sent an experienced miner named L.D. Kellogg to investigate the claim. Kellogg reported that the claim was indeed worthy of the investment, and Hearst promptly purchased the Homestake claim from the Manuel brothers for the bargain basement price of $70,000. The city of Lead, built around Homestake, was the first to be developed, and for years, it claimed the strongest economy in the region.

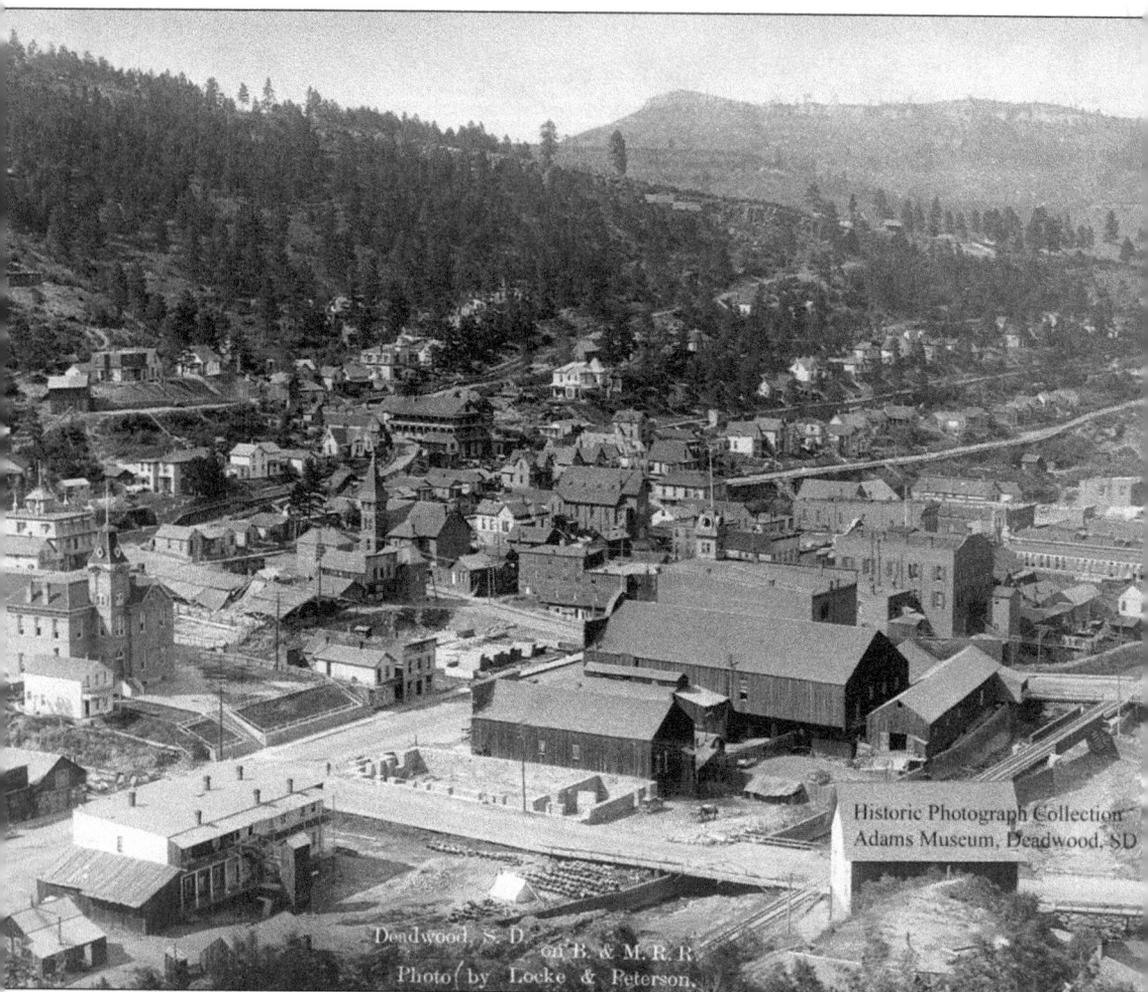

Historic Photograph Collection
Adams Museum, Deadwood, SD

Deadwood, S. D. on B. & M. R. R.
Photo by Locke & Peterson.

A city made way for a gold mine. Hearst's prize would result in cutting away the hillside upon which part of Lead resided. The mine would in time descend to 8,000 feet below the city. Although Deadwood was renowned for its dust and mud, Lead's continual noise and smoke from the mining operations made Deadwood the preferable place to reside, and gradually Deadwood attracted more of the regional commerce. Homestake would become the longest-lasting gold mine in the United States, operating continuously for 125 years and producing untold billions in gold. (Courtesy Adams Museum.)

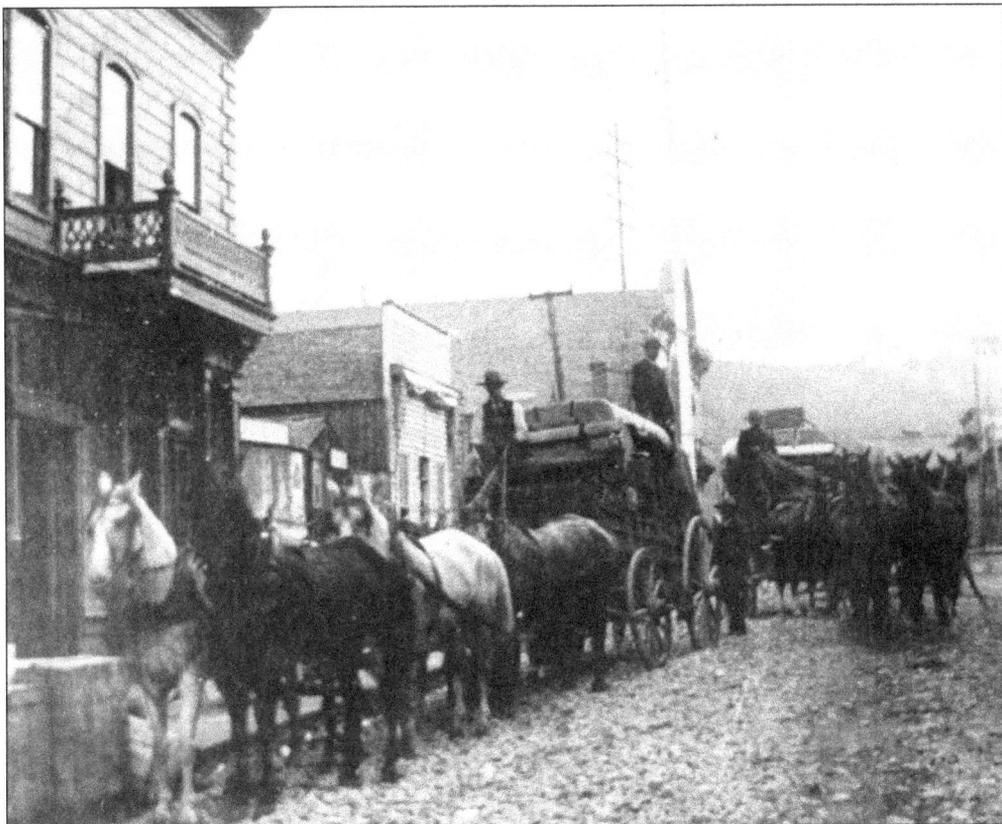

A stagecoach is at a stop in Rapid City. The stage drivers were well armed, prepared to defend the coach, their passengers, their property, and the US Mail. The companies hired only the sharpest and toughest of applicants. A stagecoach driver had to be equipped to fulfill his duty. (Courtesy Minnilusa Historical Association.)

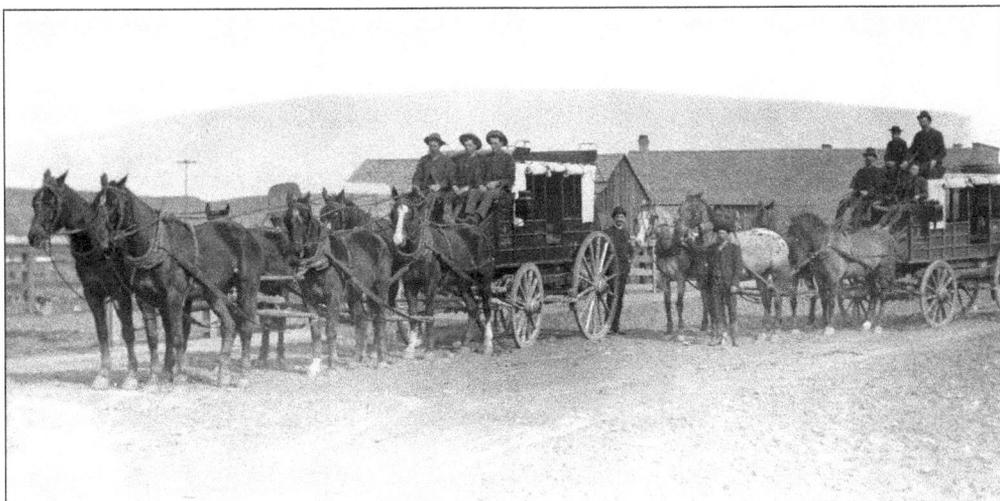

The stagecoach companies employed armed security guards to defend their shipments of bullion, "riding shotgun" beside the driver or as outriders alongside the coach. (Courtesy Minnilusa Historical Association.)

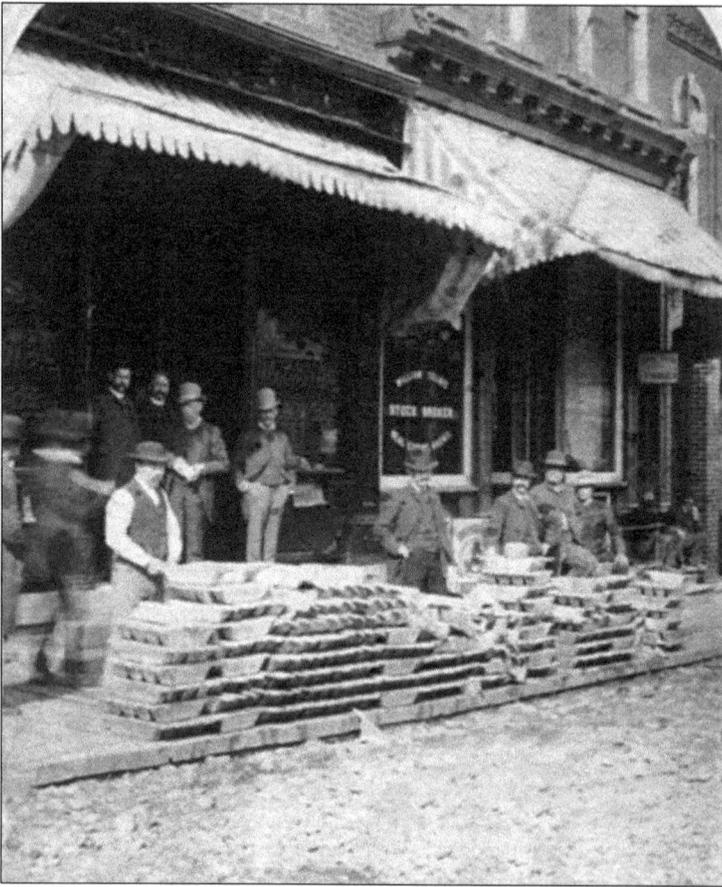

The streets are unpaved, the sidewalks are wooden boards, and gold bricks are stacked somewhat casually in front of the First National Bank, awaiting the arrival of the "Treasure Coach." Designed to deliver the shipment of gold, probably to the treasury in Denver, this stagecoach was especially secure. By current standards, a bar of gold is valued at a minimum of $500,000. (Courtesy Adams Museum.)

This is a Wells Fargo receipt for gold bars. To offer some perspective on the riches being extracted from the ground, in 1885 just two gold bars were valued at $19,000. (Courtesy Jerry Bryant.)

16

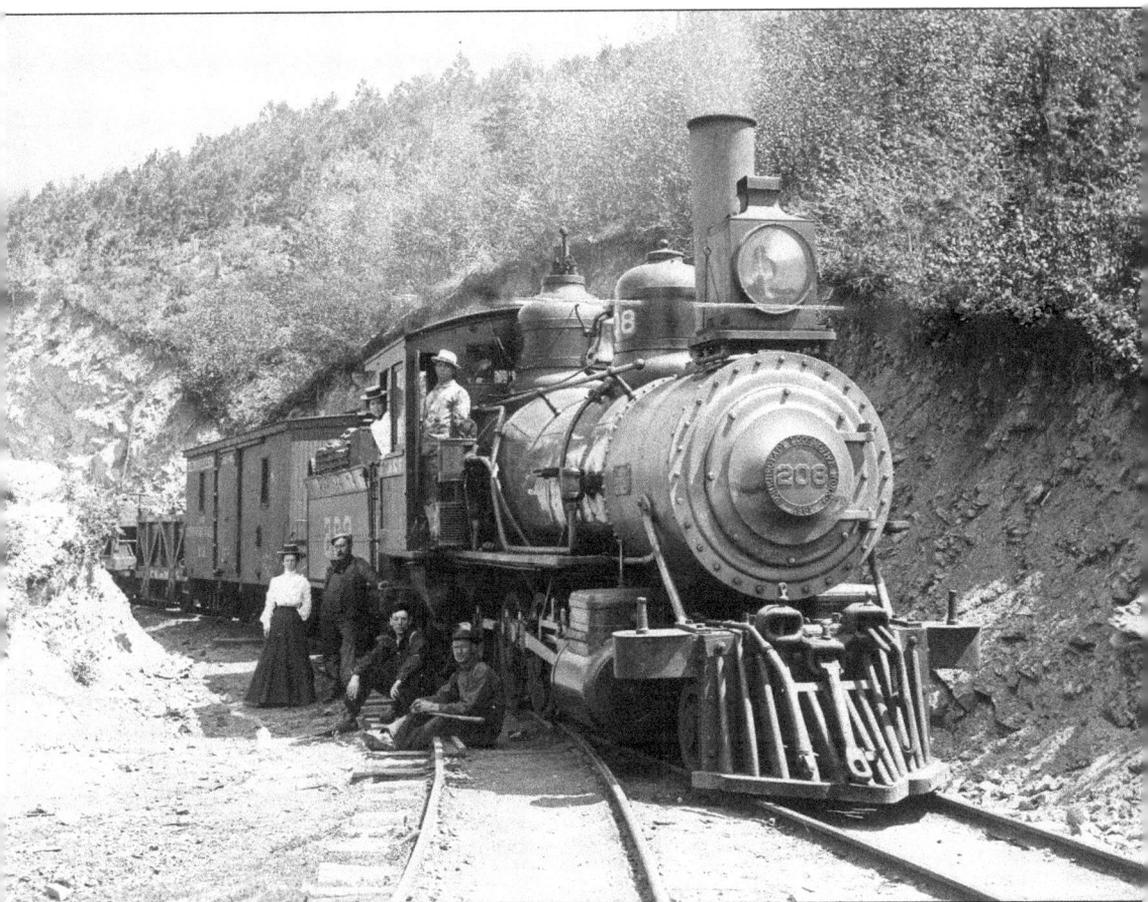

This image is from about 1890, around the time that the Fremont, Elkhorn, and Missouri Valley Railroad arrived in Deadwood. When the miners and businessmen first came into the Black Hills, all their equipment—everything—had to be carried in by horse or mule. The freight and stage lines began running into the Hills almost immediately, carrying people, equipment, and supplies. The freight companies with their ox trains could haul in heavy equipment, but they were slow. The miners and businessmen who set up in the Black Hills waited with anticipation as the railroads began building toward them. The 1880s newspapers carried regular reports of progress as the railroads approached the Hills. The long-awaited arrival of the train meant the beginning of the end of the stagecoach and the ox team. (Courtesy Minnilusa Historical Association.)

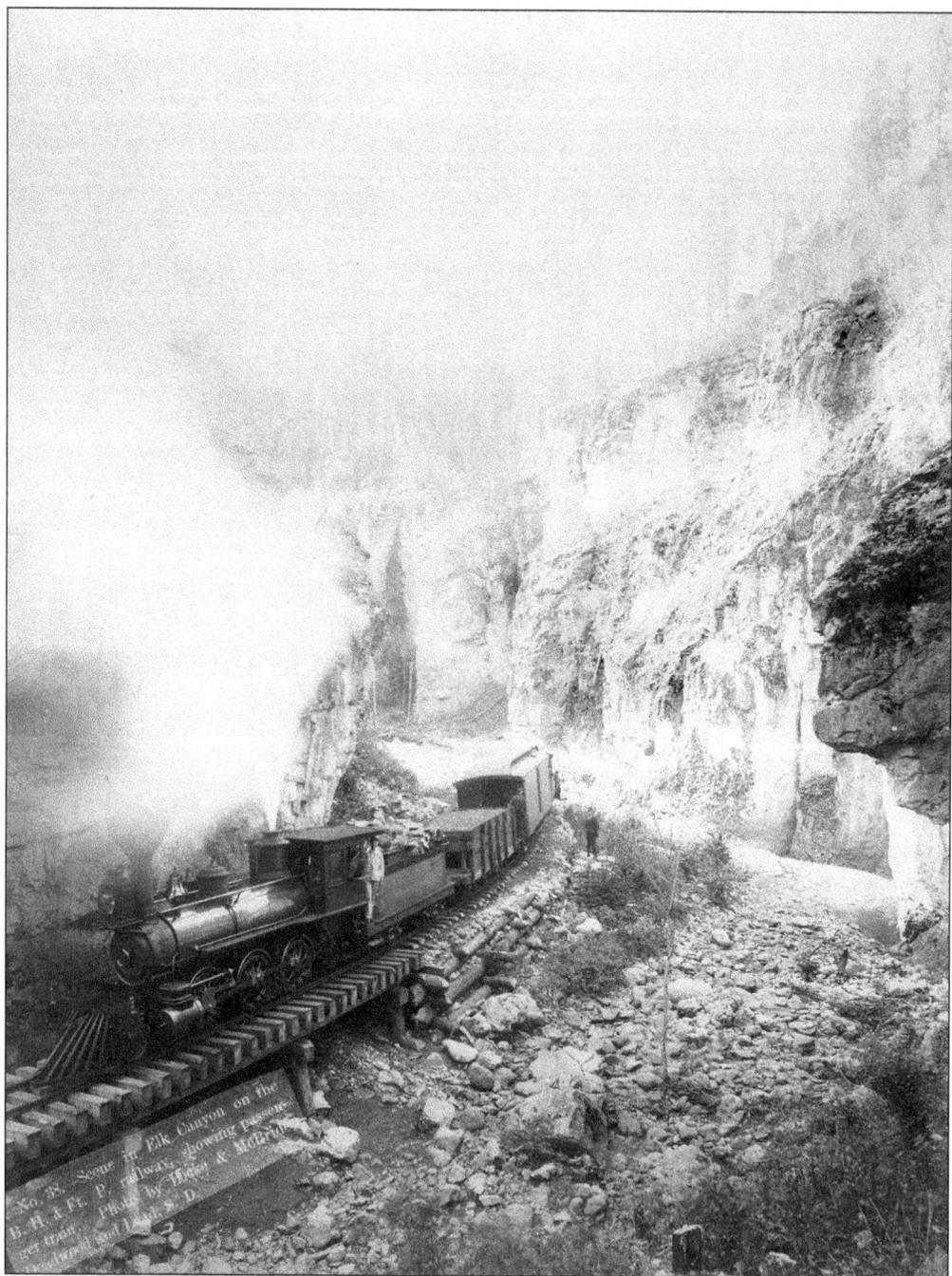

The Black Hills and Fort Pierre Railway passenger train steams through Elk Canyon. In 1890, the long-awaited Fremont, Elkhorn, and Missouri Valley Railroad arrives. For Deadwood, this was a moment of triumph; it confirmed Deadwood's reception into the cosmopolitan world. The market in real estate was already booming; the town was prepared. Deliveries and shipments to and from the East would be expedited, travel made more comfortable and convenient, and mail made more secure. As much as the railroad had arrived in Deadwood, Deadwood had arrived in the world. (Courtesy Minnilusa Historical Association.)

Two

The Merchants

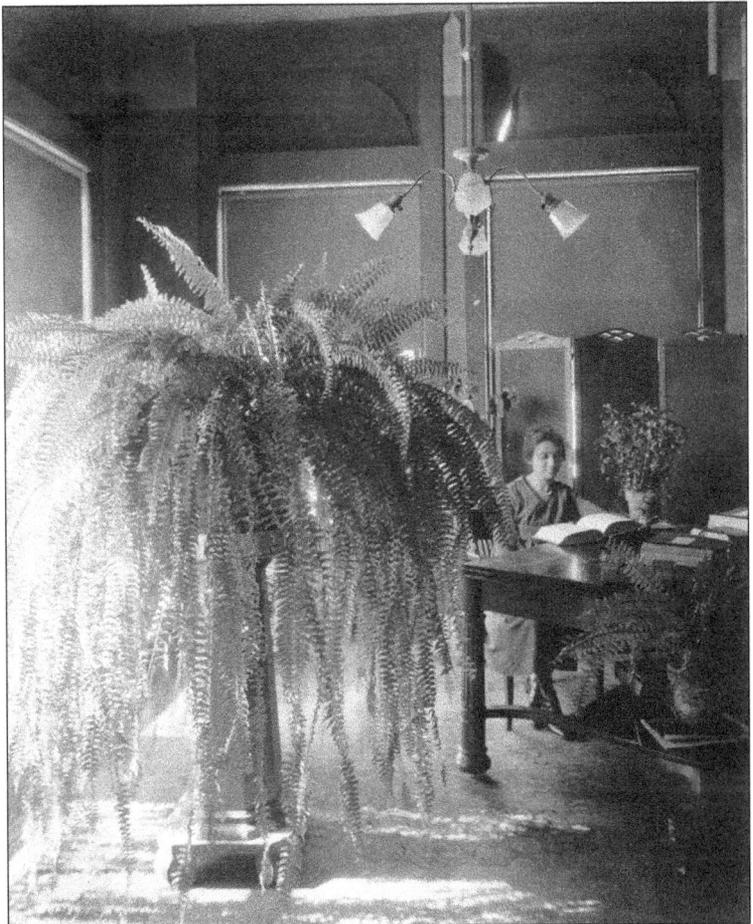

Blanche Colman is pictured in her office. Blanche was born in Deadwood in 1884. She worked for Chambers Kellar, attorney for the Homestake Gold Mine, doing most of their probate work. Later she went into private practice. In 1911, she earned the distinction of being the first woman in the state of South Dakota to pass the bar. Blanche Colman received an award for practicing law in the state for 50 years. (Courtesy Al Alschuler.)

Benjamin Baer, a successful Jewish businessman, was originally from Paris, France. According to Seth Bullock's account, Baer became a dealer in wholesale and retail liquor in Yankton, Dakota Territory. From Yankton, he traveled to Deadwood in August 1876 with a plentiful supply of alcoholic spirits, which was much in demand. Dealing in liquor was considered a respectable business on the wide-open frontier, provided one was willing to conform to the prevalent blue laws and close one's store on Sunday. In the early 1880s, Baer started the American National Bank of Deadwood. (Courtesy Adams Museum.)

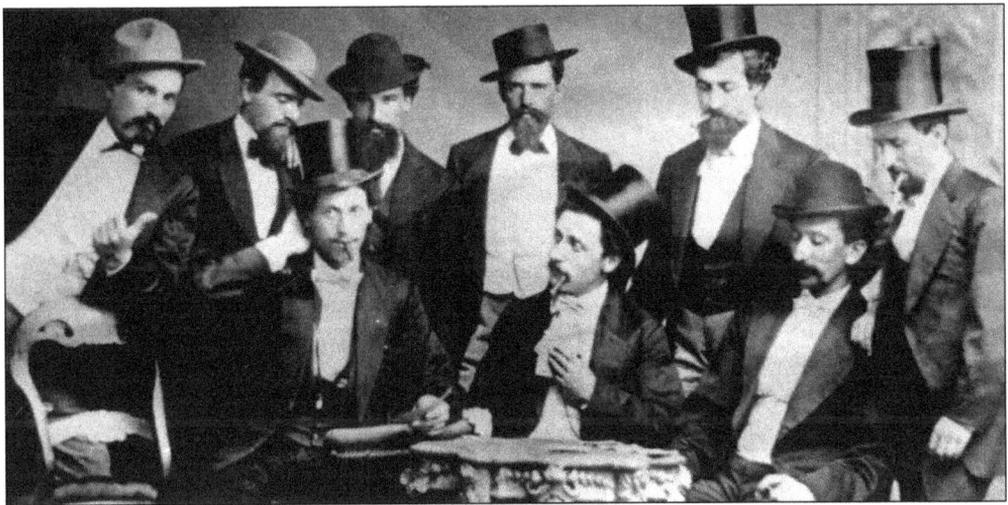

This image is a reenactment of an exceptional bit of luck for Ben Baer in Deadwood. One of his friends at the poker table had his money tied up in cattle. Ben had won every pot; however, money was scarce due to a drought that left cattlemen with starving herds, so Baer had to accept his winnings in emaciated cattle. The next morning, Ben awoke to a pouring rain that continued for weeks, ending the drought and bringing fresh grass to the pastures. To everyone's surprise, his herd flourished. He later sold the cattle, and with partner Harris Franklin, he purchased the Golden Reward Gold Mine. The players who gathered for this photograph were Ben Baer, Gus Cohn, Ed Haas, Aaron May, Sam Hess, Emanuel Fist, Louis Deutsch, Ben Oppenheimer, and Sol Ehrman, a group of Jewish businessmen. (Courtesy Adams Museum.)

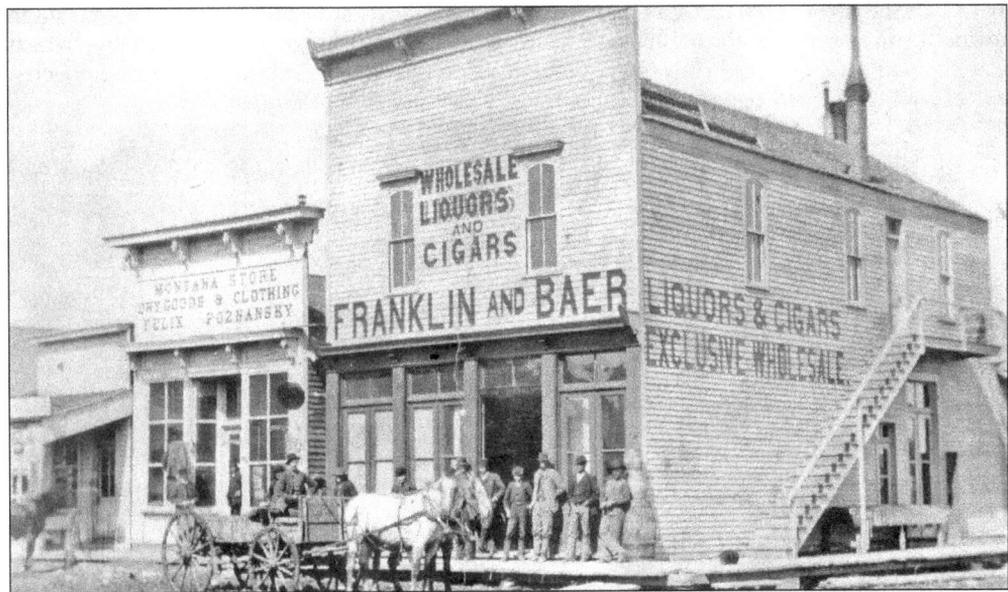

Franklin and Baer's wholesale liquor and cigar business branch was on Main Street in Rapid City. They became the largest wholesaler of these products in the city. Besides formation of their 1884 liquor and banking partnership, the business alliance of Harris Franklin and Ben Baer, Jewish businessmen, held huge investments in cattle and mining, which would become among the foremost in Deadwood's history. The building to the left houses Felix Poznansky's Montana Store; to the left of that is Hyman Levy's tailor shop. (Courtesy Minnilusa Historical Association.)

Convinced that this was the ideal place to set up his menswear shop, young Sol Bloom from Council Bluffs, Iowa, drove his team and wagon into Deadwood in April 1877. Deadwood's muddy streets proved little impediment to his business. The gold rush had exploded, and the town was bursting with excitement. In July 1877, he moved his store into a building opposite the Custer House on the corner of Main and Gold Streets. It was there that he hung out the largest sign in town. Bloom signed onto the gold dust standard, accepting gold dust as a form of currency, which was characteristic of a gold rush town. Gold dust was carried around in little leather pouches called pokes and was weighed as a form of trade. (Courtesy Adams Museum.)

The Bloom Shoe and Clothing store, particularly notable for its extensive volume of inventory, was a great success, with counters and shelves stacked high with merchandise. With this success, Bloom opened branches in Sturgis, South Dakota, and Sheridan, Wyoming. (Courtesy Adams Museum.)

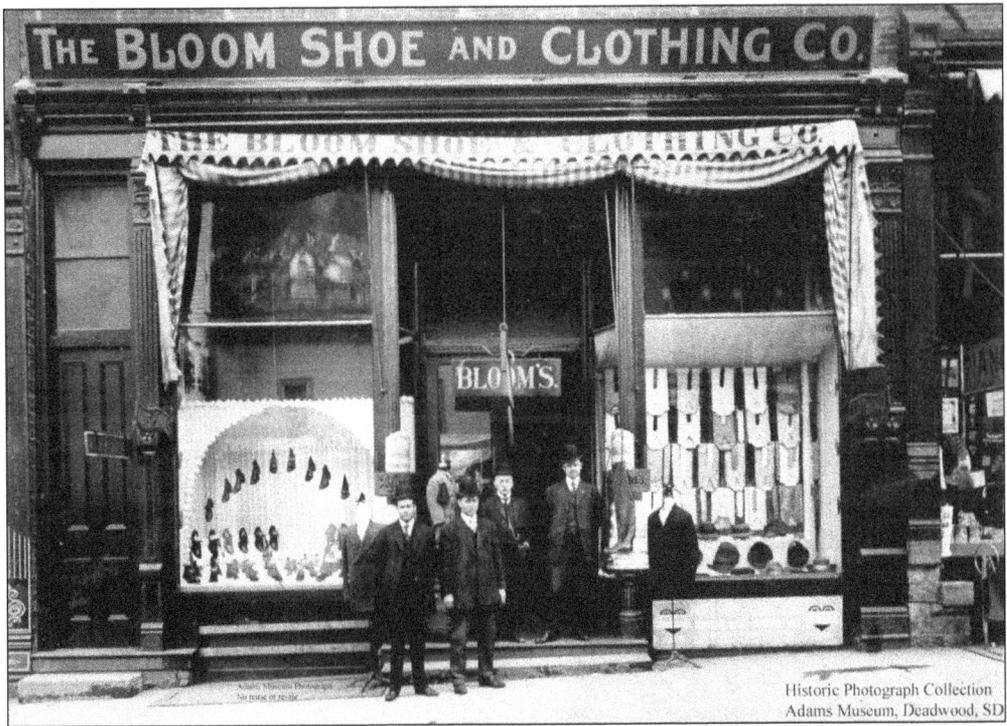

His store became more fashion-conscious and tasteful as the years went by. Sam Brown was Bloom's longtime employee. After Bloom opened his branch in Sheridan, Wyoming, and then relocated there, Brown bought the Deadwood store and continued operating the business as owner until 1937. (Courtesy Adams Museum.)

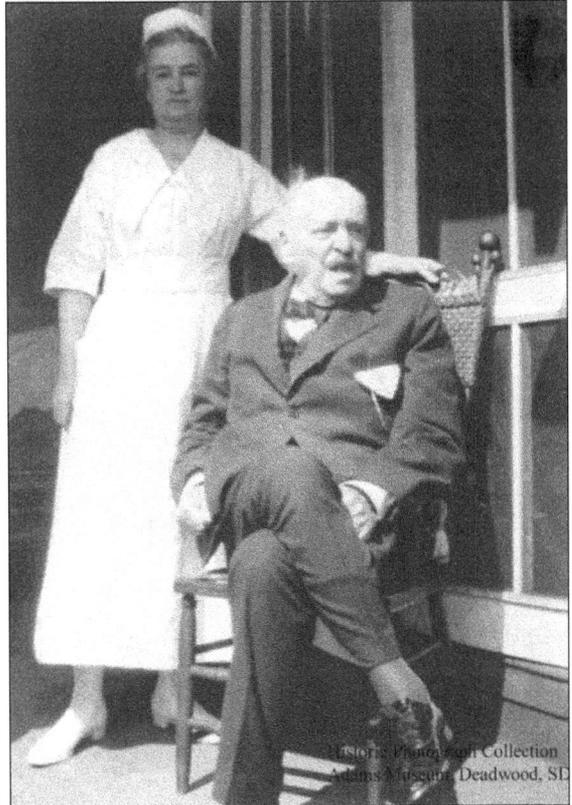

Sol Bloom's career in the mercantile business spanned half a century in the Black Hills region and clothed most of its citizens. (Courtesy Adams Museum.)

23

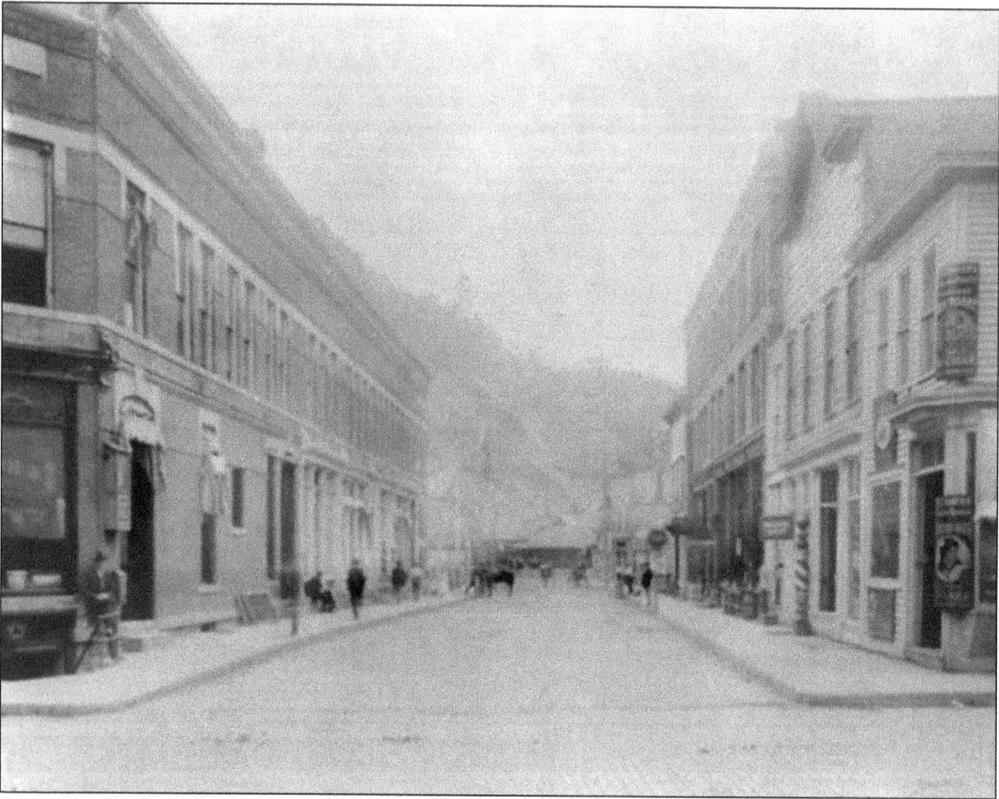

Bloom's Corner, pictured at right on the corner of Main and Gold Streets, is still known by that name. Today's building is a facsimile of the original store, which burned in one of Deadwood's many fires. (Courtesy Adams Museum.)

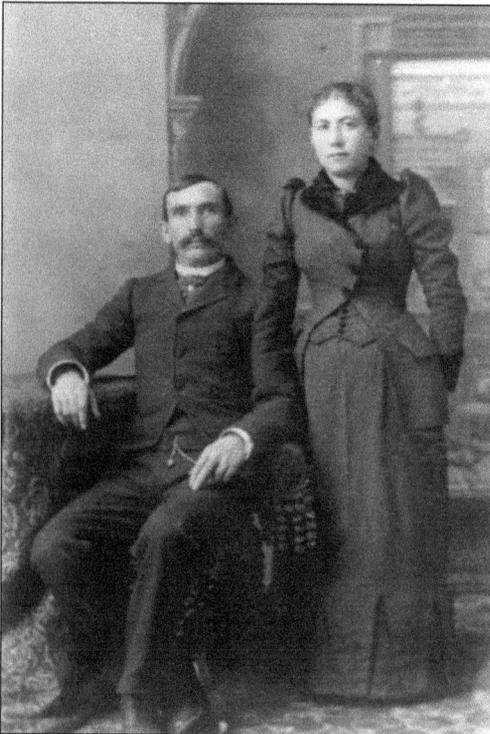

At left are Benjamin and Frieda Blumenthal. Benjamin left Koenigsburg, Germany, as a boy and traveled throughout Europe, eventually finding himself in the French Foreign Legion and just about to set sail. Instead, he stowed away on another boat that was preparing to set sail for the United States. On arrival, the captain of the ship kindly gave the boy $2 and a pair of shoes. Benjamin worked his way across the country and into the Black Hills in 1886. Once he had established himself in a small business, he sent back to Koenigsburg for his bride. Her father, Rabbi Joseph Lowenstein, made sure that the Torah would be at the religious center of this young couple's life together. (Courtesy Adams Museum.)

When Frieda Lowenstein came to join
Benjamin, because she was a woman, she
would not be permitted to either carry a
Torah or to travel alone with a man to whom
she was not related. It was arranged for
Frieda to be accompanied by a Jewish couple,
Simon and Dora Jacobs. The Blumenthal
Torah, as the Torah was known, has always
been at the center of the sacred tradition
and Jewish worship in the Black Hills. It
has resided at various times in the Masonic
Lodge or in a private home, but not until
it was taken to Rapid City did it reside in a
brick-and-mortar synagogue. Seven of the
eight Blumenthal children are pictured here.
From left to right are (seated) Gus, Ethel,
and Abe; (standing) Sol, Charlie, Sarah,
and Gertrude. (Courtesy Faye Gitter.)

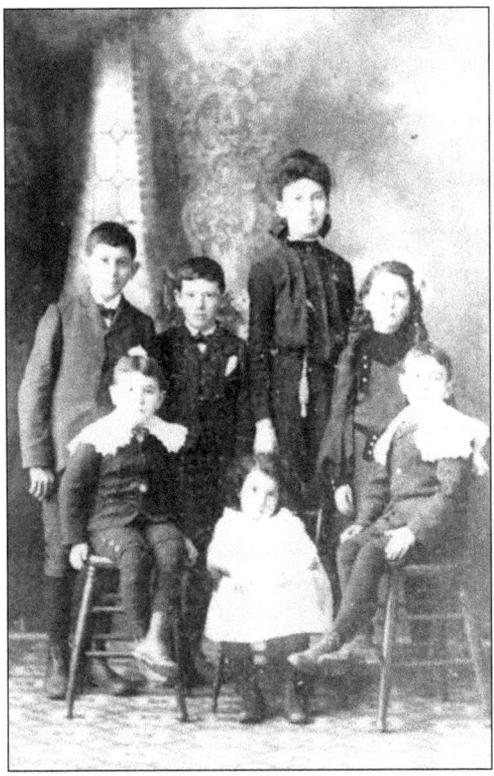

Sarah and Saul (Sol) Blumenthal are
shown in this image around 1893.
Deadwood's Jewish population gradually
dwindled, with the next generation
leaving to seek higher education and
Jewish spouses. The family of Sam
and Sarah Blumenthal Margolin
safeguarded the Torah in their home
for many years, and eventually it was
passed along to the growing Rapid City
community. Today, it is a vital part of
Jewish life at the Synagogue of the Hills
in Rapid City. (Courtesy Faye Gitter.)

From left to right above are some of the Blumenthal children: (first row) Gertrude and Ethel; (second row) Sol, Charlie, and Sarah. The Blumenthals' home was on Deadwood's Williams Street, likely named for J.J. Williams. Williams, not Jewish, but worthy of recognition for the *mitzvah* (good deed) he had done in 1874. When Moses Aarons, a young Jew and well-liked fellow member of the prospecting Gordon Party, fell ill and died as they passed through the Badlands, Williams fashioned a wooden coffin in which to bury Aarons beside the Bad River. Several other Jewish family homes, including the Colmans', were on Williams Street, located on the hillside high above the western side of Deadwood's Main Street. (Courtesy Adams Museum.)

From left to right are Sol, Abe, and Gus Blumenthal. Noted Deadwood historian and columnist George Moses recalled the Blumenthal family, saying they were all good musicians. Their family band played at dances at the park in Spearfish. The family band consisted of Sarah, Dorothy, Abe, Charlie, and Sol Blumenthal. George reminisced, "I have danced in the great dance halls of Chicago, Kansas City, Omaha, [and] Denver . . . but there was nothing to compare with those wonderful dances in Spearfish." Spearfish, known as the Queen City, was settled in 1876, as were Deadwood and Rapid City. (Courtesy Adams Museum.)

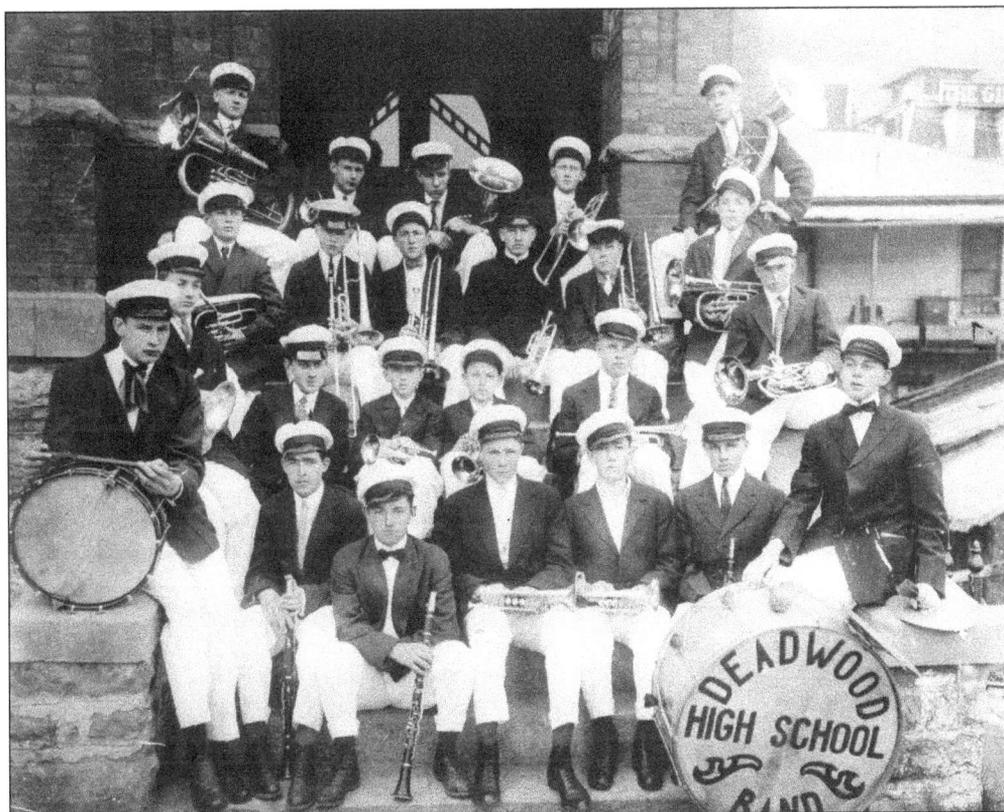

Abe Blumenthal (first row, third from right) played in the Deadwood High School Band. Abe was described as outgoing, amiable, and well liked. Abe's family's ladies' clothing business operated continuously from Deadwood's earliest days and up through the 1990s in Rapid City. The advent of gaming in Deadwood resulted in local businesses having to relocate to the new commercial hub. When it finally went out of business, it was missed. When Rapid City's YMCA was being remodeled, the Blumenthal family generously donated funding for a room. (Courtesy Adams Museum.)

Nathan and Amalia Colman, with baby Anne, are pictured here. Anne Colman was the first of what might have been a large family but only Anne, Theresa, and Blanche survived the epidemics of smallpox, diphtheria, measles, typhoid, and other deadly diseases that filled Black Hills cemeteries. Nathan Colman was an observant Jew, devout and learned in Jewish rituals and traditions. His skills and education were welcomed by his fellow Jews in the remote outpost, and true to the spirit of "frontier Judaism," he was called upon to lead the Jewish community in religious services for holidays and other functions. (Courtesy Adams Museum.)

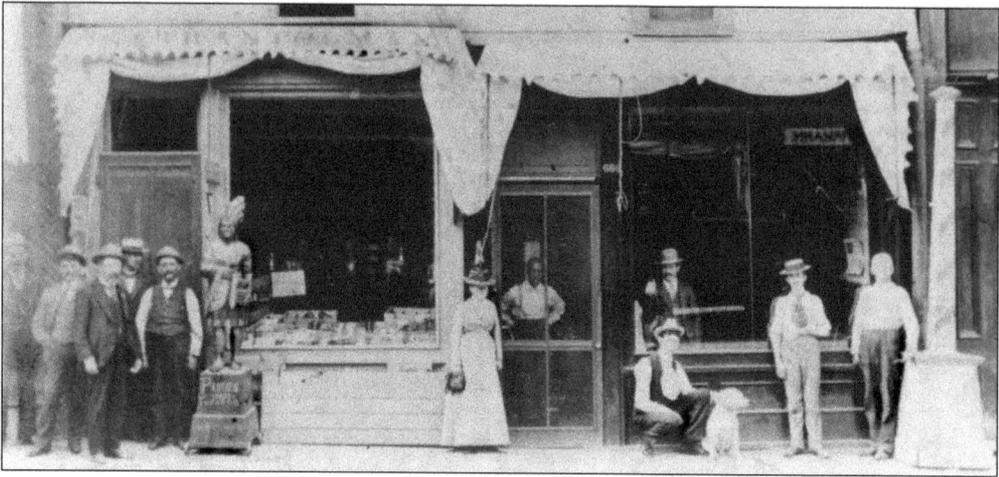

Nathan Colman, energetic, capable, and unafraid to try his hand at a new undertaking, embarked upon one after another commercial ventures, all widely disparate. His first business was a tobacco and confectionery shop, to which he added groceries. He later introduced ice and coal into his business. He then organized a stock company for the Mary Mine. Colman assumed a wide variety of positions of civic responsibility. In 1881, he was elected secretary of the fire department in Deadwood. He later acted as one of the judges of the territorial election in 1889, the year South Dakota achieved statehood. He was one of the enumerators of the 1890 census. In 1891, he sat on the Lawrence County Commission, whose job it was to decide on issues regarding taxes, bridges, and roads as the county laid down its infrastructure. (Courtesy Adams Museum.)

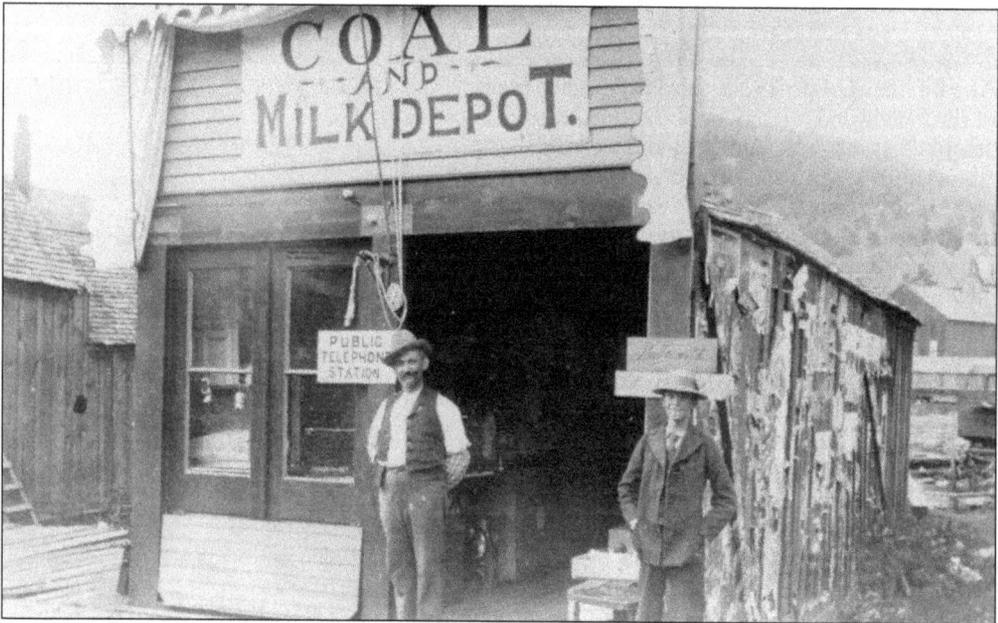

In 1878, Colman was appointed postmaster of the Beaver precinct, adjacent to Deadwood. He was elected justice of the peace in 1879. In a bid for reelection, he was endorsed by the *Black Hills Daily Times*, which affirmed that he was a "Western man . . . well suited for the job . . . If you want a man to settle your little difficulties in an honest and comprehensive manner, elect Judge Colman [who] . . . is familiar with the practice of this Territory. In fact he is no slouch of a lawyer himself." (Courtesy Adams Museum.)

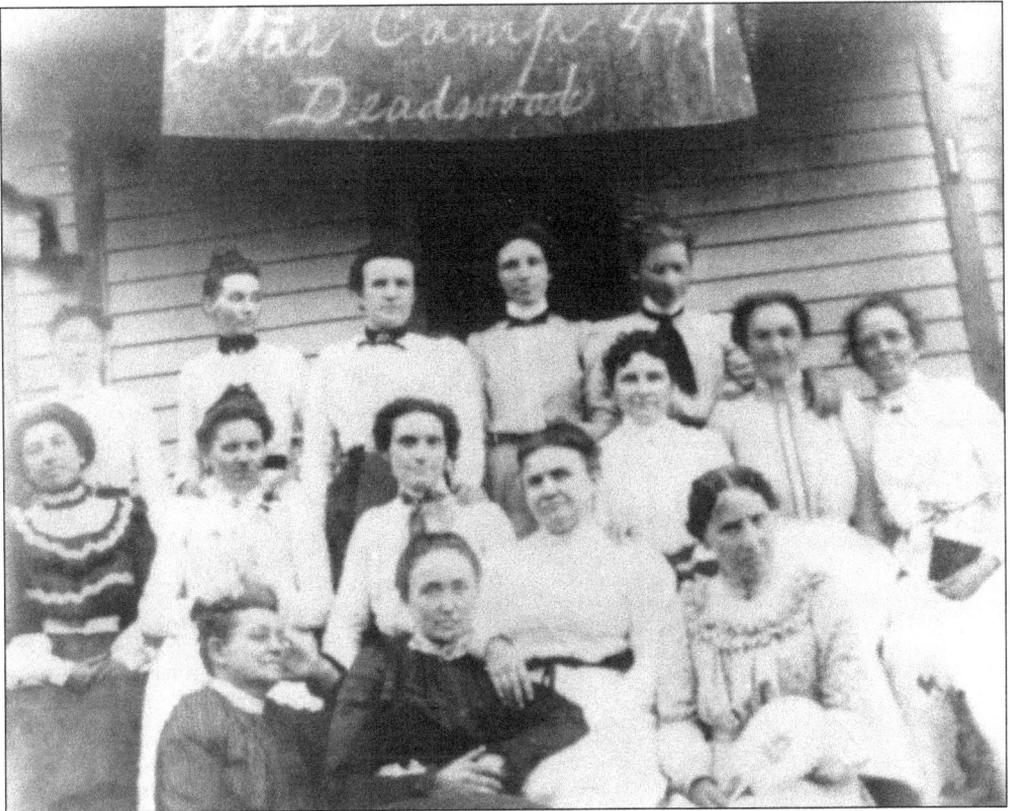

Anne Colman is shown in the third row, second from right, at Star Camp in Deadwood. Of Nathan Colman's three daughters, only Anne got married. In 1905, Nathan, acting in his capacities as both lay rabbi and justice of the peace, performed the ceremonies that united Anne and Maurice Neiderman in wedlock at the newly opened Franklin Hotel. The couple had a business in Deadwood for a while but eventually moved to Chicago. (Courtesy Adams Museum.)

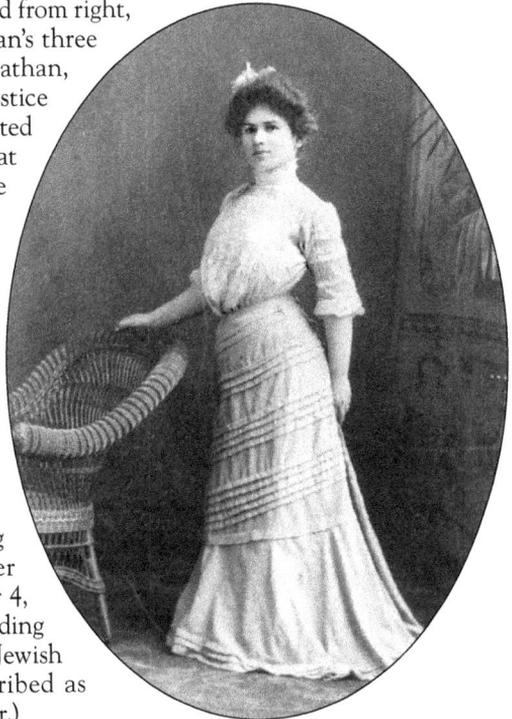

Theresa (Tess) Colman, pictured at Anne's wedding, was tall and attractive. Tess's father, Nathan, led services at most of the Jewish rites and celebrations in the community, conducting High Holidays services and leading Passover Seders, weddings, and funerals. On November 4, 1879, Nathan officiated at the first "Hebrew" wedding in the Black Hills, which was one of the first Jewish events of record in Deadwood. It was described as "beautiful and unique." (Courtesy Al Alschuler.)

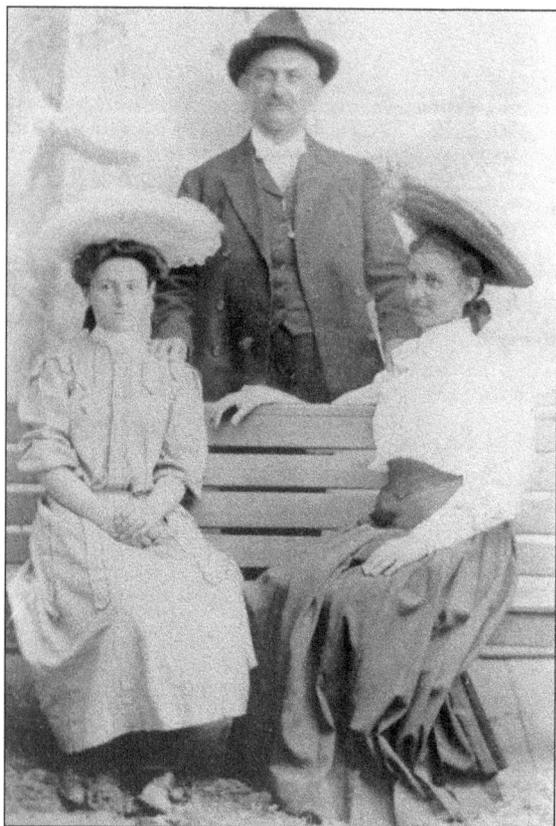

Pictured here is Nathan Colman with daughters Theresa and Blanche. The Jewish American Society for Historical Preservation (JASHP) has placed a historical marker at the foot of Jerusalem Avenue in Mount Moriah Historic Cemetery to honor the Jewish community of Deadwood and the Black Hills. This photograph is shown on that marker. (Courtesy Adams Museum.)

From left to right are (first row) Ida Levinson and Amalia Colman; (second row) Theresa and Blanche Colman. The Colmans and Levinsons were good friends. (Courtesy Deadwood Public Library.)

Pictured here are Anne; her five-year-old son Allan; Theresa; and Nathan's wife, Amalia. Anne was the only one of the Colman sisters to leave Deadwood permanently. One of the earliest newspaper articles concerning Anne relates to her riding in a car in a parade representing the state of New Mexico, which was where her father had made his first home in the United States. (Courtesy Deadwood Public Library.)

Blanche Colman (1884–1978) was the first woman in the state of South Dakota to pass the bar. Her customary walk from Deadwood to her workplace in Lead no doubt contributed to her good health and longevity. She was a true original Jewish pioneer, likely having been the first Jewish baby born in Deadwood, and the last of the original Jews to die there. A spunky, well-loved woman, Blanche now rests in the Colman family burial plot on Mount Moriah in the Mount Zion section of the cemetery, high on what has been called "Hebrew Hill." (Courtesy Deadwood Public Library.)

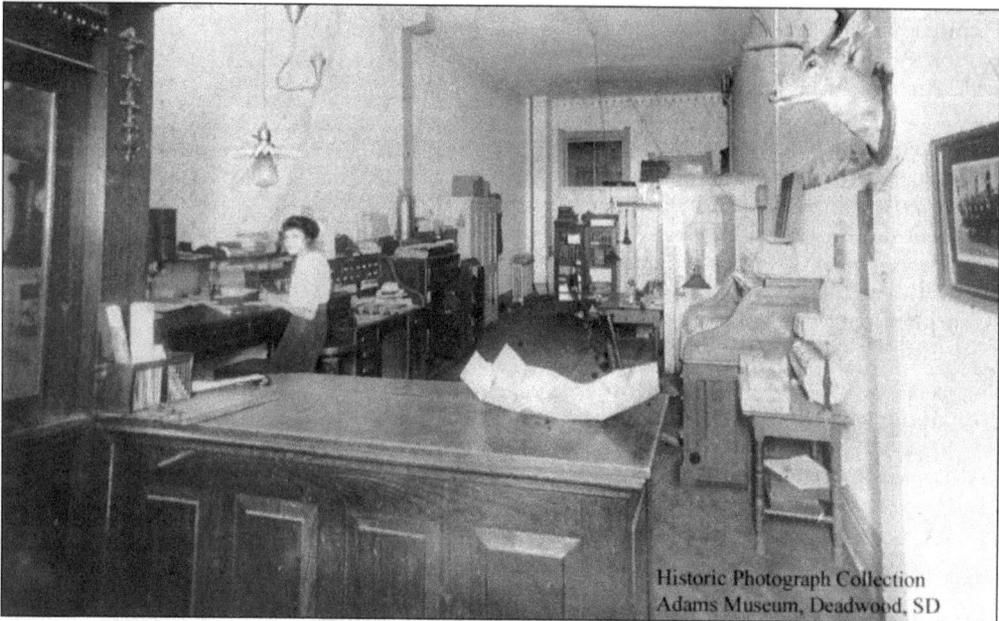

Theresa Colman is pictured here in the county auditor's office. Her father, Judge Nathan Colman, who specialized in probate, had a strong influence on his daughters. Theresa was Lawrence County auditor for 40 years. In their retirement years, Theresa and Blanche resided in the Franklin Hotel. Both are buried in the family plot in the Mount Zion section. (Courtesy Adams Museum.)

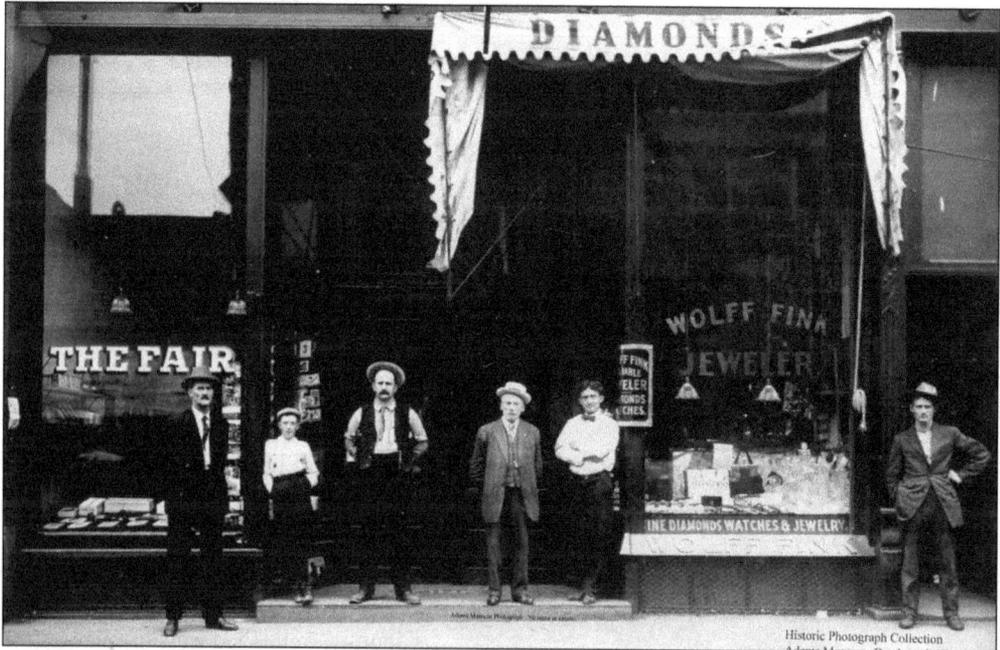

Wolff Fink is shown at center. Fink was born in Poland but was raised in Koenigsburg, Germany. According to information engraved in headstones on Mount Moriah, Koenigsburg was the birthplace of several of Black Hills's Jewish citizens. In 1882, he came to the United States on a visit to see his father, Joseph Fink, who resided at Deadwood. After working in his father's Deadwood store for one year, he was convinced to stay in the United States. (Courtesy Adams Museum.)

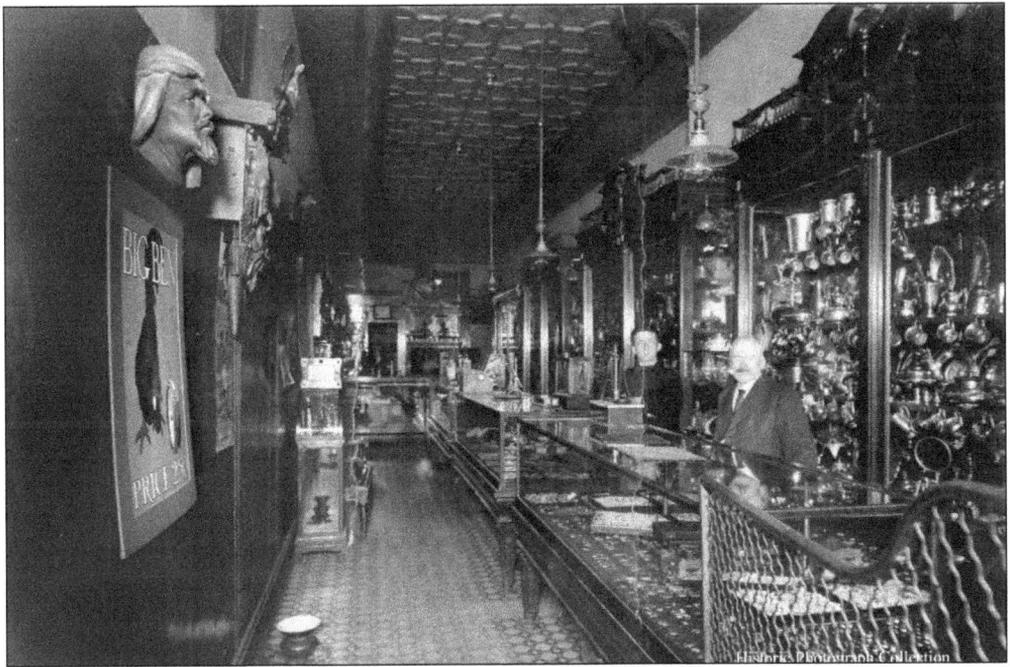

Fink and some employees are pictured behind the counter. The US Census listed the 1,440-citizen community of Lead, South Dakota, as a town. By 1900, the number of residents had grown to 6,212 and then to 8,392 in 1910, making it the second largest city in South Dakota. It was also the most prosperous, with the best wages and steady employment for the town's skilled mechanics, miners, and laborers. (Courtesy Adams Museum.)

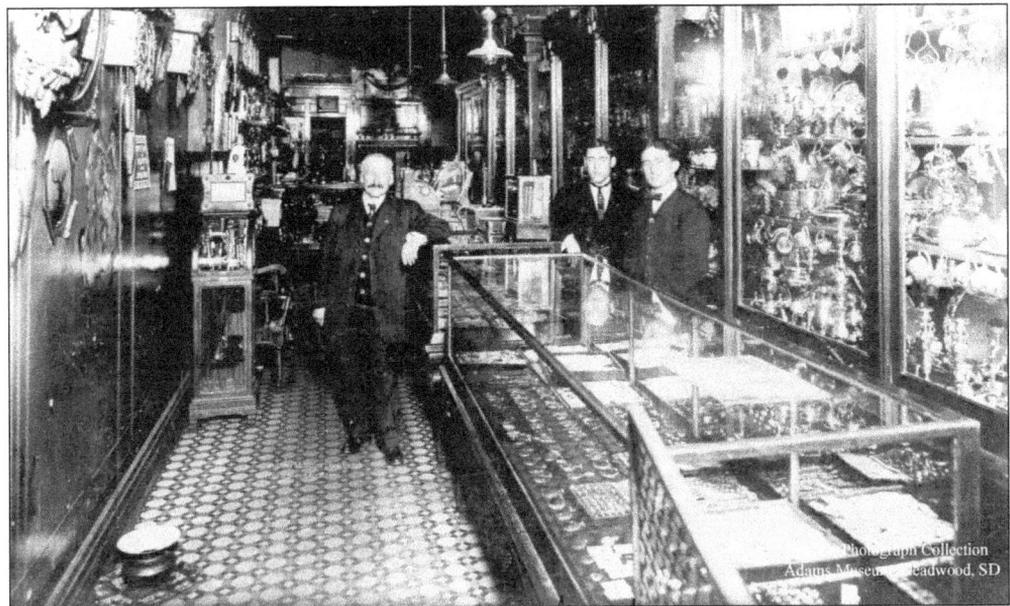

Fink's Jewelers was an elegant shop, with a fine display of urns, silver chafing dishes, and other costly articles. The showcases were filled with watches and jewelry, and lovely clocks were on display on the wall to the left. Notice the beautifully tiled floor. The spittoon conveniently located near the entrance is a concession to sanitation. (Courtesy Adams Museum.)

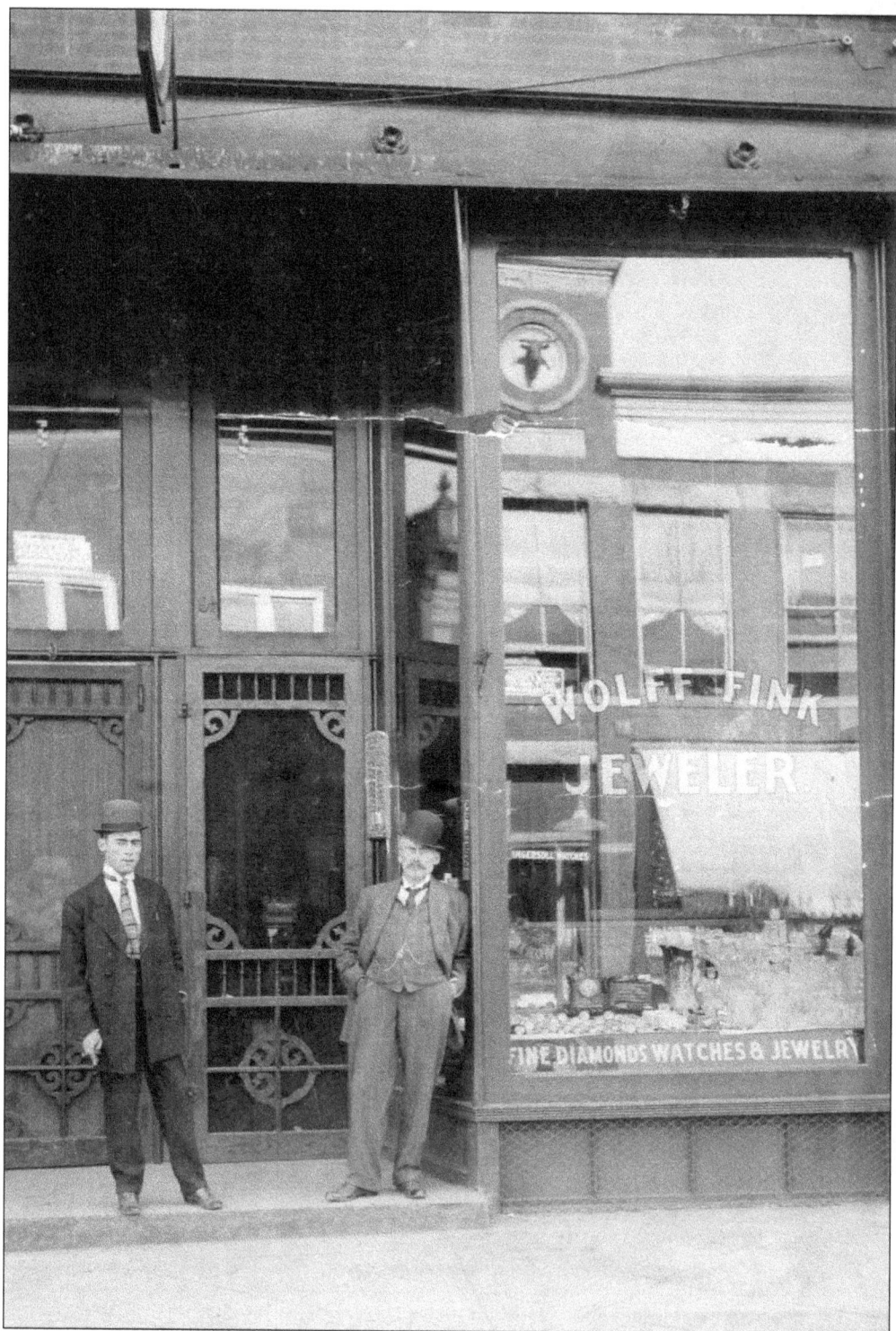

Wolff Fink (right) stands in the doorway of his jewelry store in Lead. Fink went to Lead in 1883 and set up a jewelry business that served the community for many years.

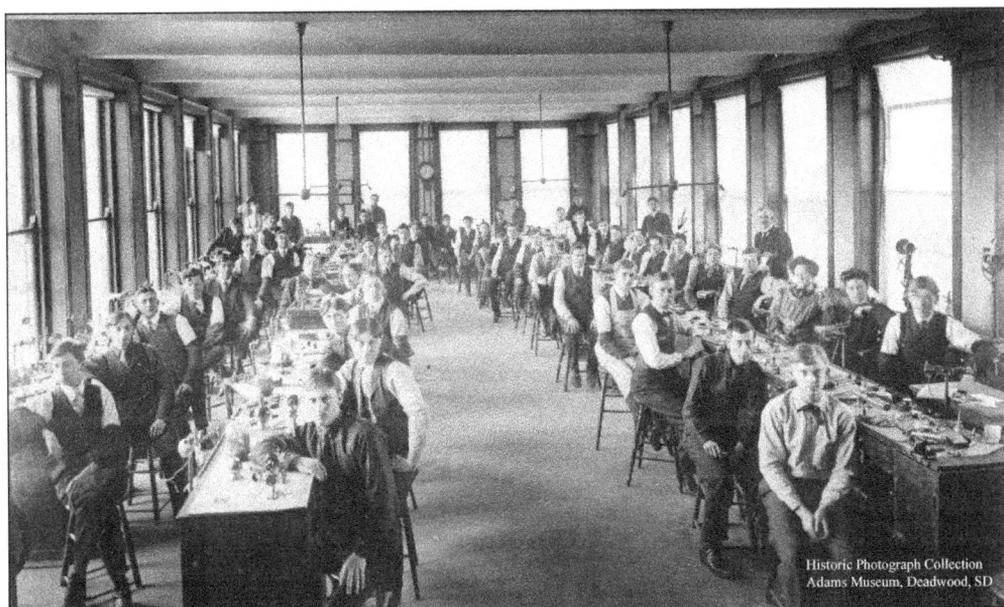

Historic Photograph Collection
Adams Museum, Deadwood, SD

Wolff Fink was an enterprising man who also started a jewelry manufacturing company in Lead that employed about 50 local citizens, although they were almost entirely men. (Courtesy Adams Museum.)

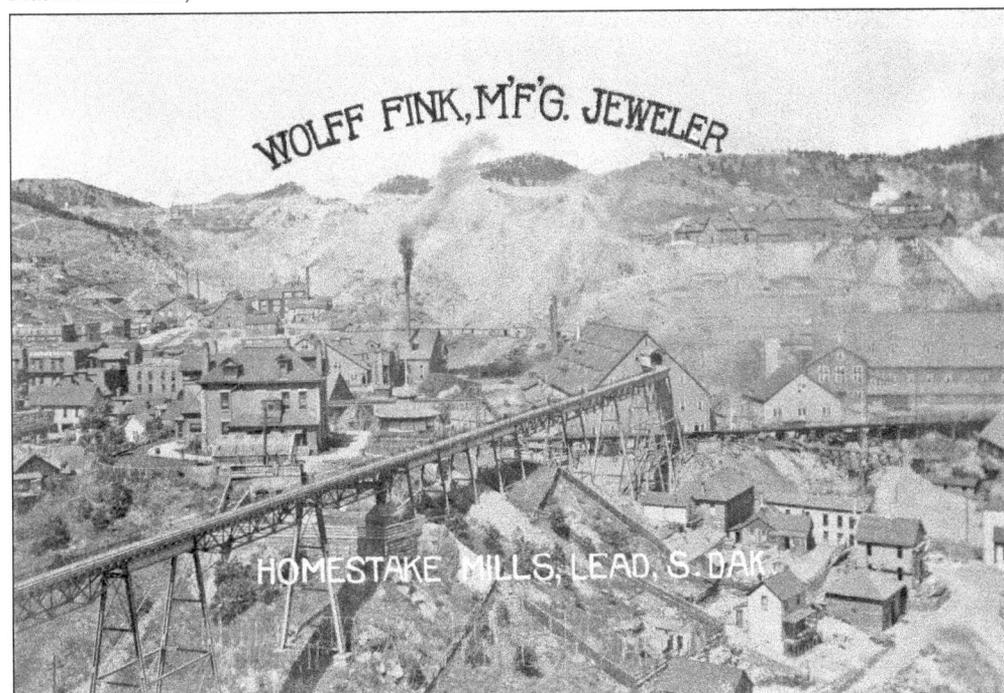

WOLFF FINK, M'F'G. JEWELER

HOMESTAKE MILLS, LEAD, S. DAK.

This postcard advertising Fink's jewelry manufacturing business shows the Homestake Mills at Lead. Wolff Fink and his wife, Anna, had one child, Louis, who attended St. John's Military Academy at Delafield, Wisconsin. The Finks are buried in the Mount Zion section of Mount Moriah Historic Cemetery. Their gravestone is ornately inscribed in Hebrew and English. (Courtesy Adams Museum.)

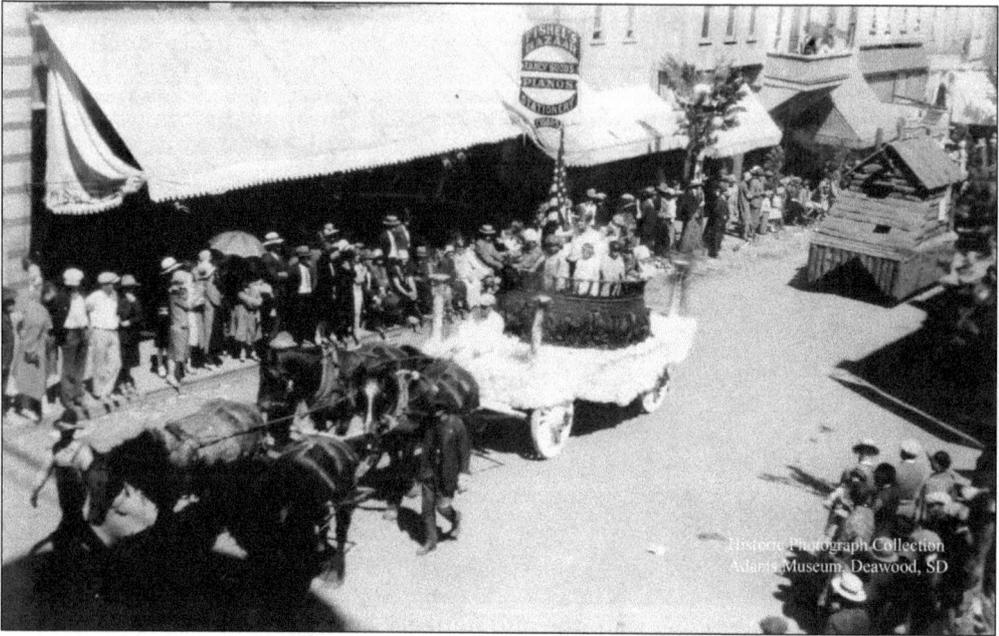

A parade passes by Fishel's stationery, notions, and piano store on Main Street. Jewish businessmen usually had a number of business affiliations, most often with other Jewish merchants. (Courtesy Minnilusa Historical Association.)

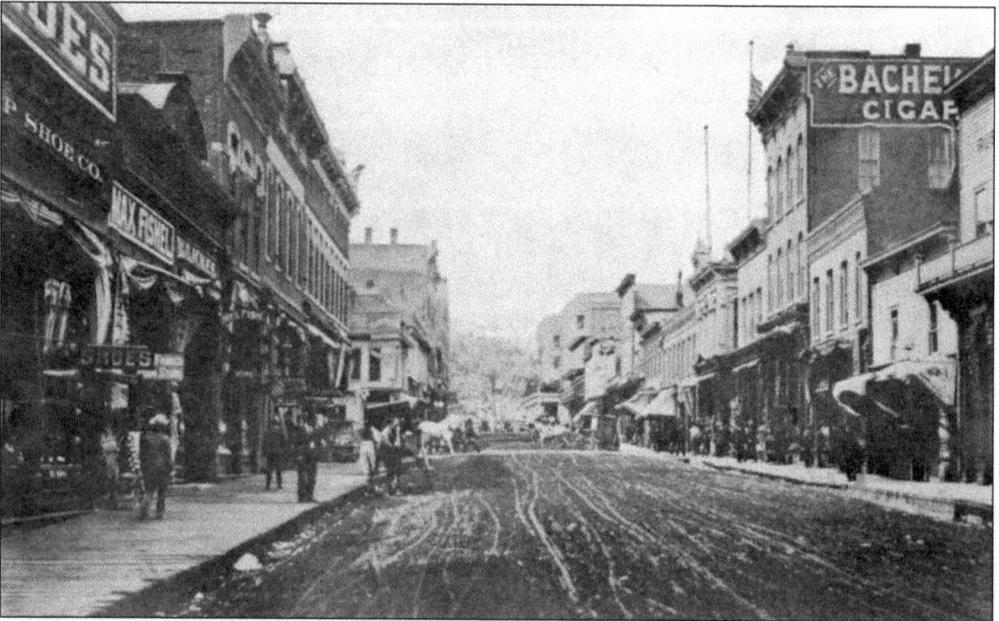

A view of Deadwood's muddy Main Street is pictured above. In 1903, Max Fishel and Ben Baer constructed a double-front brick building, with Baer operating a liquor store in his half and Fishel running a stationery store in the other half. Deadwood's sidewalks are still boards and its streets are still unpaved, but foot traffic is fairly busy. One can see Max Fishel's sign to the left, Sol Bloom's corner at the middle left, and the Franklin Hotel's portico in the right middle distance. (Courtesy Adams Museum.)

Here is Anna Steiner Franklin. Anna was a year old when the Steiners emigrated from Hanover, Germany, settling in New York, where Anna was raised and educated. Like the Franklin family, the Steiner family eventually moved to Burlington, Iowa, where Anna and Harris Franklin met. There the couple was married on January 1, 1870, and on December 15, 1870, Anna gave birth to a boy, their only child, Nathan E. Franklin. (Courtesy Adams Museum.)

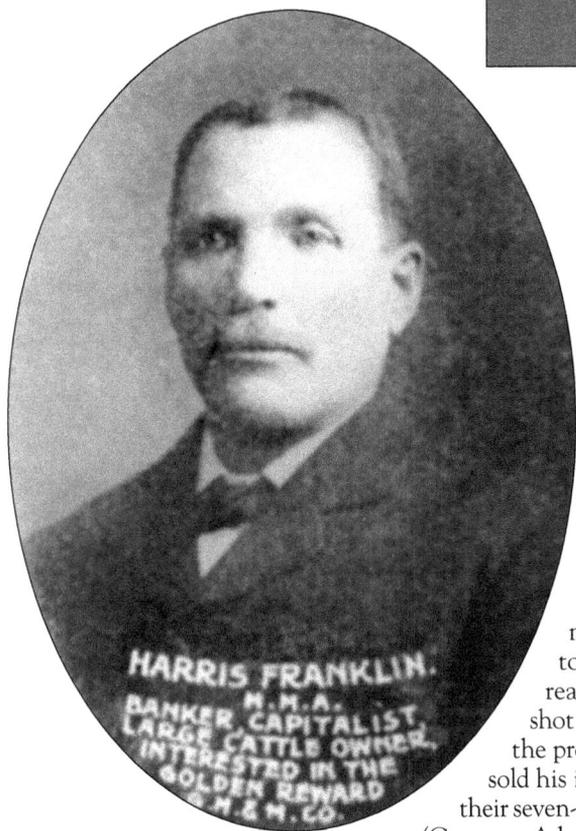

Harris Franklin, a small business owner, concluded that there was money to be made in the liquor business in a gold rush town. Deadwood's population was all too ready to exchange a pinch of gold dust for a shot of whiskey. Based on his conjecture about the prospects of the Black Hills, in 1877, Harris sold his interests in Wyoming, and he, Anna, and their seven-year-old son, Nathan, moved to Deadwood. (Courtesy Adams Museum.)

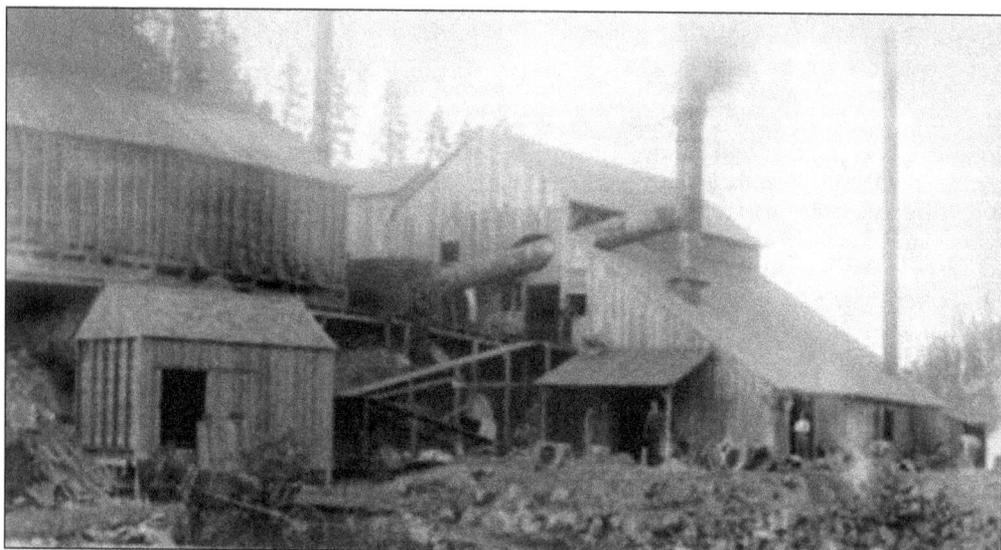

This ore smelter was located in the Black Hills. The *Black Hills Daily Times* in 1877 reported, "A handsome gold brick, the product of the Golden Reward, for two weeks was shipped east yesterday. It amounted to nearly $30,000." The Golden Reward was Harris Franklin's mine. (Courtesy Minnilusa Historical Association.)

Harris Franklin and business partner Ben Baer owned the First National Bank. Joe Poznansky, an employee from Rapid City, was busy at his usual duties at the bank on November 17, 1910, when the bank became the scene of an attempted robbery. As reported by the *Deadwood Daily Pioneer-Times*, on November 18, 1910, a stocky, 30-year-old-looking man entered the bank at about 11:00 a.m. and approached the teller's window, asking nervously, "Have you any money here?" The assistant cashier, Joe Poznansky, answered, "We have a little." The robber then said, as he reached for the gun in his pocket, "Hand it over and get it out quick." Then without waiting for Joe to either comply or refuse, he thrust the gun through the grating and pulled the trigger. When the gun discharged, Joe dodged beneath the counter, and the bullet, which glanced off the counter, struck the chandelier, reflected from the ceiling, and became lodged in the brick partition between the banking room and the director's room. (Courtesy Minnilusa Historical Association.)

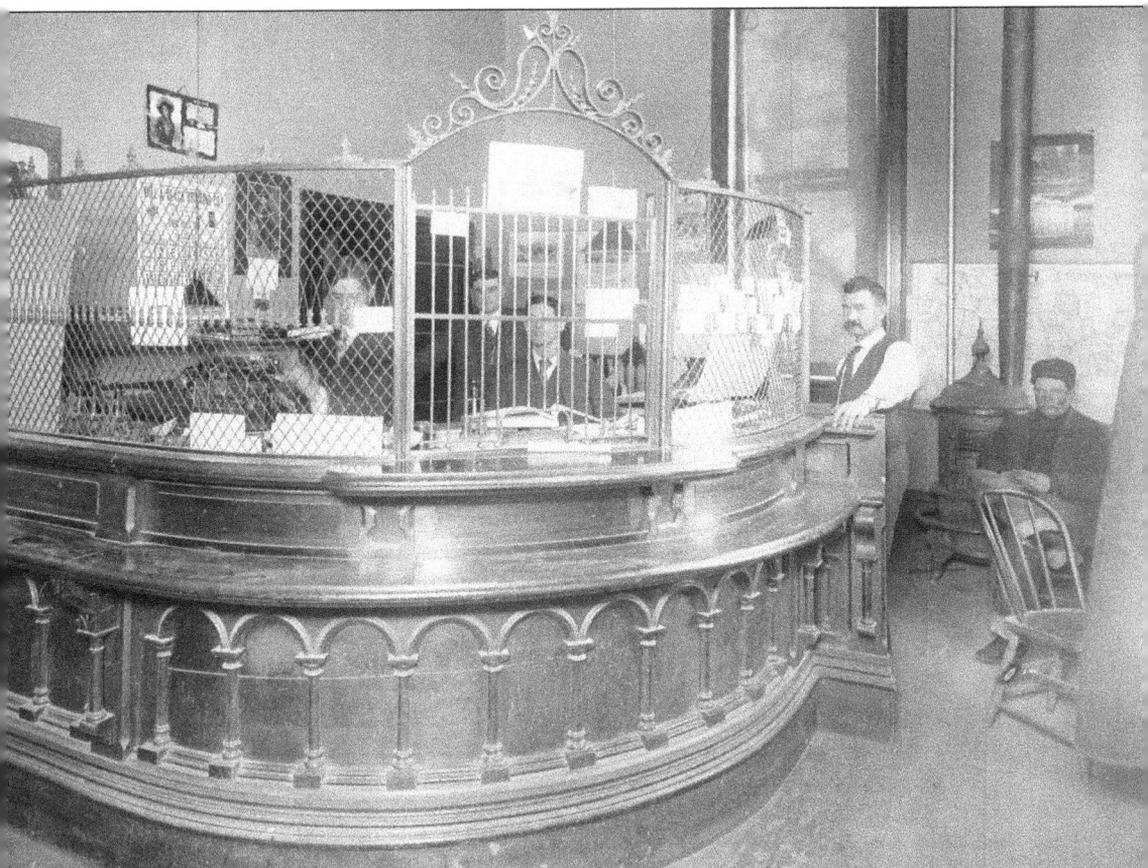

A woman customer who was in the bank at the time was so frightened that she rushed into the director's room, crashed through the window, and ended up taking the glass plate with her. The holdup man turned toward several customers who happened to be in the bank at that moment. Waving his gun in the air, he ordered them to throw up their hands. Some did as he said, but the robber paid no further attention to them, nor did he make any attempt to reach in through the window to retrieve any money. Suddenly changing his plan, the would-be robber turned to the teller's window and threw the gun on the counter saying, "What the hell's the use." Bank president Harris E. Franklin, who was seated at his desk, reportedly rushed to the director's room where a shotgun was usually kept, but found it had been removed because of some remodeling that was taking place. Franklin then returned to the teller's cage where the gun that the holdup man had thrown down had been moved from in front of the window to the end of the counter by cashier D.A. McPherson. McPherson was remarkably cool in approaching the window while the gun was still within reach of the bank robber. Franklin grabbed the gun and passed around to the outside, and holding the gun to the man's face, ordered him to throw up his hands. The robber was arrested and taken to jail. (Courtesy Minnilusa Historical Association.)

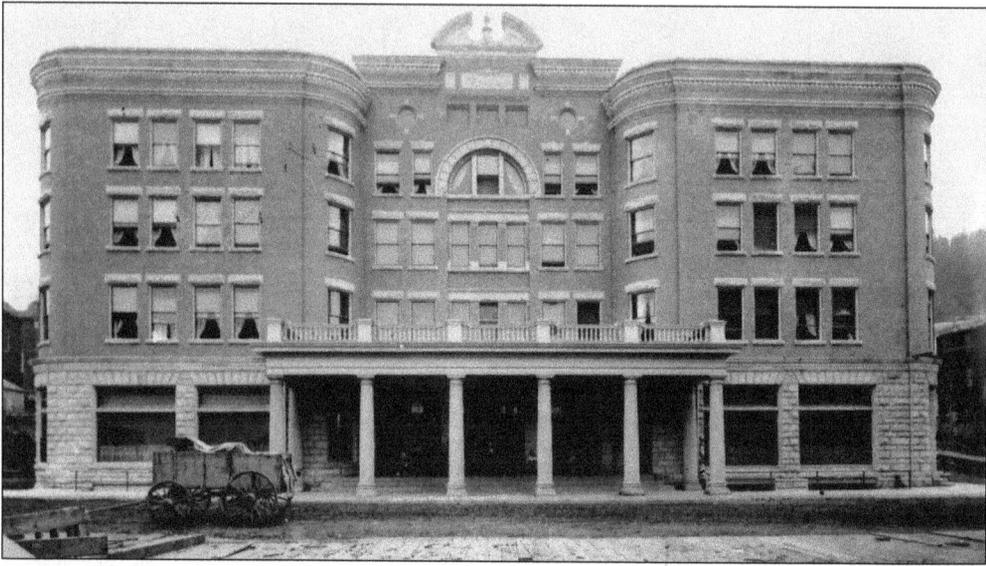

The Franklin Hotel was a creation of the Deadwood Business Club, with Harris Franklin as the principal backer. Many years elapsed between digging the hole for the foundation and the Franklin Hotel's completion. It was first-rate for that era, with amenities such as private bathrooms, in-house telephones, and in-room hot and cold running water. When it finally opened in 1903, there was a grand ball and celebration. A special musical composition, "The Franklin March," was even written for the occasion. The Deadwood Business Club hoped to attract railroad executives as well as tourists, a growing market in the Black Hills. (Courtesy Adams Museum.)

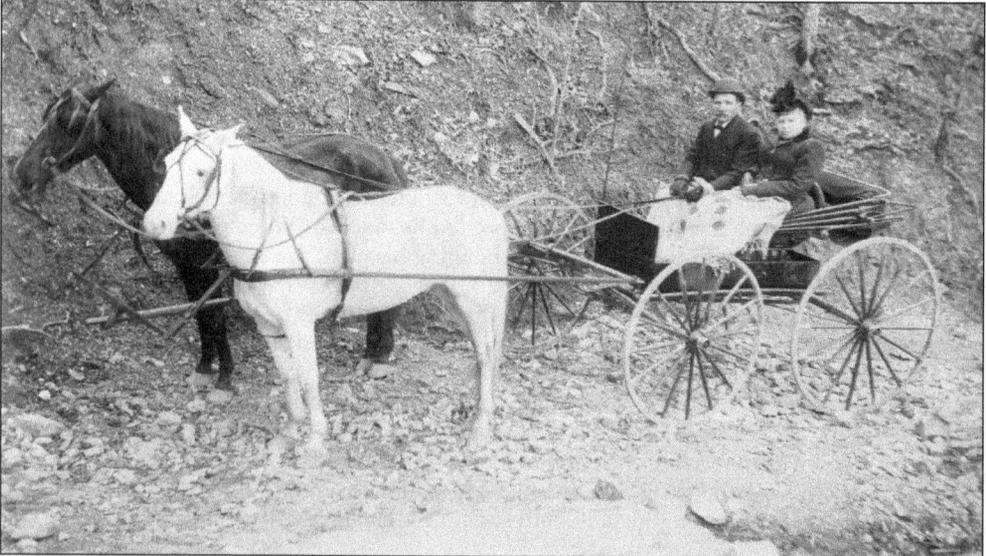

The Franklins ranked among the "Stagecoach Aristocracy," those who came into the Black Hills with the gold rush during the years before the railroad arrived. From humble beginnings to great wealth, the Franklins joined the cream of Deadwood society. Nearly everywhere they went and almost everything they did drew the attention of the press. Harris was arguably the single most successful Jewish pioneer businessman of his time and place. Anna had prudently paid $1,175 between 1883 and 1890 for four lots in the fashionable Ingleside neighborhood in anticipation of their wish to relocate. (Courtesy Adams Museum.)

As their wealth and position in society increased, the Franklins needed a fine home in which to reside and entertain—and they loved to entertain in grand style. In 1892, shortly after the arrival of the railroad, they began planning for a change. Chicago synagogue architect Simeon D. Eisendrath designed the Queen Anne–style home, which was popular at the time. Harris and Anna Franklin are photographed in front of their porch around 1899, with their son, Nathan; their daughter-in-law, Ada; and granddaughter Mildred, sitting on a bench in front of the family home. (Courtesy Adams Museum.)

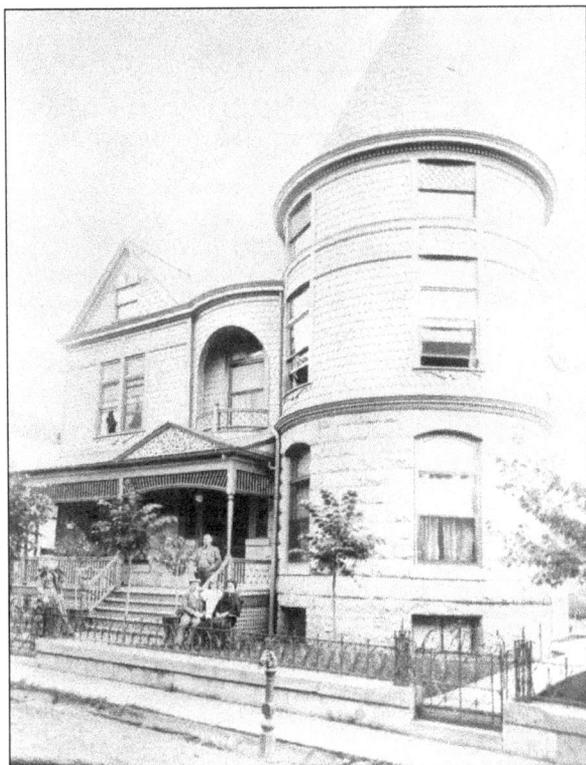

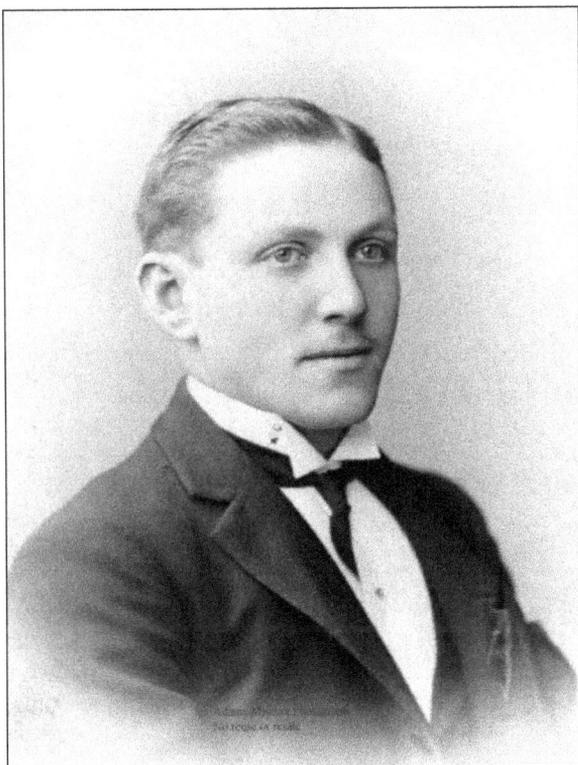

Deadwood's second Jewish mayor, Nathan Franklin, was like his father, Harris, deeply committed to advancing Deadwood; however, their approaches differed. Harris had little interest in politics, briefly serving on the city council. Nathan included politics as part of his contribution to Deadwood's progress, serving two terms as mayor of Deadwood, from 1914 to 1916 and again from 1916 through 1918. In his first mayoral race, Nathan Franklin opposed incumbent W.E. Adams, a popular pioneer grocer and merchant. The campaign was contentious, but Franklin had the popular vote as well as the support of the newspapers. Under the Citizens Ticket, Nathan swept into office with a four out of five vote. (Courtesy Adams Museum.)

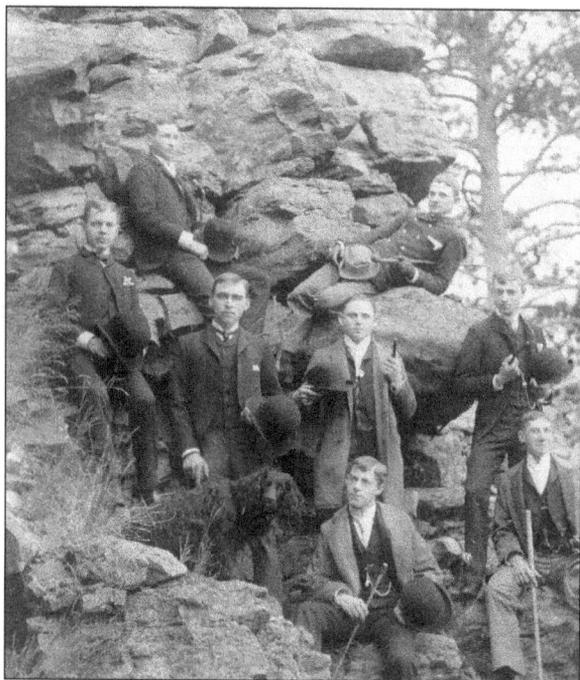

Nathan is pictured at center with friends in the Deadwood Boys Club. Unlike his father, who had little education and in youth had struggled for a living, Nathan grew up in a world of wealth and privilege. (Courtesy Adams Museum.)

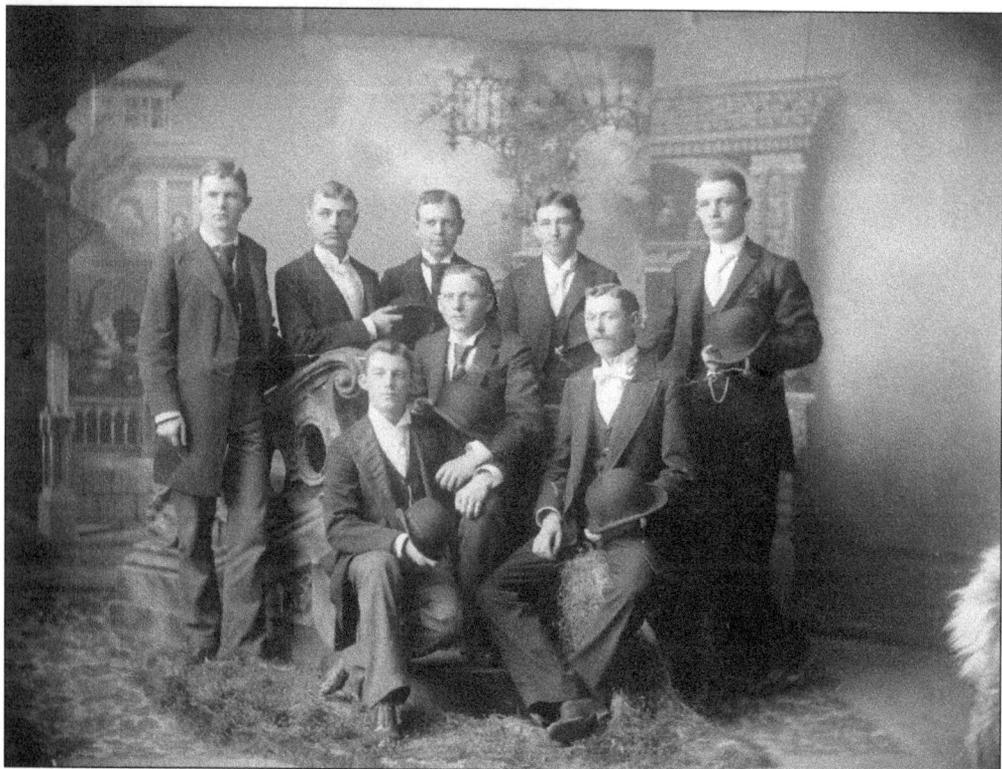

Nathan sits front and center in this studio portrait. He attended pharmacy school at Notre Dame, but summers were opportunities to return to Deadwood and spend time with friends. (Courtesy Adams Museum.)

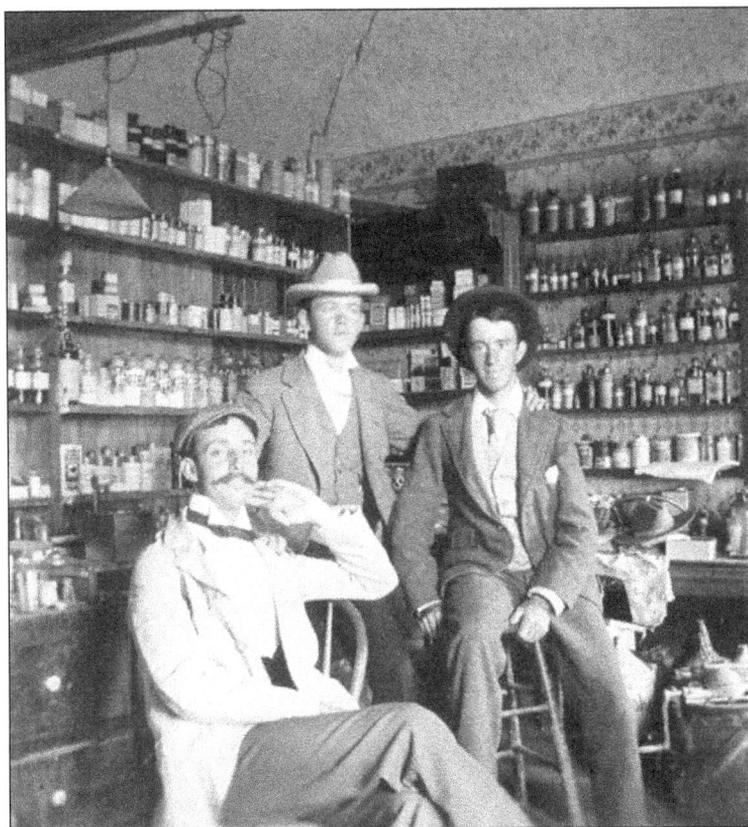

Friends of Nathan's are seen posing at his Palace Pharmacy. In the summer of 1887, he served an apprenticeship in the drugstore of Kirk G. Phillips in Deadwood. In the summer of 1888, Nathan was back at his post as one of the officers of the McDonald Hose Company of the Deadwood Fire Department. Upon graduation from college, he opened the Palace Pharmacy on Main Street in Deadwood, a business he operated for two years before starting in the banking business. (Courtesy Adams Museum.)

A scene outside the first Masonic temple in Deadwood is seen above. Many of the Jewish businessmen were Masons. Nathan was keenly interested in modern technology, which was advancing so quickly during the Industrial Revolution. He wanted to see and try everything, from voice recording machines to airplanes. He was one of the first in Deadwood to have his own automobile. (Courtesy Adams Museum.)

Nathan married Ada Kellar, a non-Jewish Deadwood girl, in 1893, a marriage that would last for Ada's lifetime. Ada was well liked in the community and took part in all of the city's social and charitable affairs. After his mother, Anna Franklin, died, Nathan bought the family home from his father for $1, and Harris left Deadwood for New York. The younger Franklins remodeled the house in 1904. Ada loved the Franklin mansion, and they, too, enjoyed entertaining there. The Franklin home, beautifully restored in 2000, now serves as the Historic Adams House, a house museum named for W.E. Adams, Nathan's political rival and the man to whom he sold the house in 1920. (Courtesy Adams Museum.)

At right are Mildred Franklin and an unidentified young friend. Mildred grew up the apple of her parents' and her grandparents' eyes. The adoring grandfather customarily gave Mildred $10 every year for her birthday. By the time she reached her 13th birthday, the gift amounted to $130, a considerable sum for a young lady in those days. When she reached the age at which she was able to travel on her own, Mildred was visiting a cousin in Washington, DC, and met David Traitel, a young Jewish businessman who traded in marble. They soon married and made their home in New York. (Courtesy Adams Museum.)

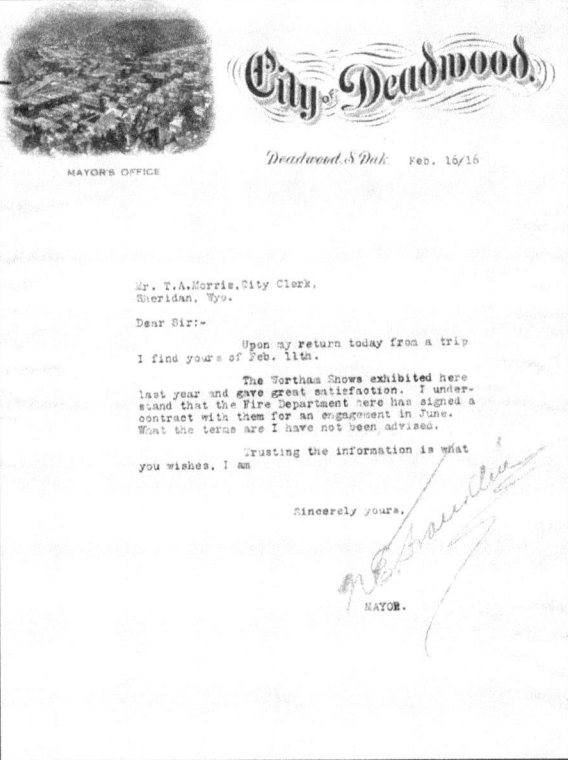

City of Deadwood

MAYOR'S OFFICE

Deadwood, S. Dak. Feb. 16/16

Mr. T.A.Morris,City Clerk,
Sheridan, Wyo.

Dear Sir:-

Upon my return today from a trip I find yours of Feb. 11th.

The Wortham Shows exhibited here last year and gave great satisfaction. I understand that the Fire Department here has signed a contract with them for an engagement in June. What the terms are I have not been advised.

Trusting the information is what you wishes, I am

Sincerely yours,

MAYOR.

This letter was signed by Nathan Franklin as Deadwood's mayor. When his second term as mayor expired in May 1918, Nathan sold the Franklin family home to W.E. and Alice Adams for $8,500. His decision came as a surprise to many, considering the divisive nature of the 1914 mayoral race. Nevertheless, W.E. Adams did acquire the home, and on August 13, 1919, his term of office completed, Nathan and Ada followed his father, Harris Franklin, and their daughter, Mildred, eastward to settle in New York City, where Nathan had decided to engage in the investment business. (Courtesy Jerry Bryant.)

45

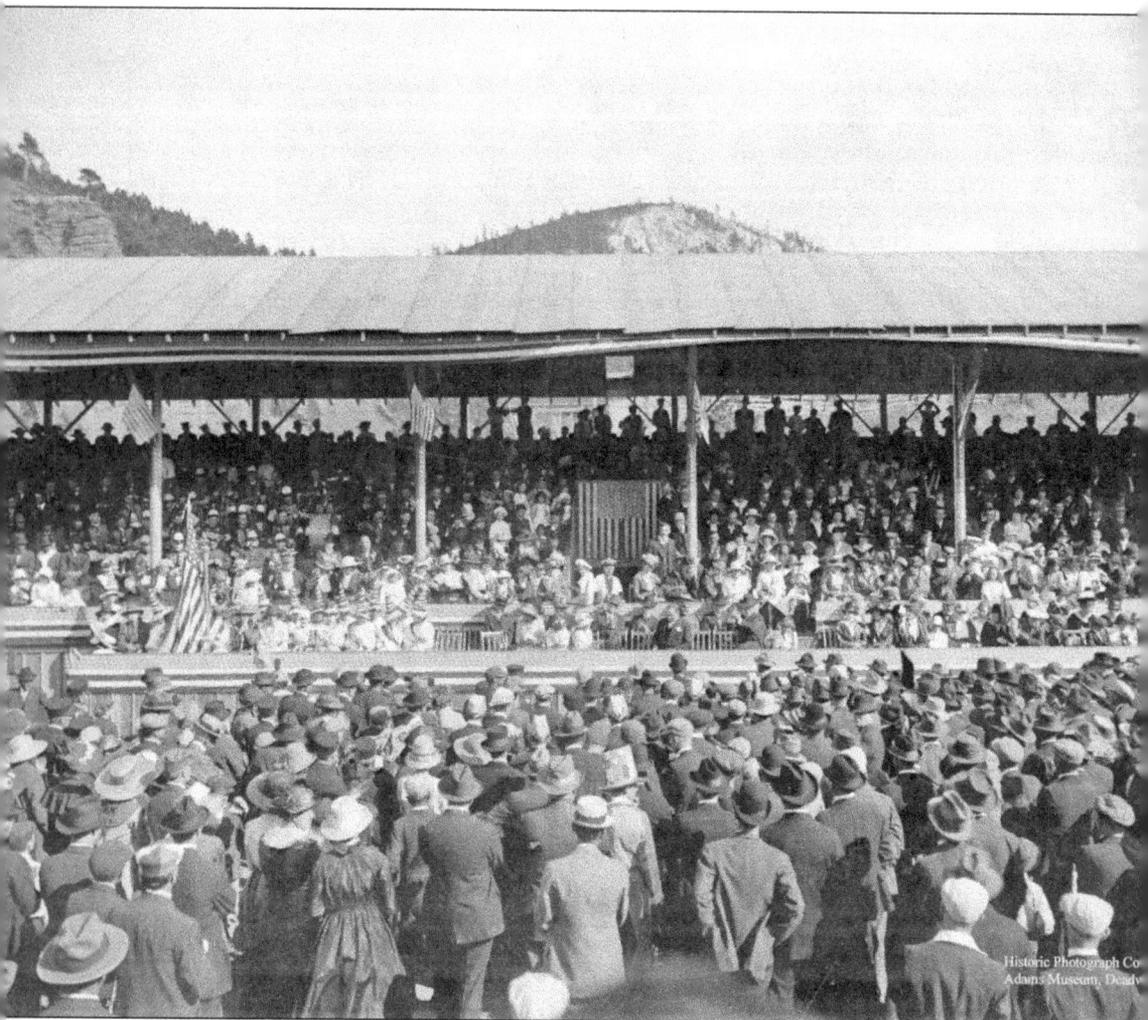

On Loyalty Day, Nathan is seen giving a speech. In his mayoral acceptance speech, Franklin outlined the goals for his administration. In addition to expressing his appreciation for his predecessor, W.E. Adams, Nathan promised to carry out his projects of continuing to pave and light the streets and look after the widows, orphans, and mentally infirm. He vowed to make every effort to beautify the city, ensure a plentiful supply of good water, and increase the efficiency of the fire department. He had served as fire chief and now would actively work to install a modern fire alarm system that would locate and announce fires, noting that every encouragement and assistance should be extended to the volunteer firemen. A practical businessman, he acknowledged that better firefighting efficiency would mean lower fire insurance rates. The Franklins left a significant imprint on the Black Hills region as well as on the state of South Dakota. Father and son had a talent for producing prosperity. They reaped a royal harvest in return. (Courtesy Adams Museum.)

Jacob (Jake) Goldberg came to the United States in 1851; he was 18 years old. The year 1876 found Jake in the clothing business in the mining town of Helena, Montana. With his adventurous spirit, he joined a large group of Montanans headed for the gold strike town of Deadwood, Dakota Territory. Among the 140 other hopefuls were two other Jewish men, Sam Schwarzwald and Sol Star, who would also leave their mark on the Black Hills. In December 1877, Jake purchased the Big Horn grocery store, at the time little more than a shack with a few basic provisions, from P.A. Gushurst, a non-Jewish entrepreneur. (Courtesy Adams Museum.)

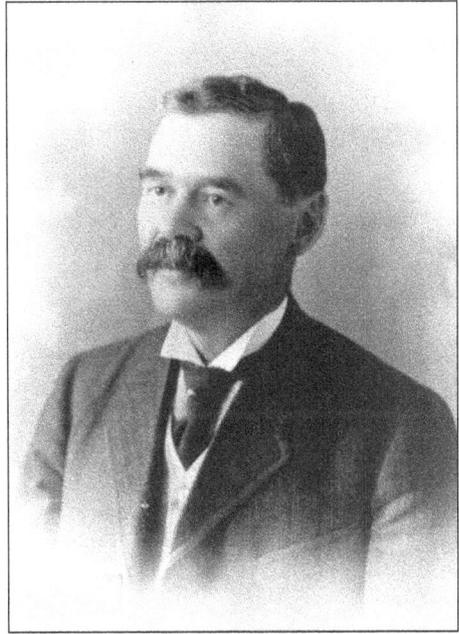

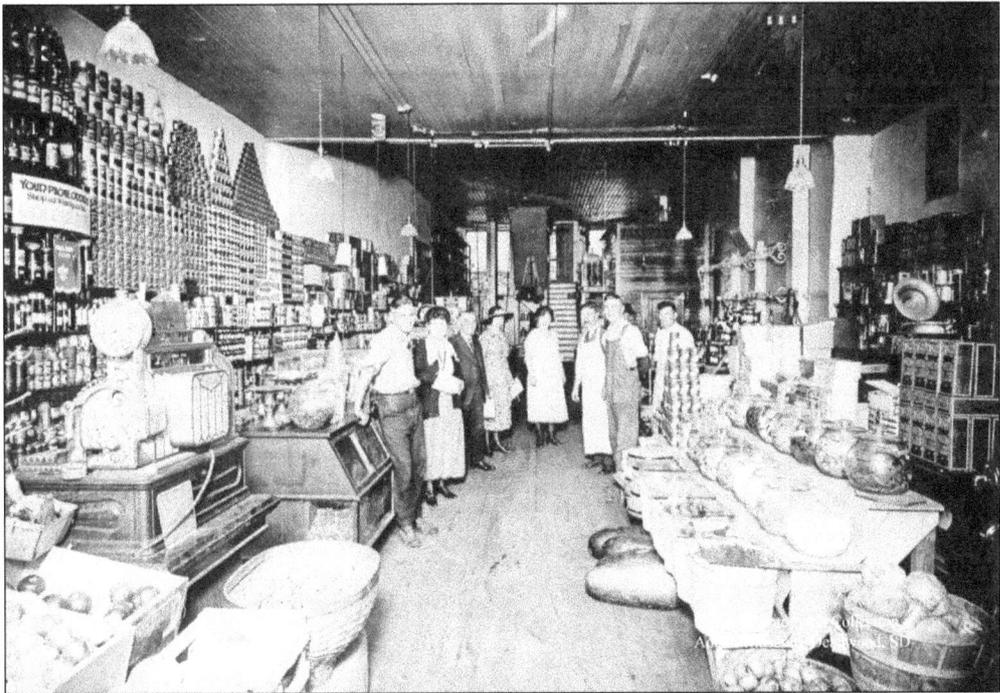

The interior of Goldberg's Grocery Store is pictured above, with Jake standing third from the left. Calamity Jane was one of his early customers. She ran up a tab, leaving a lasting souvenir of her patronage. Either the Big Horn store or Shoudy's Meat Market, its next-door neighbor, was most likely the site of the capture of Jack McCall, the man who killed Wild Bill Hickok on August 2, 1876. The Big Horn store, later named Goldberg's Grocery Store, advertised widely in the newspapers. They carried such favorites as rye bread, pickled herring, and a variety of wheels of cheese. Fresh produce came from the fertile valley near Spearfish. (Courtesy Adams Museum.)

47

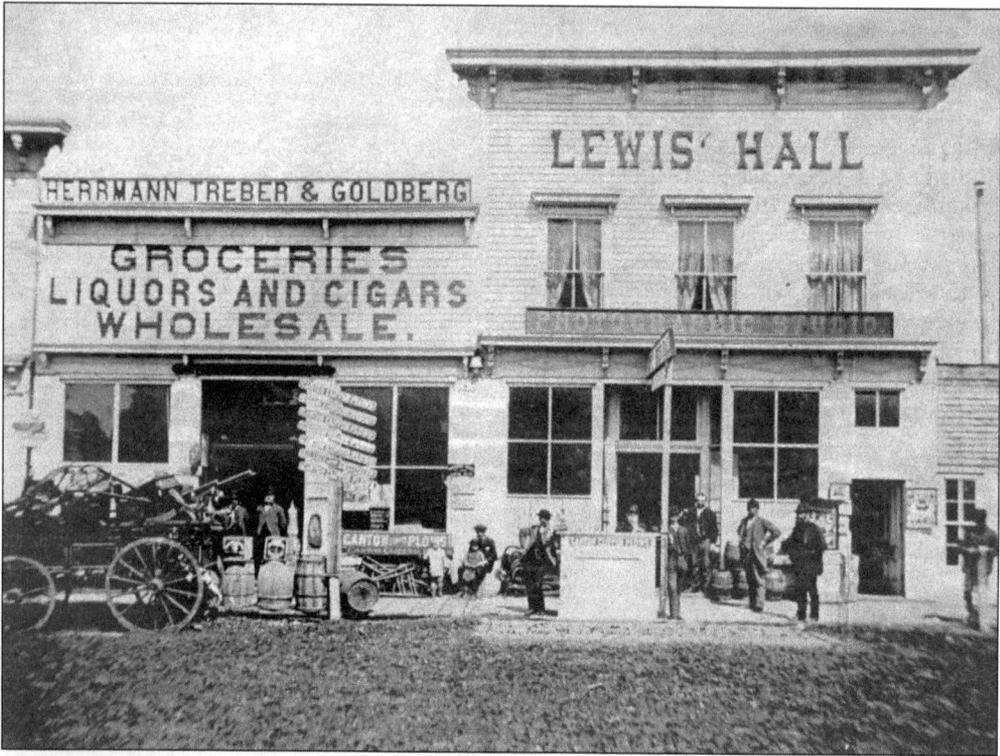

HERRMANN TREBER & GOLDBERG

LEWIS' HALL

GROCERIES
LIQUORS AND CIGARS
WHOLESALE.

Historic Photograph Collection

Goldberg, in partnership with friends Hermann and Treber, opened a wholesale outlet in Rapid City, selling not only groceries but also wholesale liquors and cigars, which were a must in the Black Hills. Jake Goldberg, who was Jewish, and John Treber, who was not Jewish, were very close friends, as were their families. (Courtesy Minnilusa Historical Association.)

Jake Goldberg, seated, with Deadwood Dick in a pose intended to attract tourist attention. Jake was a tireless promoter of Deadwood. (Courtesy Adams Museum.)

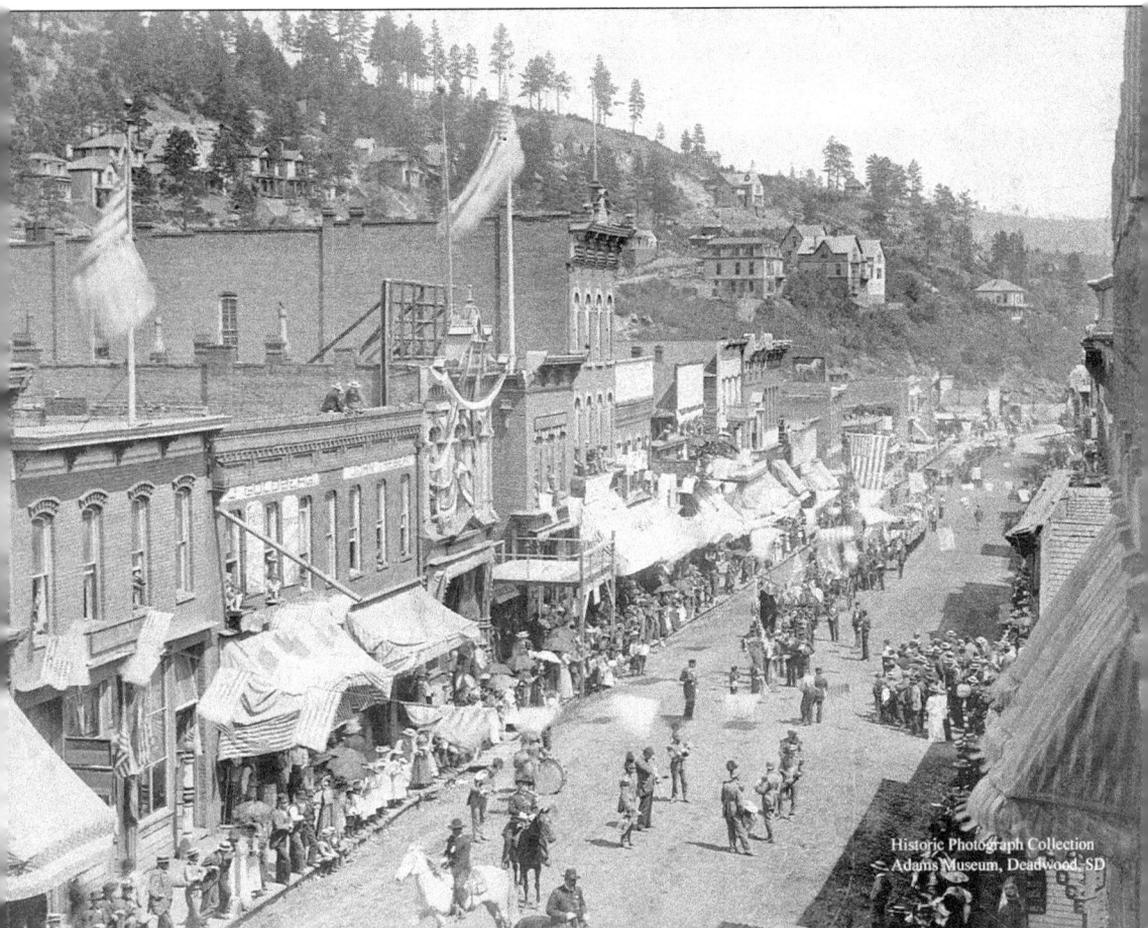

Historic Photograph Collection
Adams Museum, Deadwood, SD

Although most of their trade dealt with such staples as flour and meats, Goldberg's Grocery also provided Black Hills citizens with the little luxuries of life. One example was when Jake placed an order for cats, perhaps for rodent control or simply to offer his customers a nice furry pet upon which to lavish affection. As it turned out, the cats would roam the streets at night, and their "yammering" so irritated some neighbors that they started using the cats for target practice. Goldberg's Grocery, third store from the left on Main Street, was a Deadwood mainstay for more than 100 years. (Courtesy Adams Museum.)

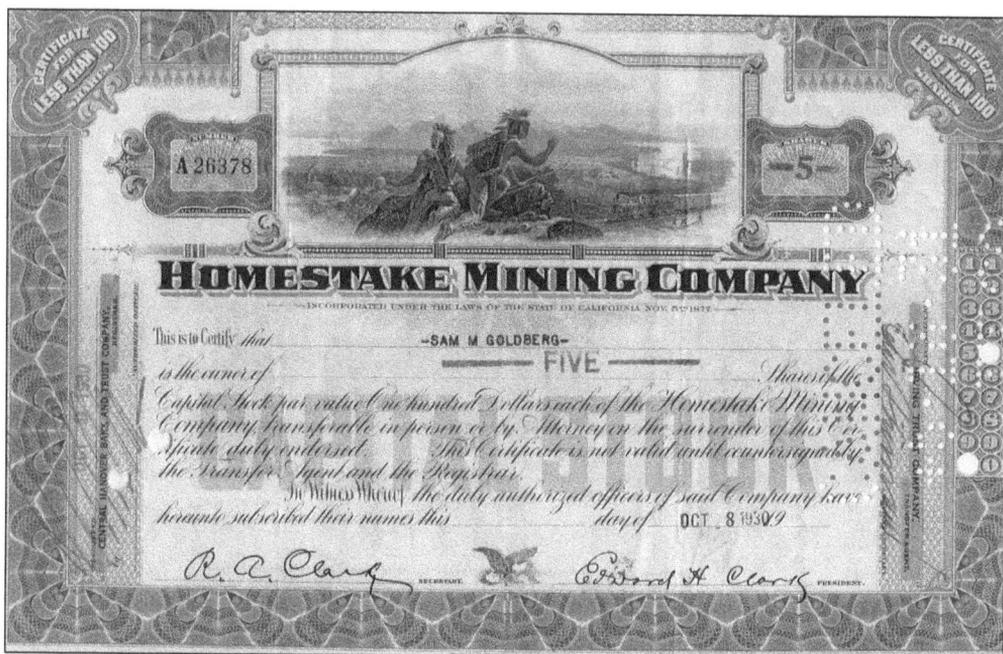

A Homestake Stock Certificate owned by Sam Goldberg is seen above. This certificate (cancelled) shows Sam Goldberg as owner of five Homestake shares, dated October 8, 1930. The Goldbergs had three children, Sam, Joe, and Julia. Most of the businessmen owned mining shares. (Courtesy Ann Haber Stanton.)

At the age of 23, Jacob Goldberg married Lena Weissner, another displaced New Yorker, who lived with an aunt in nearby Spearfish. Among the wedding guests were Jacob's brother Leo Goldberg from Salt Lake City; Joseph Hattenbach; Jonas Zoellner; Joseph Poznansky; Max Stern; Nathan Colman; Benjamin Welf; M.J. Wertheimer, and, presumably, their wives. It was common practice of the day not to refer to wives in newspapers reporting. Women's first names were not usually given, perhaps as a sign of respect, but it can be an obstacle to researchers and genealogists. (Courtesy Adams Museum.)

Jacob, in his 70s, and Lena Goldberg are pictured at their 50th wedding anniversary. Most likely looking for a place that had no need for a snow shovel, Jacob and Lena retired in California. Goldberg's Grocery Store kept its name and continued operating into the 1990s. (Courtesy Adams Museum.)

Joseph Hattenbach, pictured, started the grocery business in Deadwood in 1876 with his brother Aaron. The 1898 Census shows the business as J. Hattenbach and Bros. Grocers. To one degree or another, the Hattenbachs were also invested in mining. Records show that Joseph went to Chicago in January 1884, where he purchased a smelter for use in the Far West Mine in Carbonate Camp. It was known as the Hattenbach Smelter, the first of its kind in the Black Hills. The smelter had the capacity of 30 tons per day. In March, it was loaded onto wagons to be transported to Carbonate Camp, but the snow was so deep that it hampered their undertaking; they were still working on it in April. (Courtesy Charlotte Hattenbach.)

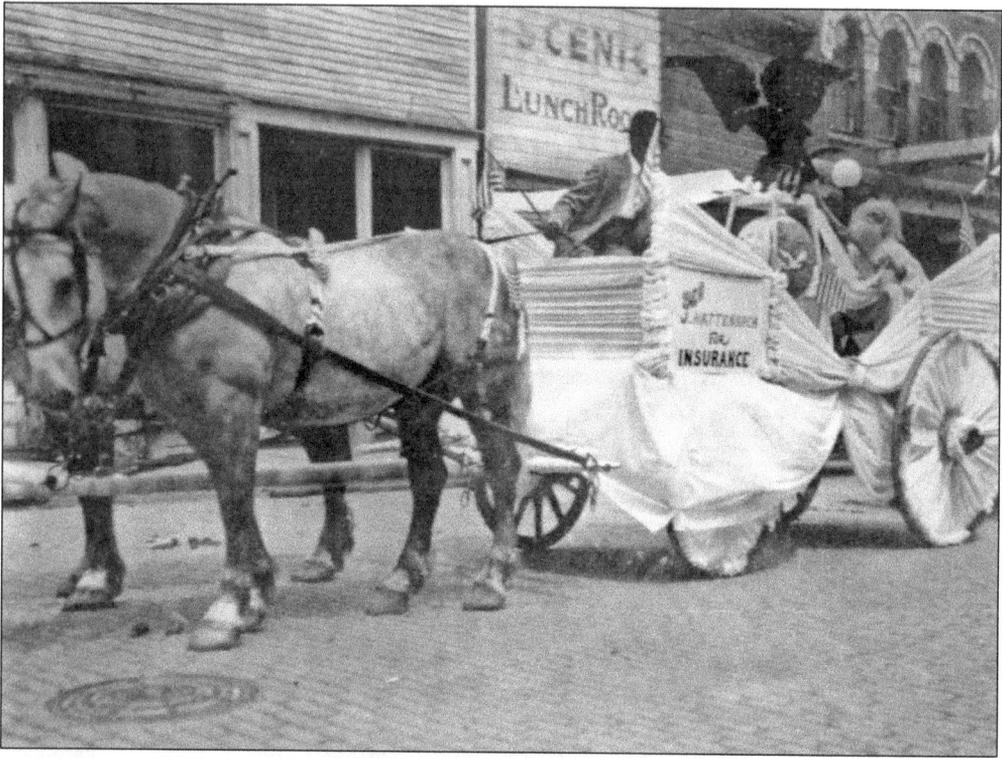

Advertising J. Hattenbach Insurance in a parade, this buggy was a popular 19th-century way of letting the public know what service or merchandise a business had to offer. The Hattenbachs were also heavily involved in mining, but the grocery store was their mainstay. (Courtesy Adams Museum.)

Aaron Hattenbach is seen at left. His family's grocery store served the region through the earliest years of Deadwood's gold rush and into the next century. The Hattenbachs were the largest Jewish family to have taken part in Deadwood's Jewish pioneering experience. Family members included Joseph and his wife, Jennie; Aaron and his wife, Belle Holstein, of the Deadwood Holsteins; Nathan and his wife, Dena; Adelia and her husband, David Magee; Ludwig (Louis); Mitchell; and David Hattenbach. (Courtesy Charlotte Hattenbach.)

Brother Nathan Hattenbach joined the family business, and in 1878, they invested in a silver mine at Carbonate Camp. Carbonate had all the features of a vigorous frontier mining town. The young settlement once boasted a busy road complete with hack service to the little metropolis of Central City, which was located midway between Lead and Deadwood. (Courtesy Charlotte Hattenbach.)

Nathan Hattenbach married Dina Wolf in Chicago in 1881. So convinced was Nathan that Carbonate would succeed, that he took his wife and children to live there for a time. In July 1882, brother Ludwig came from Sioux City to see for himself what was happening in gold rush country. His brothers took him out to Carbonate. Suitably impressed, Ludwig returned to Sioux City to report on the scene and to promote interest in the Hattenbachs' Far West Mine. However, Ludwig went into the grocery business in Sioux City with brother-in-law David Magee, Adelia's husband. (Courtesy of Marion Hattenbach Bernstein.)

MARRIAGE + LICENSE

State of Illinois,
COOK COUNTY. } ss.
THE PEOPLE OF THE STATE OF ILLINOIS,

To any Person Legally Authorized to Solemnize Marriage, Greeting:

Marriage may be celebrated between Mr. *Nathan Hattenbach* of *Deadwood* in the County of *Lawrence* and State of *Territory of Dakota* of the age of *36* years, and Miss *Dina Woolf* of *Chicago* in the County of *Cook* and State of *Ills* of the age of *18* years.

WITNESS, E. F. C. KLOKKE, Clerk of the County Court of said Cook County, and the seal thereof, at my office in Chicago, this *30* day of *May* A.D. 188*1* *E F Klokke*

Clerk of the County Court.

STATE OF ILLINOIS, } ss.
COUNTY OF COOK.
I, *Liebman Adler* a *Minister of the Synagogue* hereby certify that Mr. *Nathan Hattenbach* and Miss *Dina Wolf* were united in Marriage by me at *Chicago* in the County of Cook and State of Illinois, on the *5th* day of *June* 188*1* *Liebman Adler, Minister of the Cong. K. Anshe Maarab*

(OVER.)

Adelia Hattenbach Magee was well loved in the community. The Hattenbachs were charter members of the Deadwood B'nai B'rith. Not only did they assume a prominent place in the economy of the northern Black Hills, but their participation in Jewish life helped keep the flame of Judaism alive in the region. Adelia's husband, David Magee, a convert to Judaism, held dear to his adopted faith. (Courtesy Charlotte Hattenbach.)

Born in 1862, David Hattenbach was the first Jewish child born in Sioux City, Iowa. He made only a brief appearance in Deadwood with his arrival by stagecoach in early January 1887. He returned to Sioux City shortly thereafter. But like his brothers, he kept the interest of their family business in the forefront. Mitchell Hattenbach made his appearance in Deadwood in 1879. A newspaper notice regarding incoming freight from Bismarck indicates that Mitchell also became involved in the family's early grocery business. Apparently Mitchell returned to Sioux City soon thereafter, as well. (Courtesy Charlotte Hattenbach.)

The Hattenbach parents, mother Frances Colman Hattenbach and father Gedaliah Hattenbach, otherwise known as Godfrey, remained in Sioux City but are included here to illustrate some familial connections. In some cases, families within the Black Hills' Jewish community either were related when they arrived or became related through marriage while in the Hills. Frances was a Colman, making the Hattenbachs cousins to the Colmans. (Courtesy Charlotte Hattenbach.)

Godfrey (Gedaliah) Hattenbach is seen at left. The Hattenbachs set their stamp on Carbonate mining district, where silver was the main treasure. But other mineral treasure, such as gold and tin, helped to make the Carbonate mining district one of the fastest-growing mining regions of the Black Hills, with a meteoric flash of prosperity—and an even more precipitous plummet. Now the hotels, the saloons, the shops, the post office, the school, the newspaper, the restaurants, and the Chinese laundries have all vanished. It is inaccessible, overgrown with vegetation, and the Black Hills forest has reclaimed its own. (Courtesy Charlotte Hattenbach.)

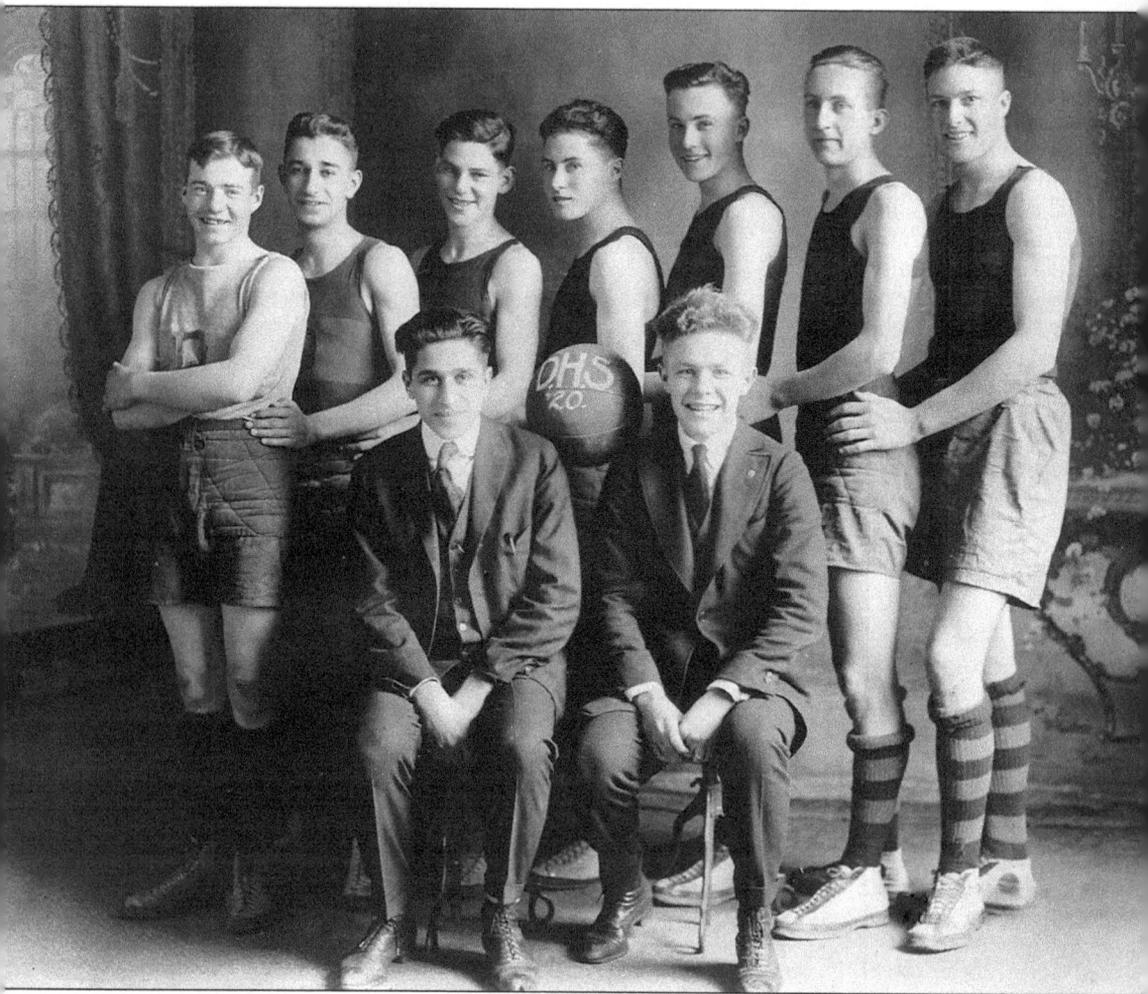

Bert Jacobs (standing, second from left) was the son of Simon and Dora Jacobs. Born and raised in Deadwood, Bert attended Deadwood High School and played on the basketball team there. Bert and his wife, Ruth, are buried in the Jacobs family plot on Mount Moriah. (Courtesy Adams Museum.)

From left to right, friends Simon Jacobs, Mike Russell (a non-Jew), and Artie Welf are pictured here on Deadwood's Main Street. Jacobs is a popular Jewish name, and there were at least two families with that name in early Deadwood. Foremost in the family legacy of Simon and Dora Jacobs, who settled in Deadwood in 1886, was their part in bringing a Sefer Torah scroll into Deadwood in the 1880s. They accompanied bride-to-be Frieda Lowenstein and a Torah scroll from Germany to Deadwood. To the Jewish people, this is recognized as a *mitzvah gadol*, the fulfillment of a major good deed. (Courtesy Adams Museum.)

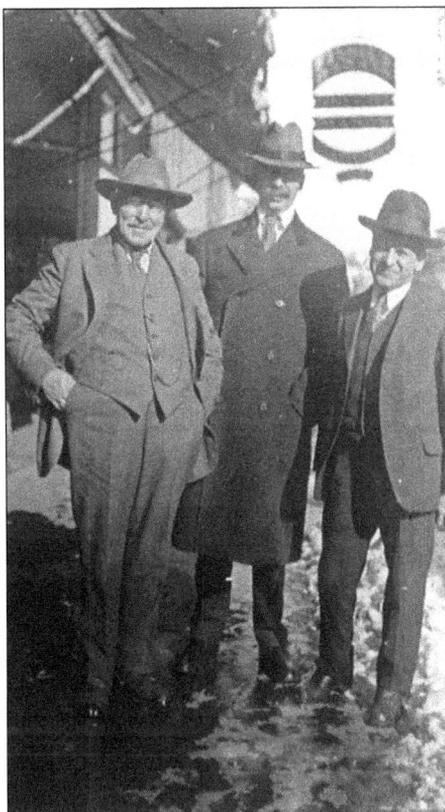

Historic Photograph Collection
Adams Museum, Deadwood, SD

The Phoenix Building, pictured around 1879, was so named because it arose from the ashes of yet another of Deadwood's devastating fires. Bert and Ruth Jacobs operated the New York Store, a ladies' clothing store, in the Phoenix Building for many years. In its current iteration, the building was purchased by the Costner brothers and fully remodeled and renamed the Midnight Star. It has a number of restaurants, bars, and casinos. (Courtesy Adams Museum.)

57

Louis Jacobs was a merchant. Louis, Nat, and Henry Jacobs were brothers, but not necessarily related to the other Jacobs families in the area. Louis Jacobs remained in the Black Hills and is buried in Mount Moriah's Mount Zion section. (Courtesy Adams Museum.)

Nat Jacobs was a real estate and insurance businessman; however, he is not included in Mount Moriah's rolls. (Courtesy Adams Museum.)

58

Although it is known that Henry Jacobs was a brother to Louis and Nat, there is no record of his occupation and he is not included in Mount Moriah's rolls. (Courtesy Adams Museum.)

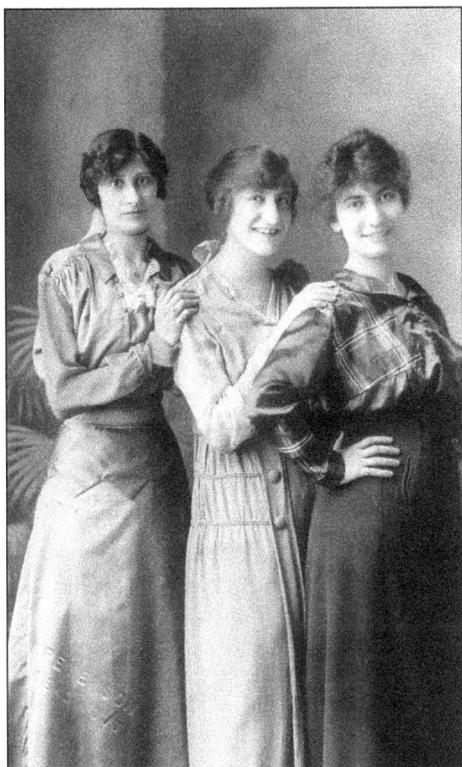

From left to right are girlfriends Ida Levinson, Tess Colman, and Sarah Blumenthal around 1910. (Courtesy Faye Gitter.)

This holiday get-together includes, from left to right, (seated) Joe Levinson; (standing) Ida Levinson, unidentified man, Sarah Blumenthal, Amalia Colman, Theresa (Tess) Colman, and Blanche Colman. (Courtesy Deadwood Public Library.)

In Deadwood, the Levinsons, jewellers Sol and Joe, have their family name spelled out in the capstone of their building on the east side of Main Street. Shooting and scandal were not new to Deadwood, but they were to the Jewish community there. Nonetheless, in 1901, Leo Winsberg shot Sol Levinson in the left breast, in an attempt to kill him. Winsberg was arrested and convicted of attempted murder, but Levinson lived to tell the tale. Joe Levinson later moved to Rapid City, where he opened another store and had a beautiful sign created with the family name spelled out in stained glass. When he died at the age of 47, the sign was taken down and stored in the basement. It has since been retrieved and is displayed in front of their former store on Seventh Street. (Courtesy Ann Haber Stanton.)

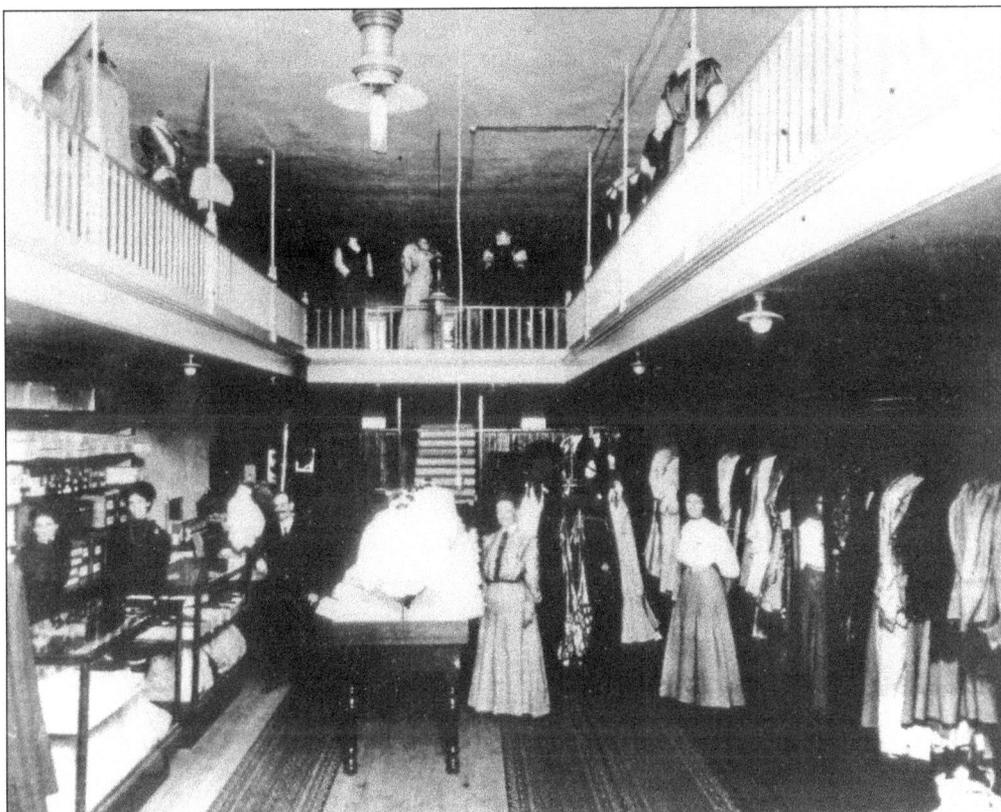

The New York Store, with fashions for ladies, was an institution in the Black Hills for almost a century. It passed from the hands of one Jewish family to another. The Salinskys started the store, and the last owners were Burt and Ruth Jacobs, but the Blumenthals and the Margolins also had ownership in between. In 1902, Sarah Margolin (the second woman on left) worked in the store. (Courtesy dhsclassmates.blogspot.com.)

Seen here are Sam Margolin and Sarah Blumenthal around 1918. Sam was a traveling salesman whose territory took him to Deadwood. There he met Sarah Blumenthal, the eldest daughter of Benjamin and Frieda Blumenthal. Sam tried homesteading for a while, but life on the farm was not for him. He joined the US Navy before World War I. After the war ended, Sam came back to Deadwood to marry Sarah. (Courtesy Faye Gitter.)

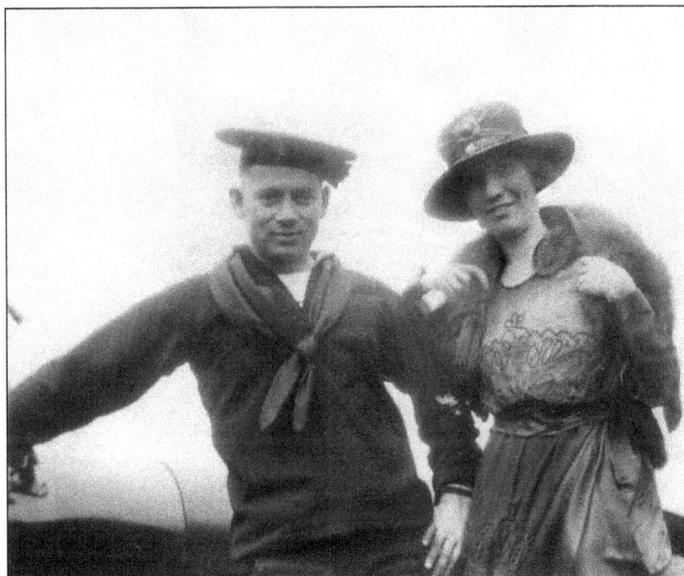

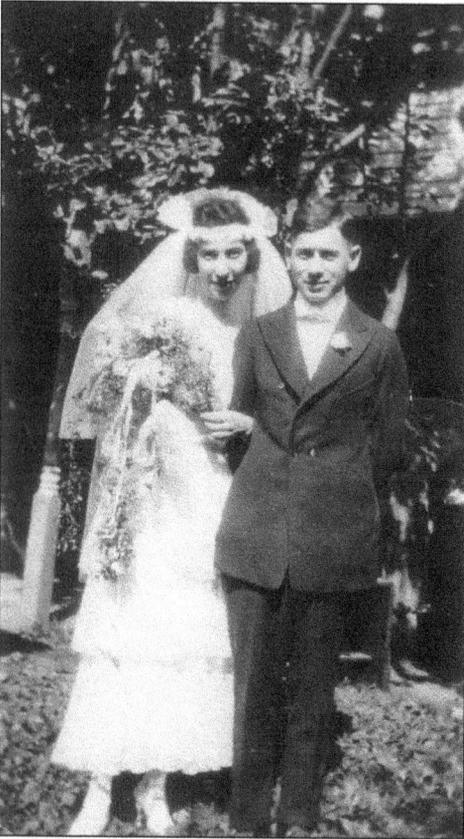

Sarah and Sam Margolin are pictured here on their wedding day in 1920. The Margolin home on Washington Avenue in Deadwood would later be the location of the Blumenthal Torah, also known as the Deadwood Torah. It remained at the Margolin residence for many years, as the Jewish population in the northern Black Hills decreased. The Torah was later taken to Rapid City and turned over to the care of the Adelstein family for use at the Synagogue of the Hills. (Courtesy Faye Gitter.)

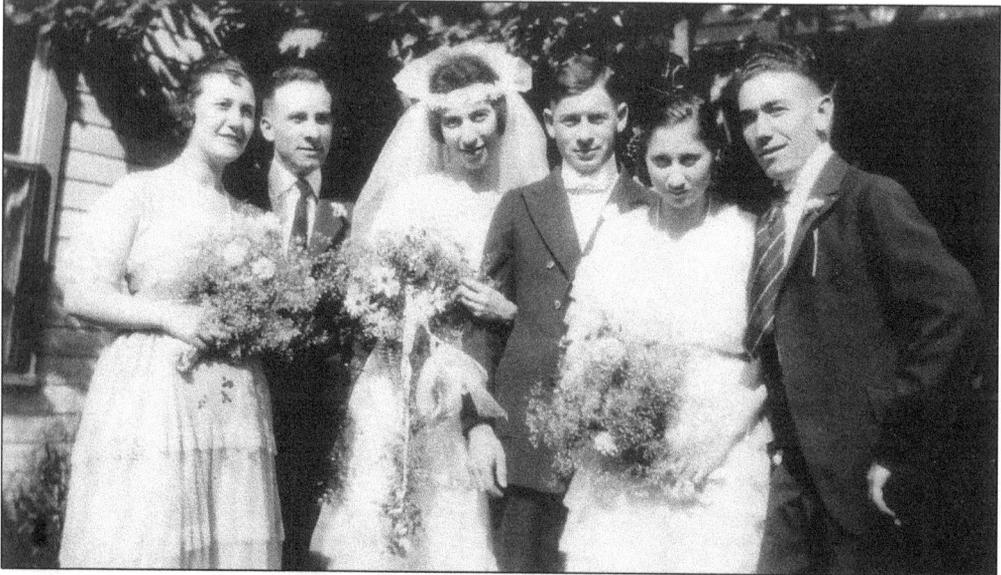

Sarah and Sam Margolin are shown with their wedding party. Sarah's sister Gertrude and her future brother-in-law Lou Sachs are on the left side of the photograph. Gertrude and Lou Sachs eventually settled in Sioux City. On the right are Sam's sister Ruth Margolin and Sarah's brother Abe Blumenthal. (Courtesy Faye Gitter.)

Sam and Sarah's wedding guests are seen above. From the left, the first six people standing in the second row are Sam's sister Ruth Margolin, of Sioux City; Lou Sachs, of Sioux City; his future wife, Gertrude Blumenthal; Amalia Colman, the small elderly woman; and then the bridal couple, Sarah and Sam Margolin. The second person standing on the right is Sam's mother, Frieda Blumenthal, and Goldie Margolin is the first person sitting on the right. The second person over from Goldie is Ida Levinson, and next is Sam's sister Anne Margolin. Blanche Colman is beside Anne. Sarah had worked for the Salinskys, making hats in the New York Store. After she and Sam were married, they bought the store. Peggy Margolin also worked there, and in later years, she and her husband, Lawrence Gavenman, bought the store from Sam and Sarah. They later sold it to Bert and Ruth Jacobs. (Courtesy Faye Gitter.)

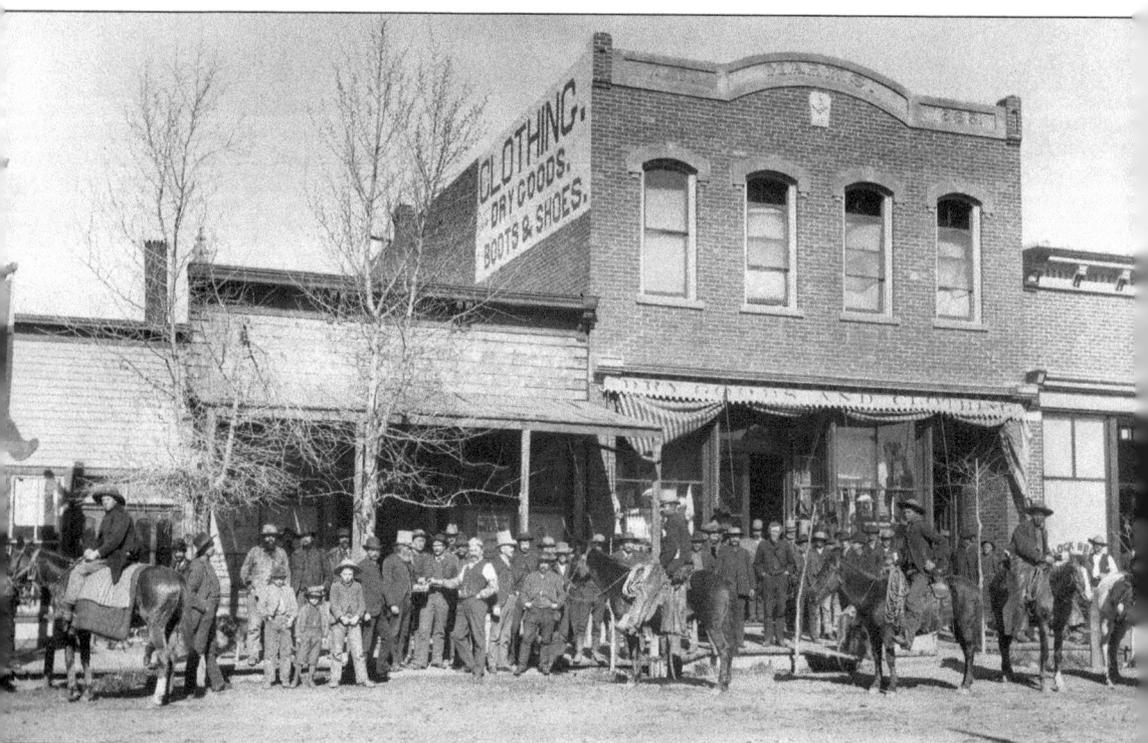

A thriving brick-and-mortar store such as the one owned by Harry Hiram (H.H.) Marks (1863–1953) in Rapid City would have been the fulfillment of a dream for many a "pack peddler," such as Marks had been. The building is gone now, but there is a trail high in the Hills, named for H.H. and other pack peddlers like him, called the Jew Peddler Trail. It has disappeared off the maps and soon may vanish from memory altogether. It speaks of a time of hardship and hope, when prospectors at their diggings and peddlers passing through with their wares and small necessities, such as eyeglasses, needles, and knives, each needed what the other had. They say that H.H. was a bit odd, but possibly he just felt isolated. He did have a wife and a beautiful little blond-haired daughter, Elizabeth. In later years, after his wife had died, he moved his business to Keystone, a small town south of Rapid City. He must have loved the sound of the singing coming from the Congregational Church on Sundays, because he would stand outside, listening. He finally donated a piano to that church and requested that his funeral be held there. Among those attending the funeral in Keystone was a small contingent of Jewish people from Rapid City, including Mr. and Mrs. Julian Morris and Joe Poznansky. H.H. Marks is buried in the Keystone Cemetery, which has no special Jewish section but his gravesite looks out towards the mountains and a splendid panorama. (Courtesy Minnilusa Historical Association.)

Jacob Morris was a Rapid City dry goods merchant. The Morris and the Poznansky families were the two main Jewish families in Rapid City. (Courtesy Minnilusa Historical Association.)

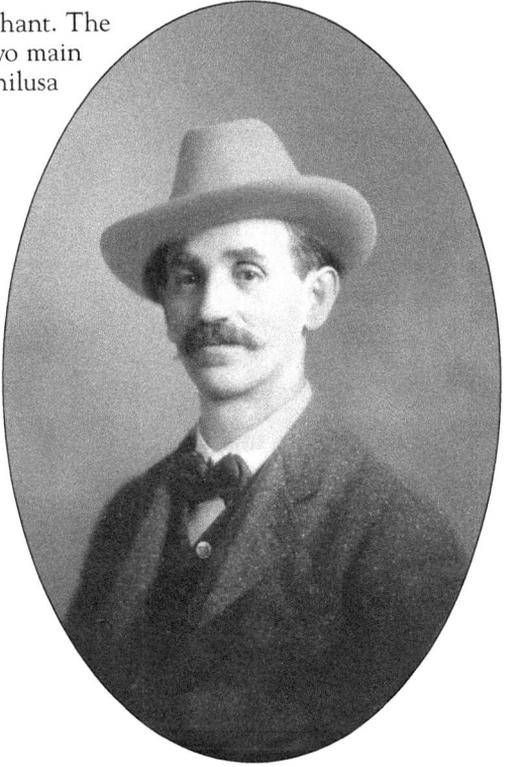

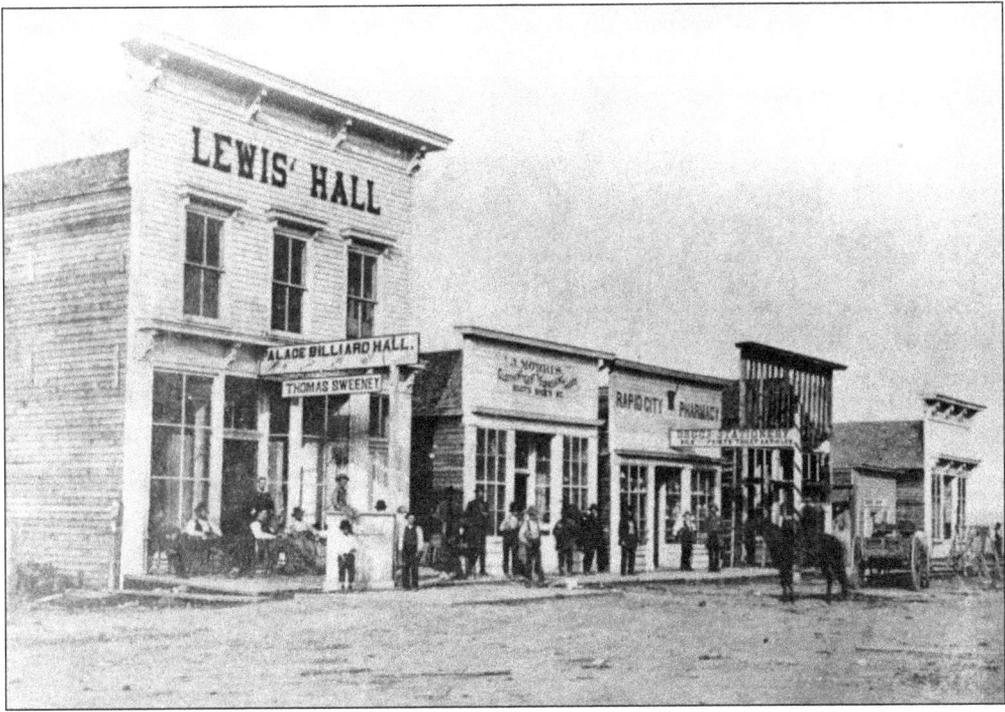

Jacob Morris's original dry goods store on Main Street in Rapid City is seen here. (Courtesy Minnilusa Historical Association.)

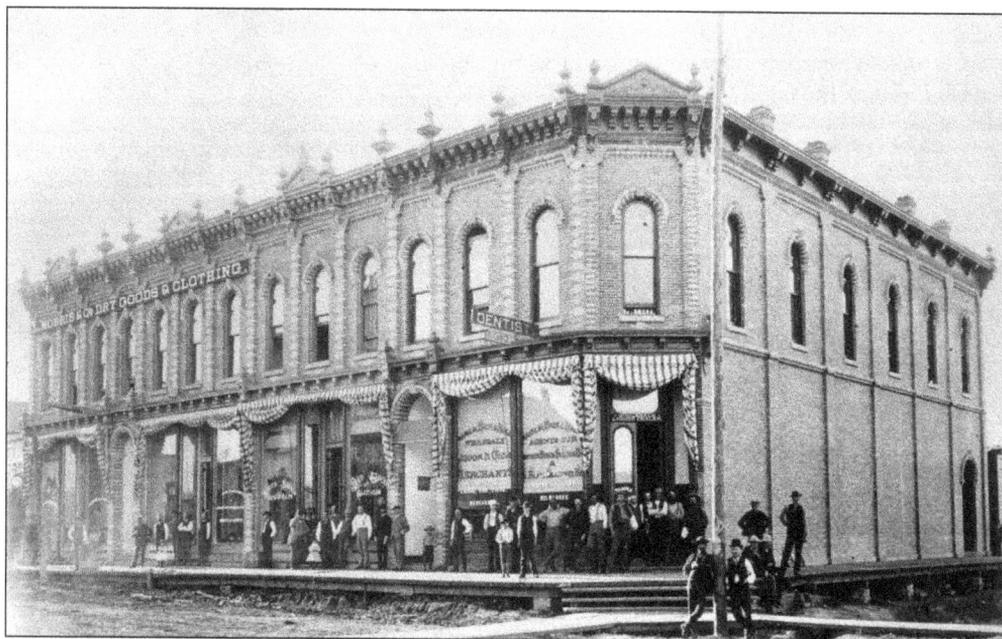

Jacob Morris later constructed this elegant brick building on the northwest corner of Sixth and Main Streets in Rapid City. It was one of the first brick buildings constructed in Rapid City and part of the structure housed the dry goods business of Jacob and his brother Louis Morris. The streets were still unpaved, and there were board sidewalks. The rest of the building was occupied at various times by professional offices, shops, and a furniture/casket builder. The building has been meticulously restored and currently serves as an art gallery, book/music shop, and high-end gift shop. (Courtesy Minnilusa Historical Association.)

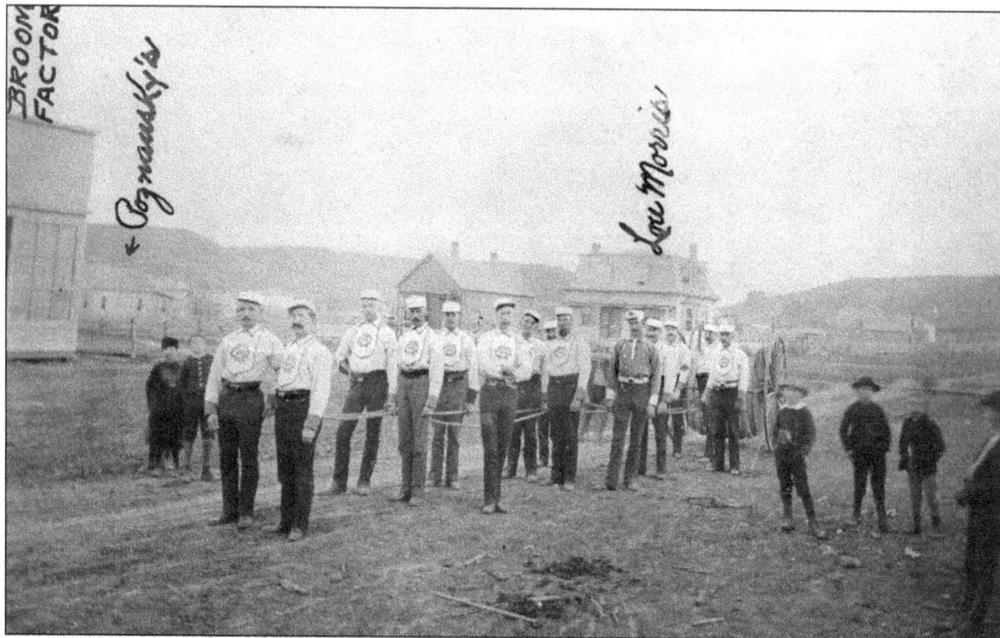

Homes of the Louis Morris and Felix Poznansky families in Rapid City, Dakota Territory, are pointed out in this photograph of a fire hose team. (Courtesy Minnilusa Historical Association.)

Jacob Morris's business is shown advertising, horse-and-wagon style, on Rapid City's Main Street. (Courtesy Minnilusa Historical Association.)

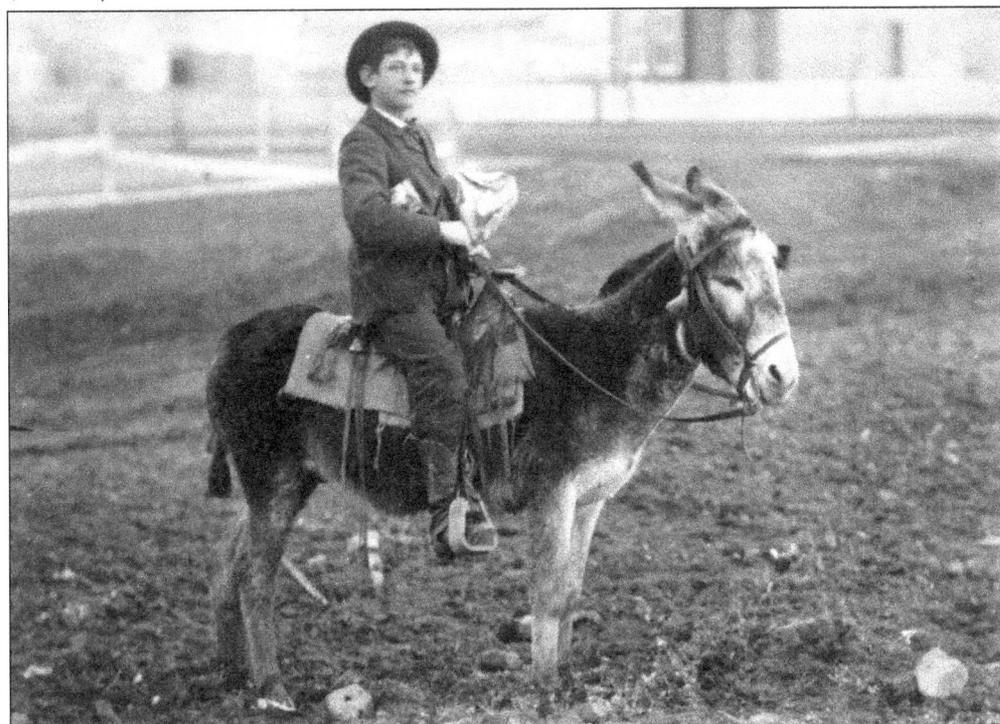

Marcus (Mox) Poznansky, who was raised in Rapid City, is pictured here riding a donkey. (Courtesy Minnilusa Historical Association.)

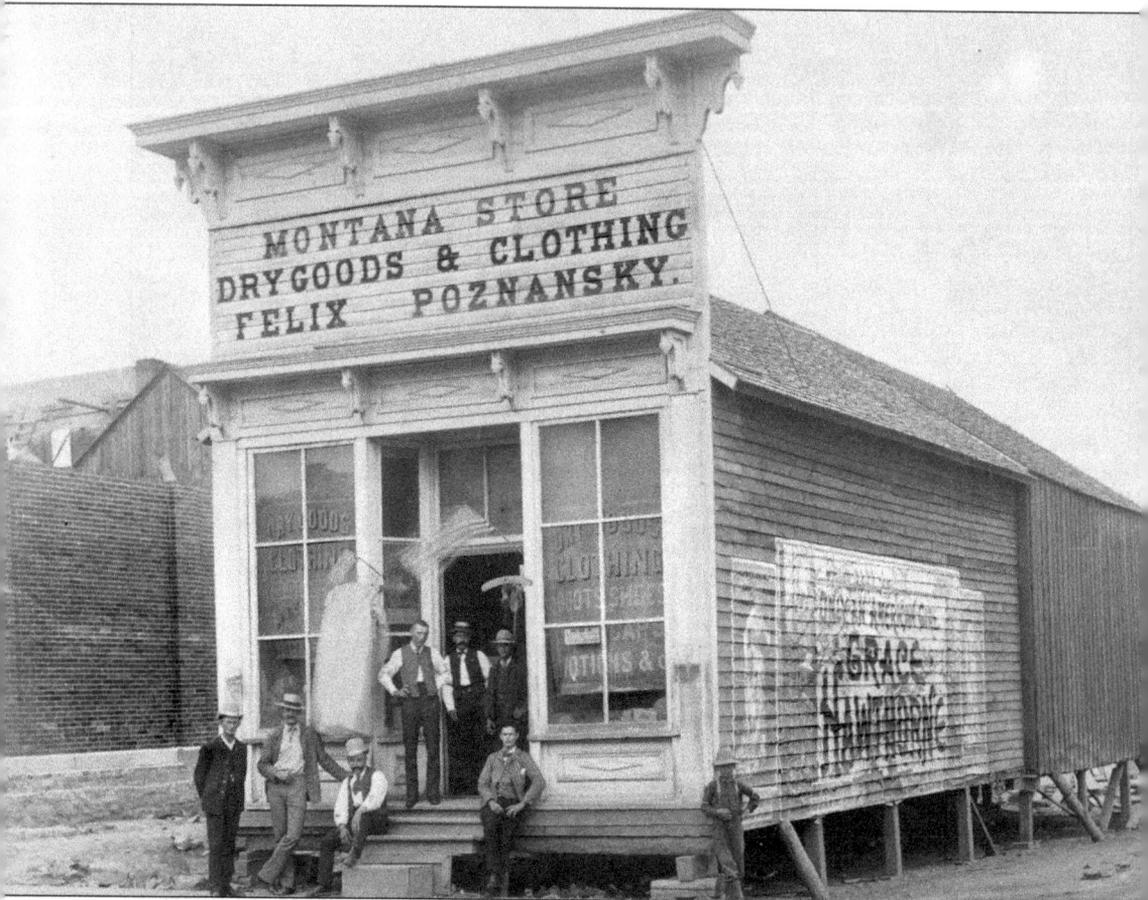

Felix Poznansky's Montana Store is in transit. The Montana Store was named as an homage to Poznansky's previous address in Helena. Near the northwest corner of Sixth and Main Streets, Felix (leaning) stands in the doorway with Mox, his youngest son, beside him on the right. His store is being moved to another location in Rapid City to make room for Jacob Morris's new brick building on the northwest corner of Sixth and Main Streets. From small beginnings, Felix built a fine business. In 1885, he took a large stock of goods to Chadron, Nebraska, ready to take immediate possession of a new building he had purchased from Jewish Deadwood owners Ben Lowenthal and Meyer "Mike" Gottstein, saying that he would "soon be ready for business." It was not unusual for successful merchants to open branches in other towns. (Courtesy Minnilusa Historical Association.)

Mox Poznansky, the youngest of the Poznansky boys, was an industrious lad. Photographs of Mox usually show him at work. (Courtesy Minnilusa Historical Association)

Joseph, Marcus "Mox", Julia, and possibly Felix Poznansky (seated) pose for this picture. The Poznansky name was familiar in the Black Hills from the earliest pioneering days up until fairly recent history. Felix was probably not a rabbi, as the *Black Hills Daily Times* reported, but he was qualified as a *mohel*, prepared to perform ritual circumcisions on Jewish boy babies throughout the Black Hills when called upon. On February 9, 1892, the *Black Hills Daily Times* reported, "Felix Poznansky, rabbi, was in Lead and circumcised the infant son of Mr. and Mrs. Joe Chamison." (Courtesy Minnilusa Historical Association.)

The class of 1890, the first graduating class of South Dakota School of Mines, included Benjamin Poznansky, Carrie Feigel, and Eva Robinson, all pictured at left. After graduation, Ben left Rapid City to work for the Mennen Company in Colorado. Ben died in December 1918 in Pueblo, Colorado, and is buried in the old Jewish section of Mountain View Cemetery, Rapid City. (Courtesy Minnilusa Historical Association.)

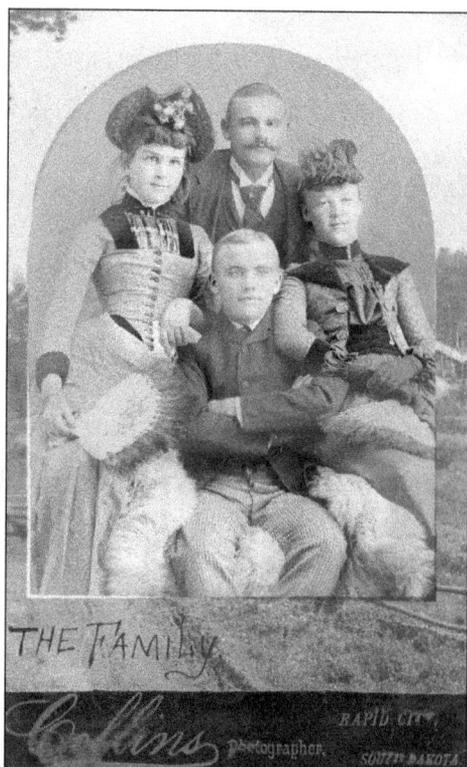

Ben Poznansky is pictured with his wife, who was most likely not Jewish, and family. Julia and Mox Poznansky stayed in Rapid City and remained single all their lives. It is unclear which of these ladies would have been Ben's wife. (Courtesy Minnilusa Historical Association.)

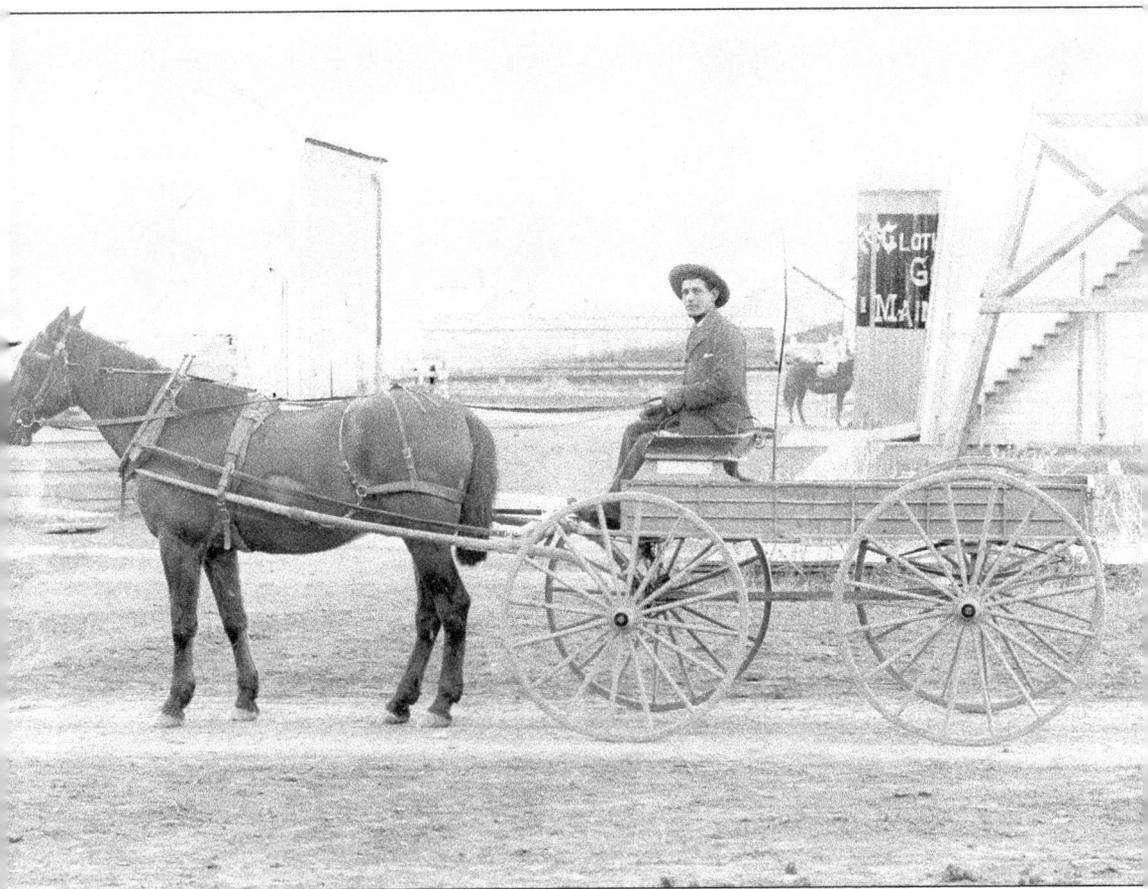

Mox Poznansky is holding the reins of a horse cart. One of Mox's first jobs was as the city cattle herder. (Courtesy Minnilusa Historical Association.)

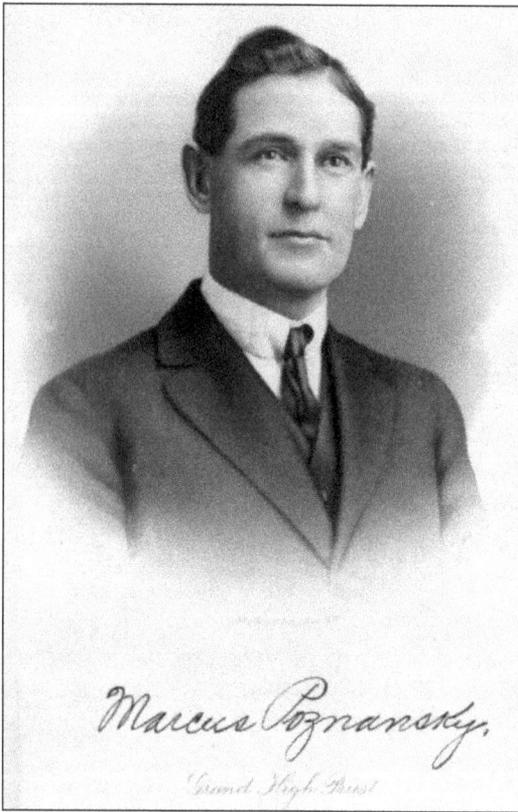

From 1915 to 1916, Marcus (Mox) Poznansky was the Grand High Priest of a fraternal organization, possibly of the Masons or the Knights of Pythias in Rapid City. (Courtesy Minnilusa Historical Association.)

Mox was born in Helena, Montana, like his older brothers, Ben and Joe. As a young man, he worked at the Bee Hive, a retail store in Rapid City. Later on, he and E. Schleuning operated a meat market. (Courtesy Minnilusa Historical Association.)

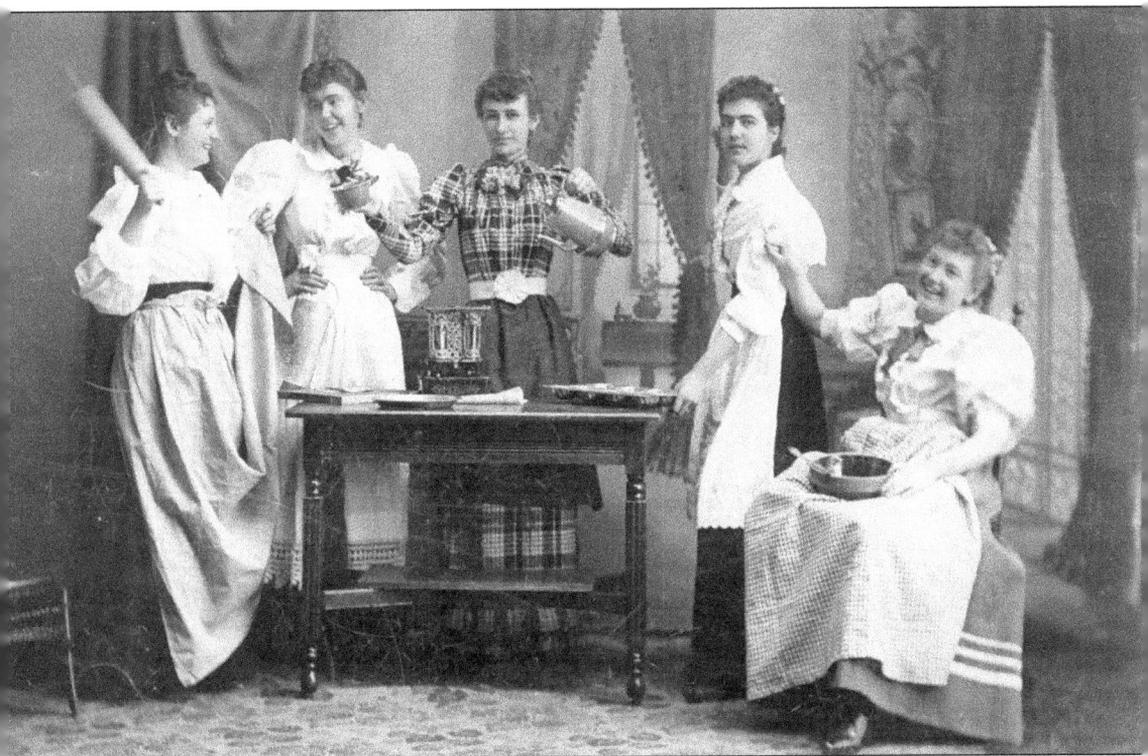

In the plaid dress, petite Julia Poznansky, with four playful girlfriends, is shown at center. In 1889, Felix built a beautiful home on West Boulevard in Rapid City for his family. The house still serves as a fine residence. Julia was remembered as distinguished and ladylike, displaying "good manners and upbringing." Julia never married, never worked, and was doted on by her brother Mox. In her later years, Julia participated in some of the earliest activities of the Jewish community as it developed in Rapid City. She was a member of Rapid City's branch of Hadassah, an organization with few members in Rapid City but very active and charitable nationwide; a member of the Synagogue of the Hills; and a generous contributor to the synagogue. Julia passed away on September 9, 1963, and was buried in their family plot in Mountain View Cemetery. She is not forgotten. Julia was one of the founding members of the Synagogue of the Hills, and her name is recited yearly in remembrance at *yizkor*, the memorial list read on Yom Kippur at the synagogue. (Courtesy Minnilusa Historical Association.)

Joe Poznansky was a proud volunteer firefighter. Although the words *bar mitzvah* do not appear in the newspaper notice, the first-known newspaper reference to Joseph appears at his 13th birthday in December 1879, the age of bar mitzvah, when a boy is recognized as a young man in the wider Jewish community. To achieve bar mitzvah, Joe would have been schooled in Hebrew as well as the basics of Judaism, teachings his father could provide. This was celebrated with a grand party comparable to "anything like it in the Eastern states." Joseph's early employment included a job as bookkeeper at Harris Franklin's First National Bank in Deadwood. (Courtesy Minnilusa Historical Association.)

Mox Poznansky, second from right, is shown with a group of people, probably city officials and their wives, in front of city hall in Rapid City. (Courtesy Minnilusa Historical Association.)

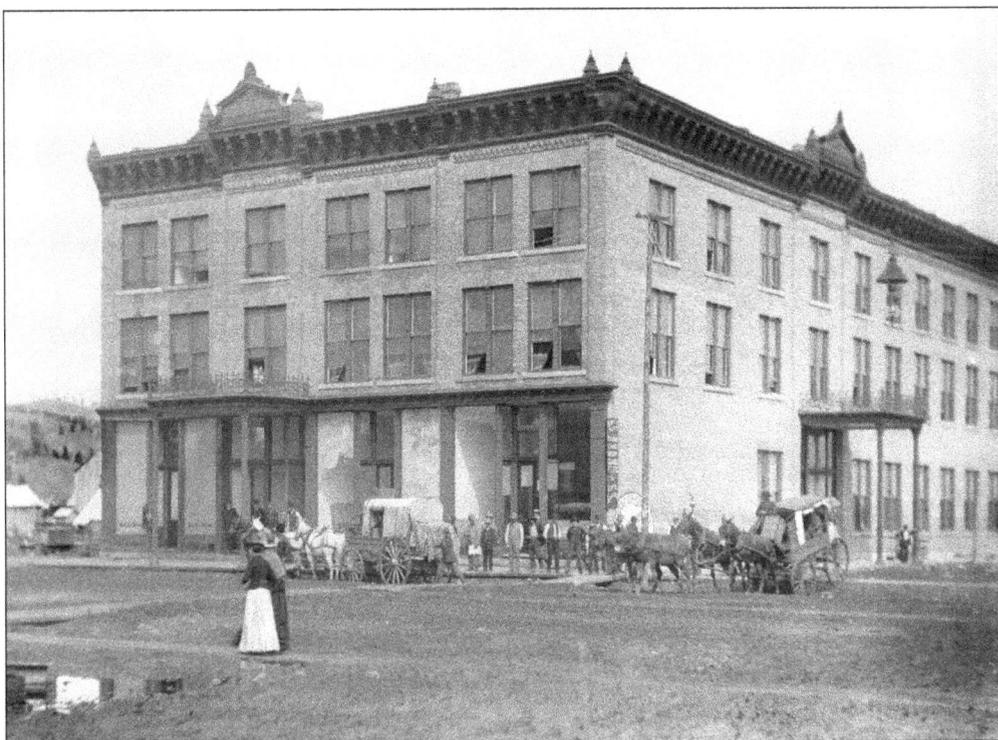

Pictured in the 1890s, the Harney Hotel was a landmark in Rapid City for almost a century. (Courtesy Minnilusa Historical Association.)

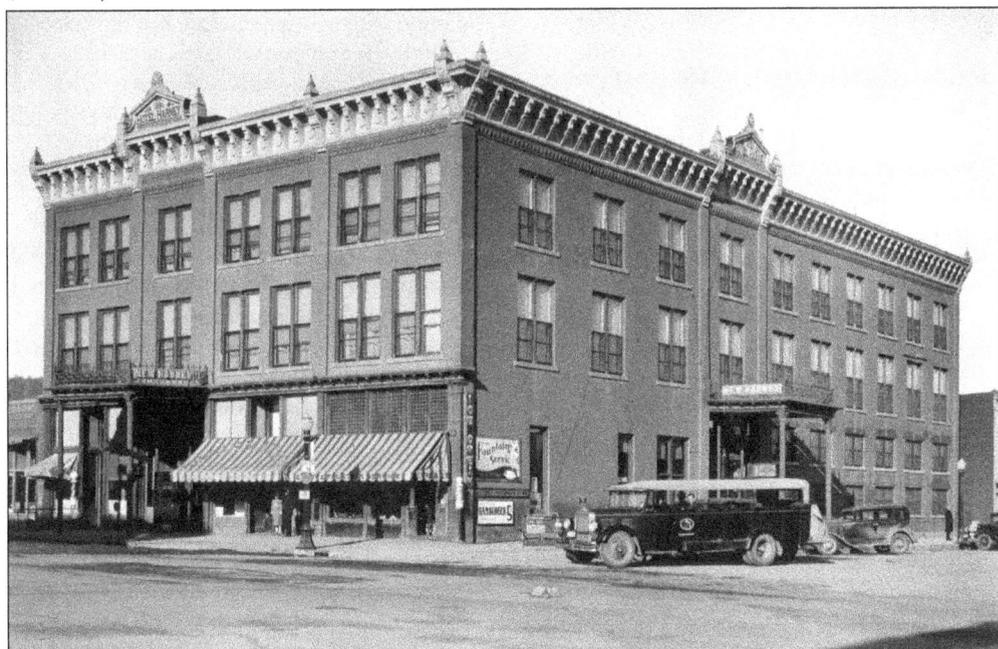

Pictured in the 1920s, the New Harney Hotel on the corner of Main and Eighth Streets, was where Mox Poznansky operated his insurance office. Mox was described as a short man, quite proper, and extremely kind. (Courtesy Minnilusa Historical Association.)

The First Hebrew Wedding in the Hills —
List of the Presents
(Black Hills Daily Times November 4, 1879 p. 4 col. 4)

The first Hebrew marriage ever celebrated in the Black Hills occurred in Deadwood Sunday evening [November 2, 1879], and in addition to this important historical fact it was one of the most prominent social events since the settlement of the country. Upon the occasion referred to, Mr. David Holzman, one of our business clothing dealers, and Miss Rebecca Reubens, the beautiful and accomplished daughter of Mr. Louis Reubens were joined in the holy bonds of wedlock. The interesting ceremony took place at the residence of the bride's parents in Ingleside in the presence of at least sixty ladies and gentlemen of our best Hebrew society and of other nationalities. At 5 o'clock the bride and groom entered the parlor, looking a little timid but happy as a garden of roses in June, when the Hebrew marriage ceremony was performed by the bride's father, which was subsequently sanctioned, or legalized according to our laws, by Judge Coleman, after which the newly married couple adjourned to the banquet room and received the congratulations of the assembled guests. The festivities continued until about 1 o'clock yesterday morning, at which time the joyous company began to disperse and before the dial band marked another hour of the couple's wedded life all were gone, leaving them to peaceful slumbers and blissful dreams.

The presents presented to the bride and groom were altogether the most elegant bridal gifts ever seen in the Hills. They were as follows:

Mr. and Mrs. Ed Whitehead, a large silver water pitcher and fruit boat; Jacob Behrman, an elegant silver cake basket and spoon holder; J. Goldbery, a handsome silver jewel case; J.A. Schiller, a large and handsome silver water pitcher and goblet; P. Cohn, silver butter dish and knife; Leo Rosenthal, silver mounted glass pickle dish and fork; Wm. Munter, a large silver caster; Louis Epstein, a jewel box mounted with a cut glass cologne bottle; Moses Liverman, a beautiful rosewood jewel box; Jake Wertheimer, large table lamp; Mr. and Mrs. G.M. Gillette, a neat little clock; Wm. Brown, silver spoons and case; Ed Cohn, silver caster; Joseph Mitchell, two beautiful silver goblets; Mr. and Mrs. C.H. McKinnis, a handsome perfumery bottle; Ben Baer, a pair of very nice cut glass in a silver frame for pickles, etc.; Mr. and Mrs. Judge Colman, a silver call bell; Mr. and Mrs. O.P. Grantz, an elegant silver cake basket; Mr. and Mrs. Seth Bullock, a full set of silver knives and forks and case; Mr. and Mrs. Goldbloom, silver card receiver; M.J. Werthheimer, napkin rings and case; Mr. and Mrs. Liebmann, a handsome silver card receiver; W.W. Baird, pin cushion and jewel case, a very neat affair; Mr. and Mrs. H.B. Beaman, a cigar ash receiver, which is not particularly rich nor elegant but unique; Mr. and Mrs. M.H., silver door bell, Mr. and Mrs. J.B. Graves, large silver pudding knife and fork.

The first Jewish wedding in the Black Hills, as reported in the *Black Hills Daily Times*, took place in Deadwood in 1879. The Jewish wedding was performed by the bride's father, Louis Reubens, and legalized by Judge Nathan Colman. Rebecca Reubens was married to David Holzman, another Deadwood merchant, at the Reubens' family home. There is no mention of Louis's wife, which is a characteristic of journalism at that time. Louis Reubens was elected president of the Hebrew Benevolent Society, which formed in 1879. He was also on the board of directors of the Deadwood public schools in 1881.

Sam Schwarzwald arrived in Deadwood in 1876, about a week after Wild Bill Hickok was shot. His first business dealings in Deadwood were in grain and produce. In the fall of 1877, he opened his first new and used furniture business under the name Stone and Schwarzwald, later becoming the sole owner. The merchandise was brought into Deadwood by bull train from the ferry at Fort Pierre. In 1894, he constructed a brick and stone building at 620 Main Street. In 1897, he expanded his business, acquiring the adjacent building at 622 Main Street. He built his business into one of the largest and longest-lasting mercantile establishments in Deadwood. Sam passed away in 1927. (Courtesy Adams Museum.)

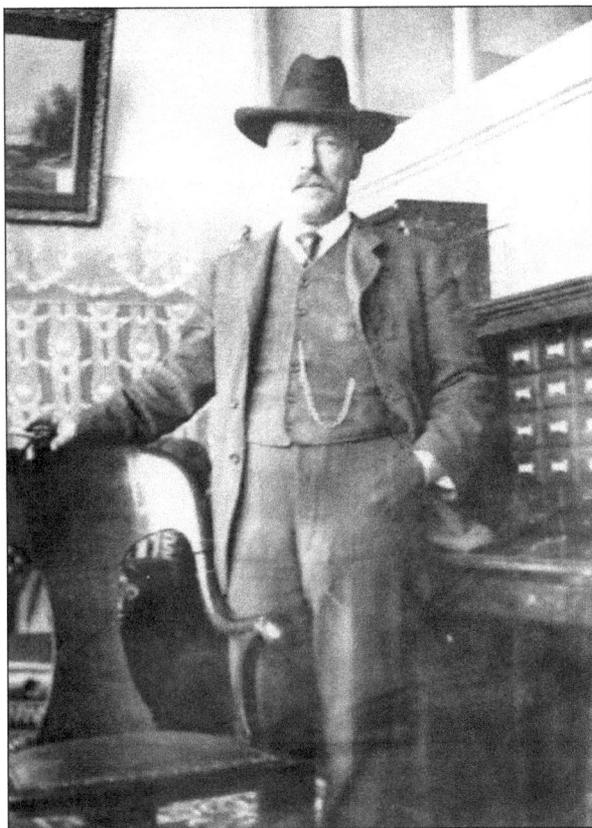

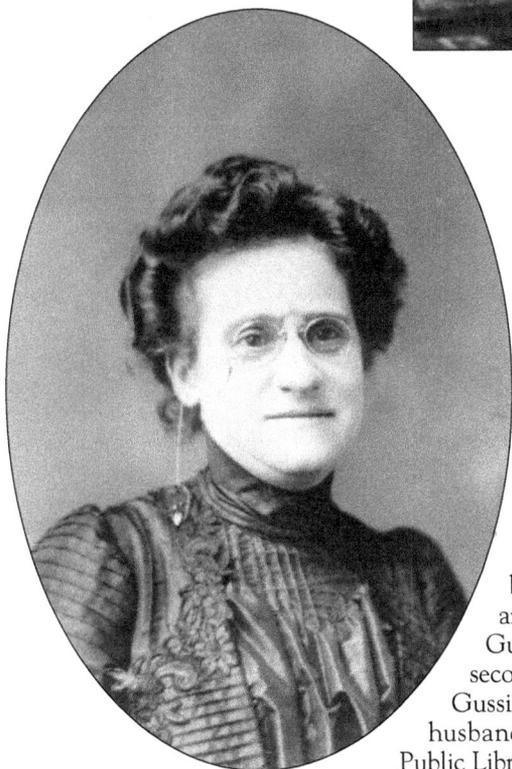

Gusta "Gussie" Lowenthal Nathan Schwarzwald came from a large family, most recently from Brooklyn, New York. There were at least two brothers, Max and Ben, and two sisters, Pauline and Esther, who lived in the Deadwood-Lead area. Gussie's first marriage ended in divorce, but her second marriage to Sam Schwarzwald was successful. Gussie worked in the furniture store alongside her husband, Sam Schwarzwald. (Courtesy Deadwood Public Library.)

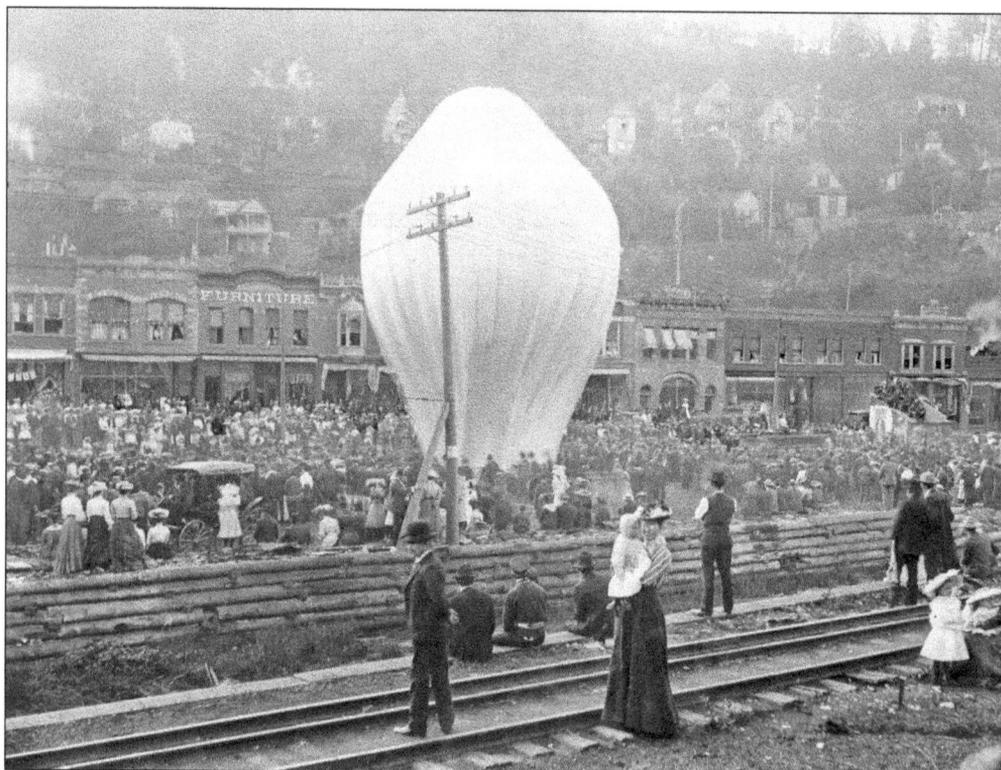

Balloon-raisings were popular events in the 1800s. At this balloon-raising, one can see the Schwarzwald Furniture store on lower Main Street in the background. (Courtesy Adams Museum.)

Gussie Schwarzwald is seen in the furniture store she and her husband, Sam, owned. Gussie seemed to enjoy her work there. (Courtesy Marc Aldrich.)

Posing above are three sisters, from left to right, Esther Lowenthal, Gussie Lowenthal Nathan Schwarzwald, and Pauline Lowenthal. Esther married Oscar Silver of Lead. On February 21, 1879, the *Black Hills Daily Times* wrote, "Silver, Oscar. Will furnish the music for the Miners Union Ball." On June 7, 1885, the *Black Hills Daily Times* announced, "Son born Friday evening to wife of Oscar Silver, Lead." (Courtesy Marc Aldrich.)

From left to right, Pauline Lowenthal, Charlie Nathan, and Esther Lowenthal Silver are shown at a hotel in California, dressed as if for a wedding. (Courtesy Marc Aldrich.)

Gussie's brother Ben Lowenthal and his family are pictured here in 1907. The family lived in Central City. Note the ornate framing, which was typical of the day. (Courtesy Marc Aldrich.)

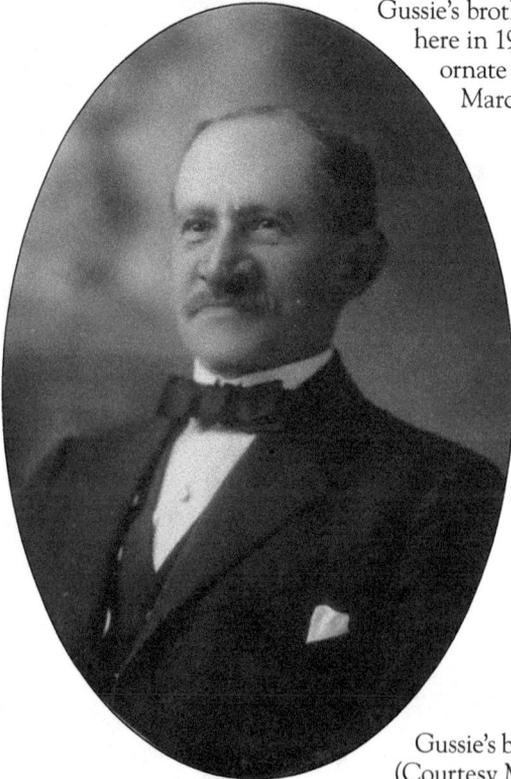

Gussie's brother Max Lowenthal is pictured here in 1916. (Courtesy Marc Aldrich.)

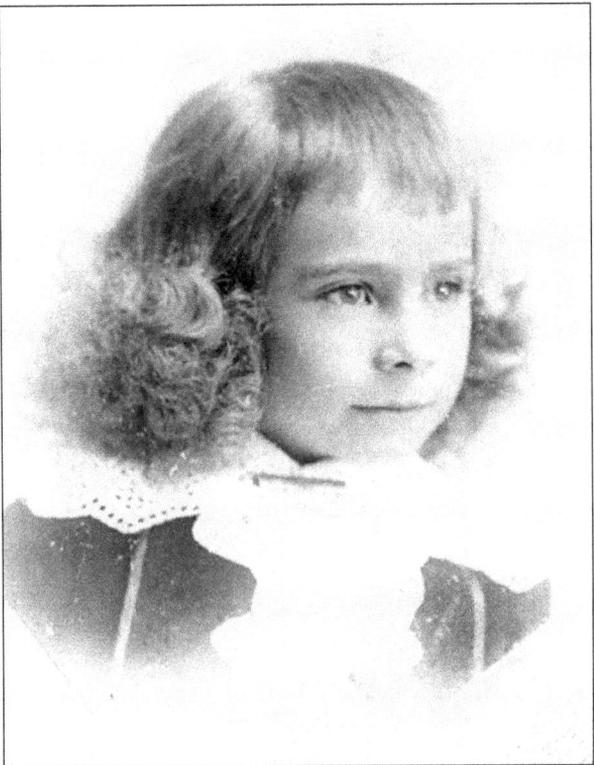

Gussie's son Charlie Nathan is pictured here with bangs and long, curly locks, fashionably attired in the Little Lord Fauntleroy style. (Courtesy Marc Aldrich.)

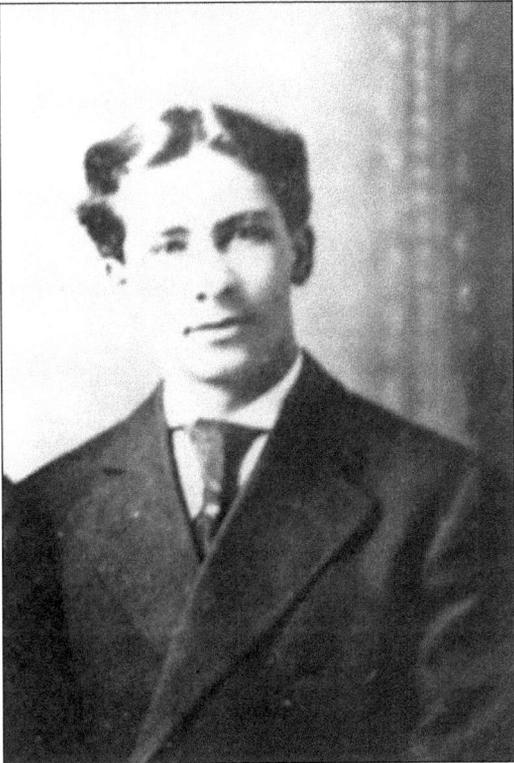

Charlie Nathan is pictured at left as a young man. (Courtesy Marc Aldrich.)

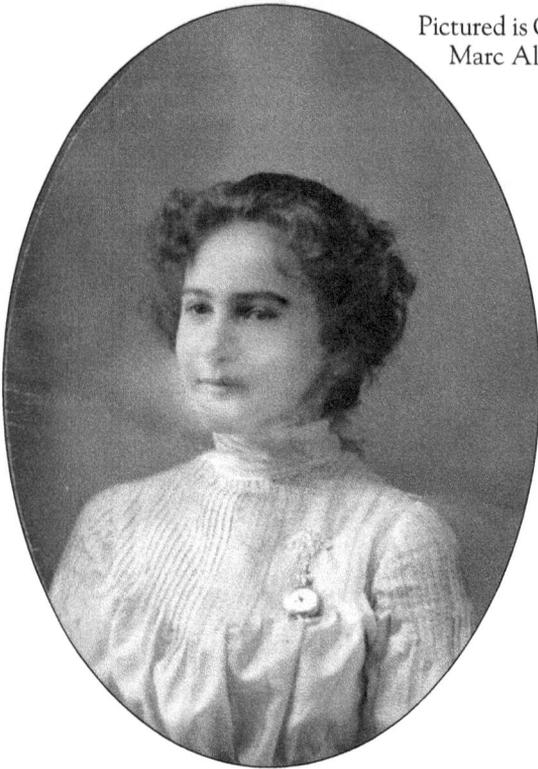

Pictured is Gussie's daughter Theresa Nathan. (Courtesy Marc Aldrich.)

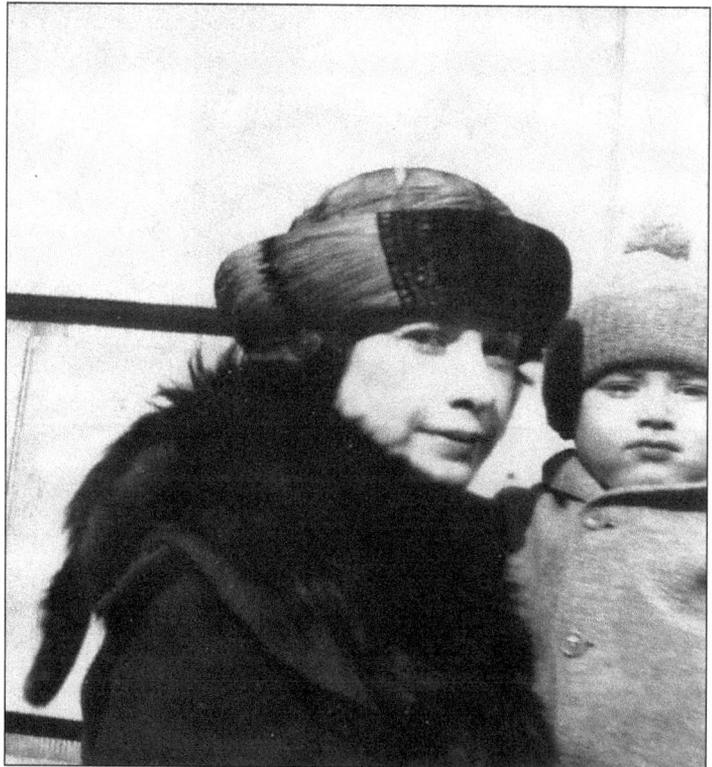

Theresa Nathan married Levander Aldrich. The little child pictured here is Leo Aldrich. (Courtesy Marc Aldrich.)

In this image, Leo Aldrich is probably three or four years old. (Courtesy Deadwood Public Library.)

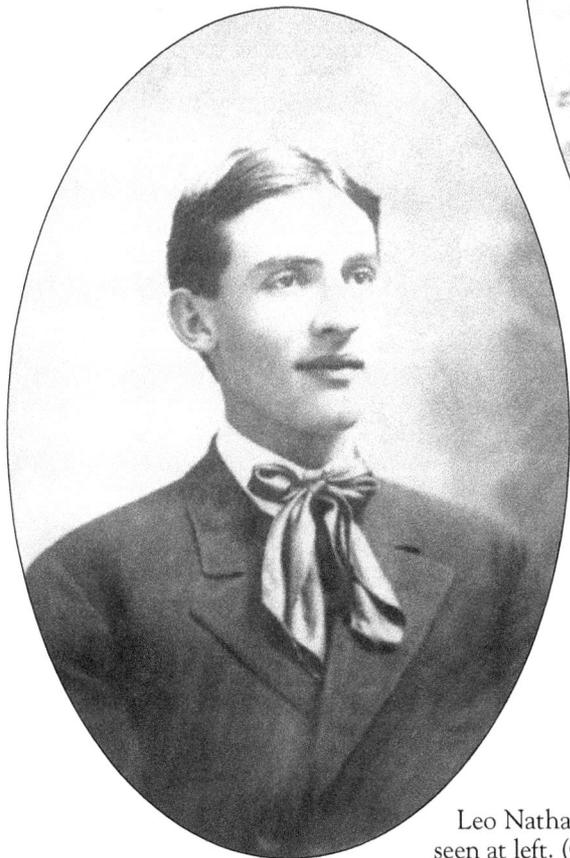

Leo Nathan's high school graduation photograph is seen at left. (Courtesy Marc Aldrich.)

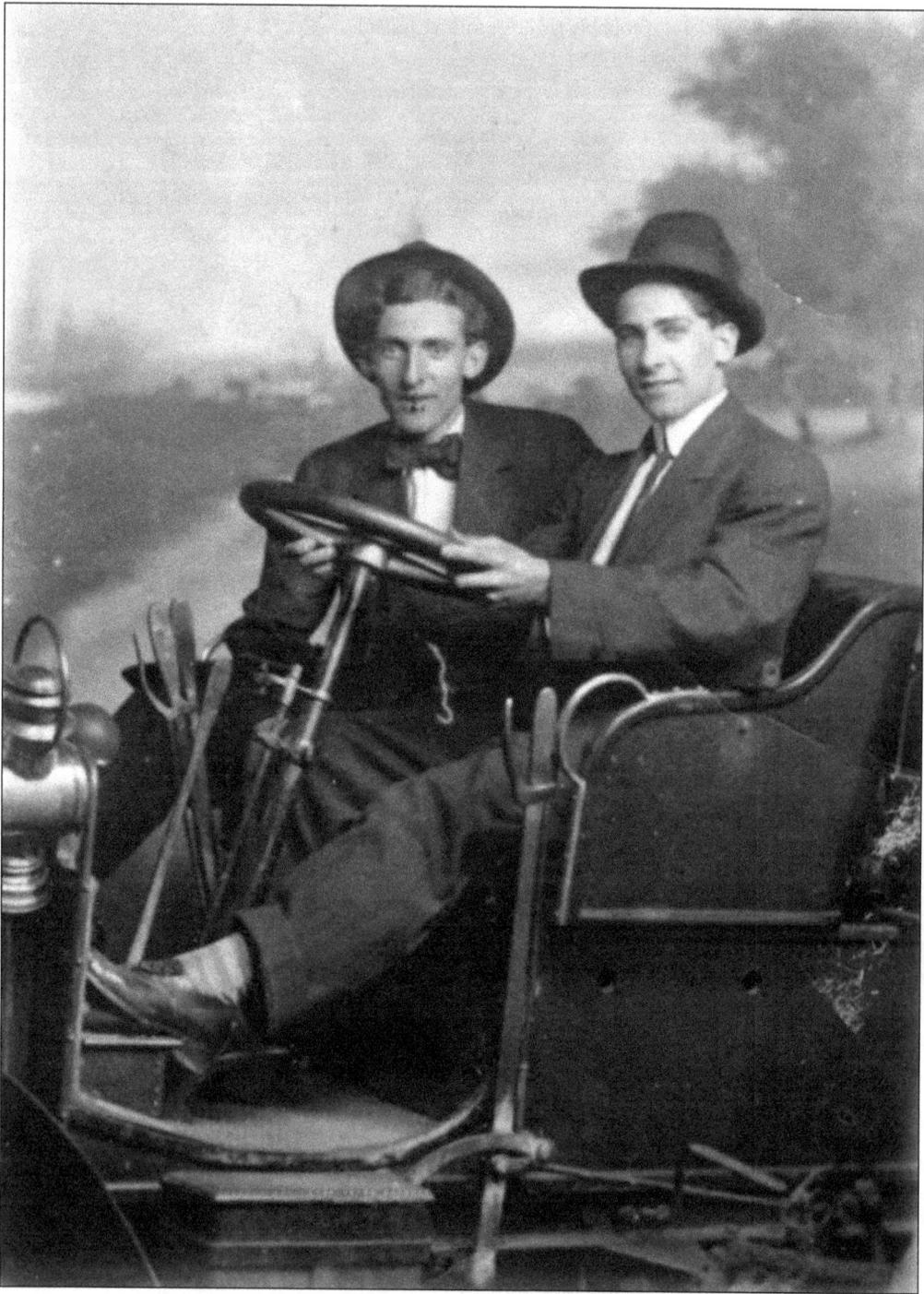

Brothers Leo and Charles Nathan pose for a photograph in the 1910s. (Courtesy Marc Aldrich.)

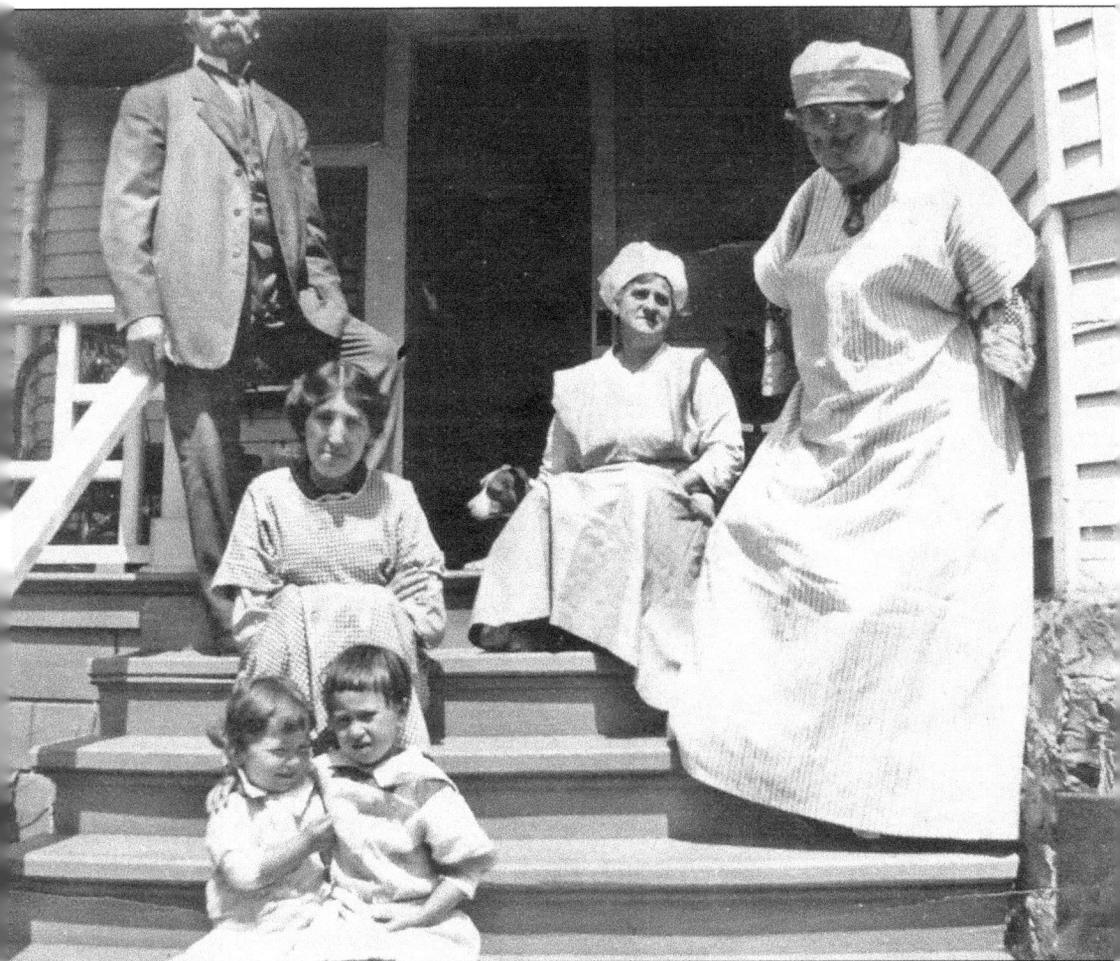

Gussie Schwarzwald (seated on top step) gets a visit from family friends Henry Keimer and Blanche Keimer (both standing) and an unidentified woman and children (all seated) in 1914. The Keimers operated an entertainment facility called Keimer Hall. Blanche Keimer adopted a young Jewish boy named Lester Dansky. Lester was killed in action serving in the Army Air Corps during World War II. Lester's gravesite is engraved with the image of a fighter airplane. Blanche and Lester are buried next to each other in the Mount Zion section of Mount Moriah Historic Cemetery. (Courtesy Marc Aldrich.)

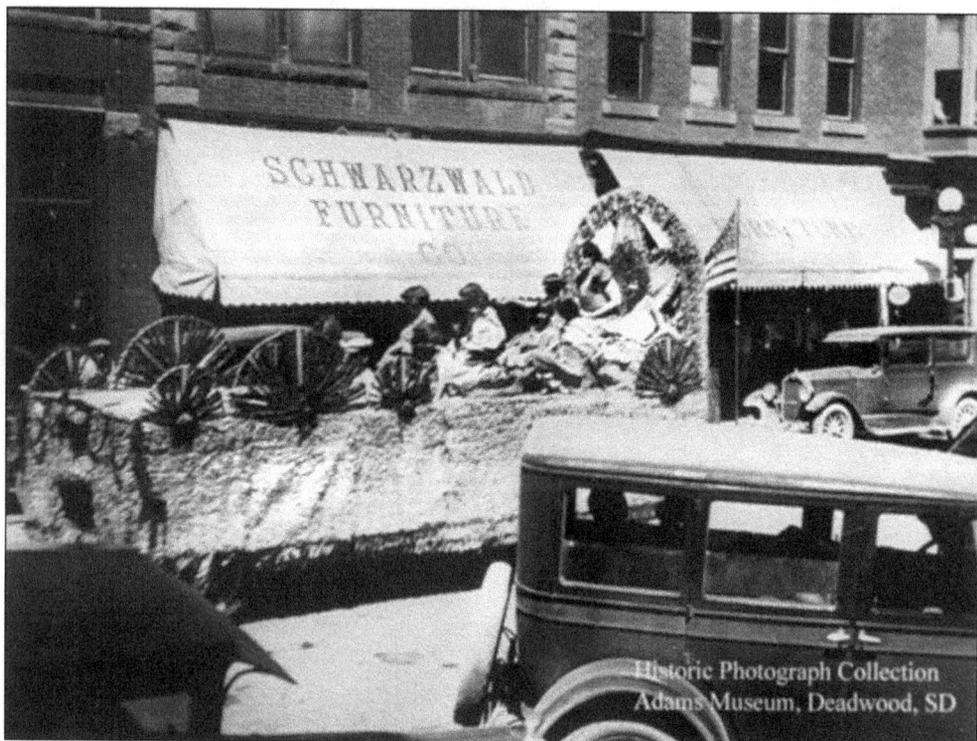

This view is of Schwarzwald's Furniture from a second-story window across the street. A parade is proceeding up Main Street in Deadwood. (Courtesy Marc Aldrich.)

Charlie Nathan and his mother, Gussie Schwarzwald, are seen here. Charlie Nathan began by working for Schwarzwald's and eventually took over the store's management. (Courtesy Deadwood Public Library.)

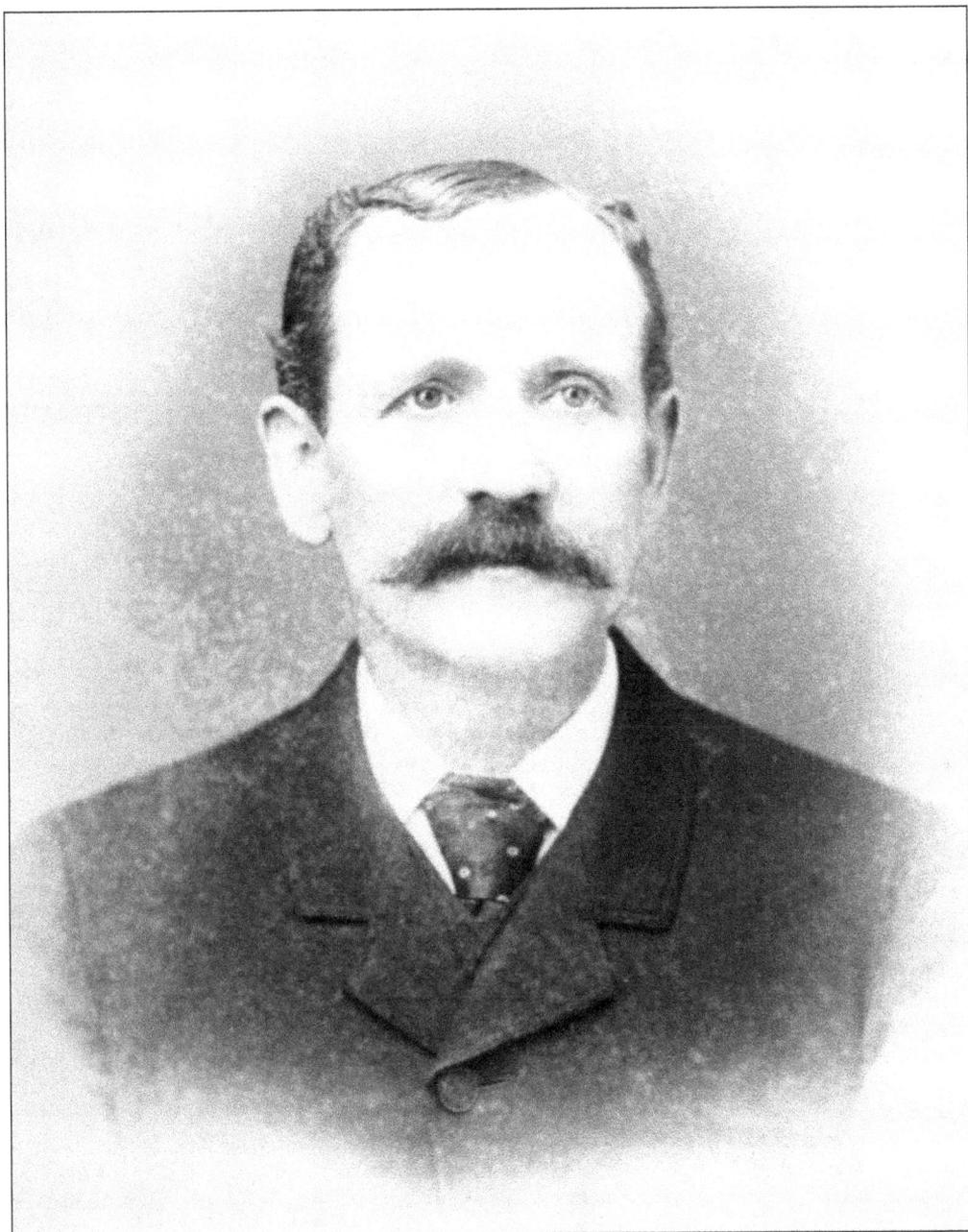

Sol Star, Deadwood's first Jewish mayor, was born in Germany and immigrated to the United States as a young boy. He started out in the clothing business and had commission/auction houses in Helena and Virginia City, Montana. Later, he branched out into banking and became remarkably successful. In 1870, at the age of 30, Sol's assets were valued at more than $10,000, a great fortune for the time. In Helena, Montana, Star formed a friendship with Capt. Seth Bullock, who shared Sol's interest in business and government. The pair made plans to join the "stampede" for gold in the Black Hills. Upon learning of their intentions, the *Butte Miner* newspaper published a farewell message, "Mr. Sol Star . . . Sorry you are going, Sol, but good luck to you." (Courtesy Adams Museum.)

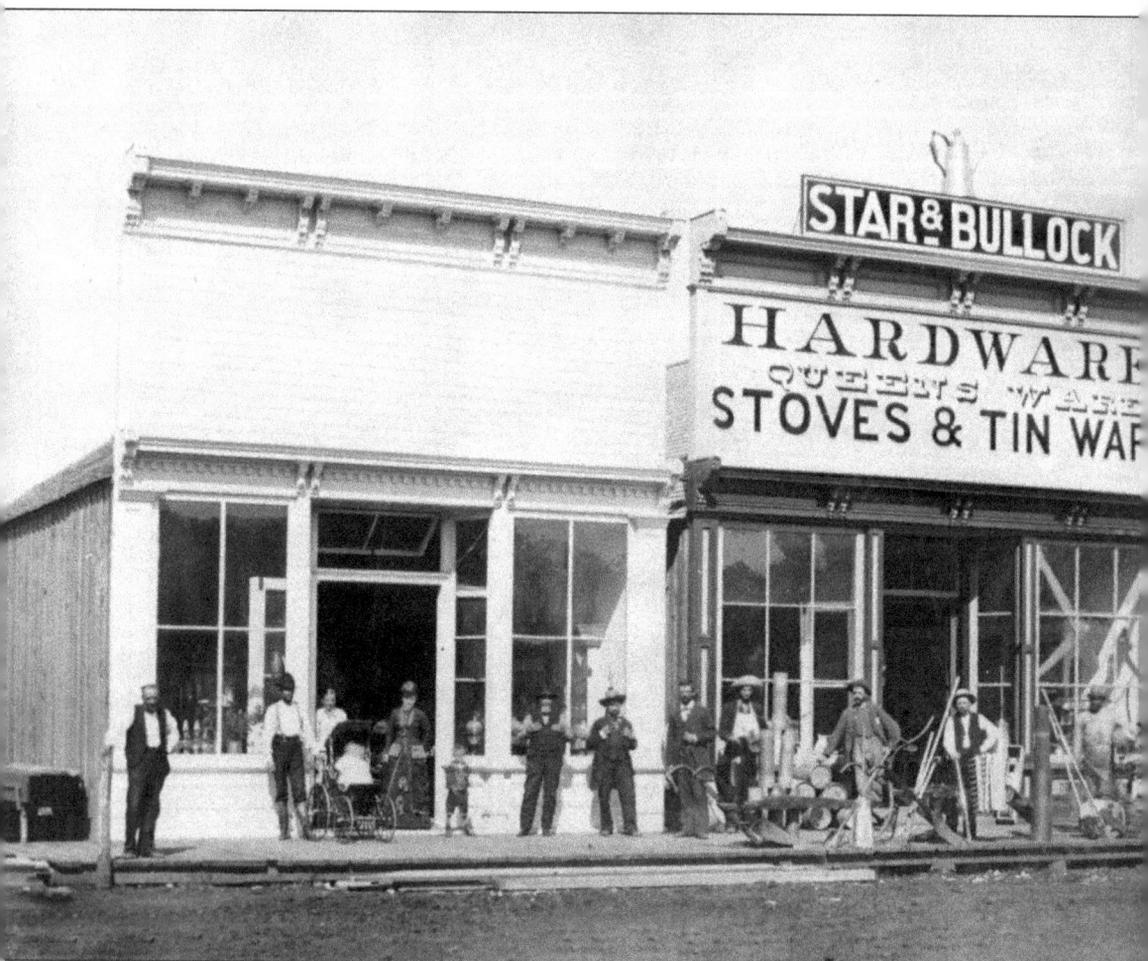

In Deadwood, Sol Star went into the hardware business with partner Seth Bullock. It did not matter that Star was Jewish and Bullock was not. According to Watson Parker in *Deadwood: The Golden Years*, with the partners' stock of equipment such as Dutch ovens, dynamite, axes, rope, pans for prospecting ($8), picks ($12), and shovels ($10), all of which were basic necessities to the miners, the partners set to work. In anticipation of the needs of a Deadwood winter, they had an inordinately large supply of chamber pots, and these sold very well. Bullock became Deadwood's sheriff, and Star went on to become Deadwood's first Jewish mayor, a position he held for seven terms, or 14 years. His leadership helped guide Deadwood from a lawless Wild West frontier mining camp to a civilized town, the center of commerce for the Black Hills region for more than 50 years. Sol was an entrepreneur, a rancher, and a politician, and his concern for the interests of his community made him a social and political icon. Sol Star also had a flour mill, a convenience for processing grain grown on his croplands and from the fertile valley east of the high hills. Star was known to distribute sacks of flour to citizens in need. It was said that as long as Sol had his flour mill, nobody in Deadwood went hungry. (Courtesy Adams Museum.)

The handsome stone building still operating as the Bullock Hotel stands where Star and Bullock's Hardware Store began in a tent in August 1876. The tent soon was replaced by a frame building. By 1878, Star and Bullock were extending their services, becoming building contractors for local development, providing fencing, iron shutters, fireproof doors, and roofing for business and public projects. In 1880, the frame building made way for a sturdy sandstone structure, the front of which was used as a hardware store. They annexed the adjoining building to the south. The rear part, built as a warehouse, survived the fires of 1879 and 1894. (Courtesy Adams Museum.)

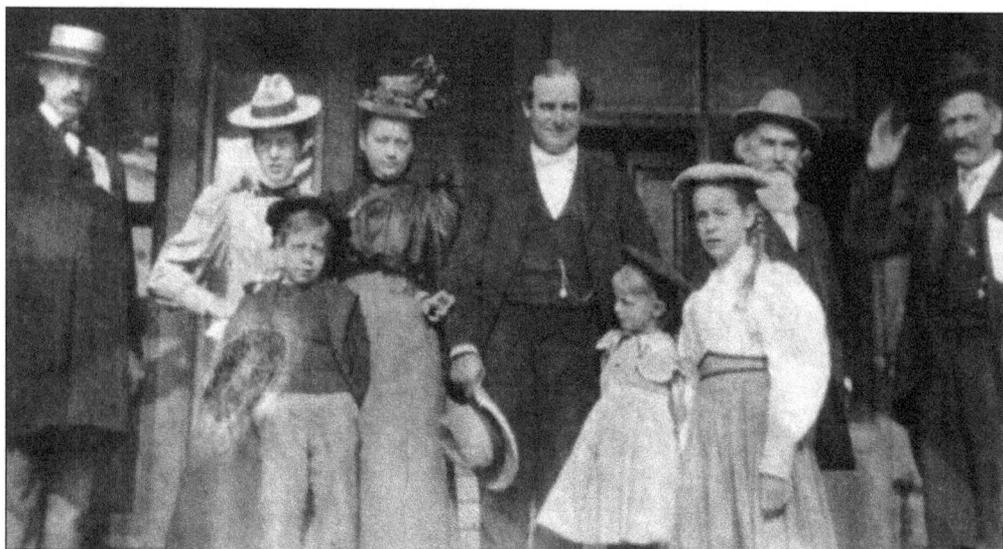

Mayor Sol Star (at right) is shown with William Jennings Bryan and his family, likely preparing for a Chautauqua. Star and Bullock's Hardware branched throughout the Black Hills area and on into Wyoming and Montana. Star also had interests in mining and was extensively involved in agriculture. The town of Belle Fourche now sits on land that was originally developed as the S&B (Star and Bullock) Ranch, at once a weekend retreat, fruitful cropland, thoroughbred horse farm, and productive cattle ranch. (Courtesy Deadwood Public Library.)

Sol Star, center, Seth Bullock, right, and an unidentified man, left, are shown above. This photograph was taken at the Redwater River, near the S&B Ranch. They raised fine horses and livestock, as well as crops, at the ranch. The partnership of Sol Star and Seth Bullock that began in the gold mining town of Helena, Montana, would become one of the most dynamic and prosperous of Deadwood's many business affiliations, contributing significantly to the economic development of Deadwood, Belle Fourche, and many other Black Hills towns and some neighboring states. Unfortunately, their business partnership ended in a legal dispute; however, their friendship remained throughout their lives. Sol Star, who was Jewish but not particularly active in the religious life of the Jewish community, was an energetic and involved Mason, having ties to several lodges, including Deadwood's Chinese Masonic lodge. He was also a Grand Master of Deadwood's Grand Lodge. (Courtesy Adams Museum.)

Star's death in 1917 was a huge loss to the Black Hills community. There were memorial services held at the Masonic Temple where Star was a past Grand Master. Solomon Star's death certificate shows that he originated from Germany and his father's name was Morris Star. At 77 years old, Sol died on October 10, 1917, and the cause of death was "chronic pulmonary tuberculosis," with "old age" as the contributing factor. His certificate also states that his occupation was clerk of courts. It says nothing about the dedication with which he served his community for so many years, right up until the end, or his sense of adventure, or the love he felt for his fine horses, or the pain he lived with from his "rheumatism," or his zest for life. His nephew Louis Swartz from St. Louis came to take his uncle's last remains to St. Louis for burial. (Courtesy Ann Haber Stanton.)

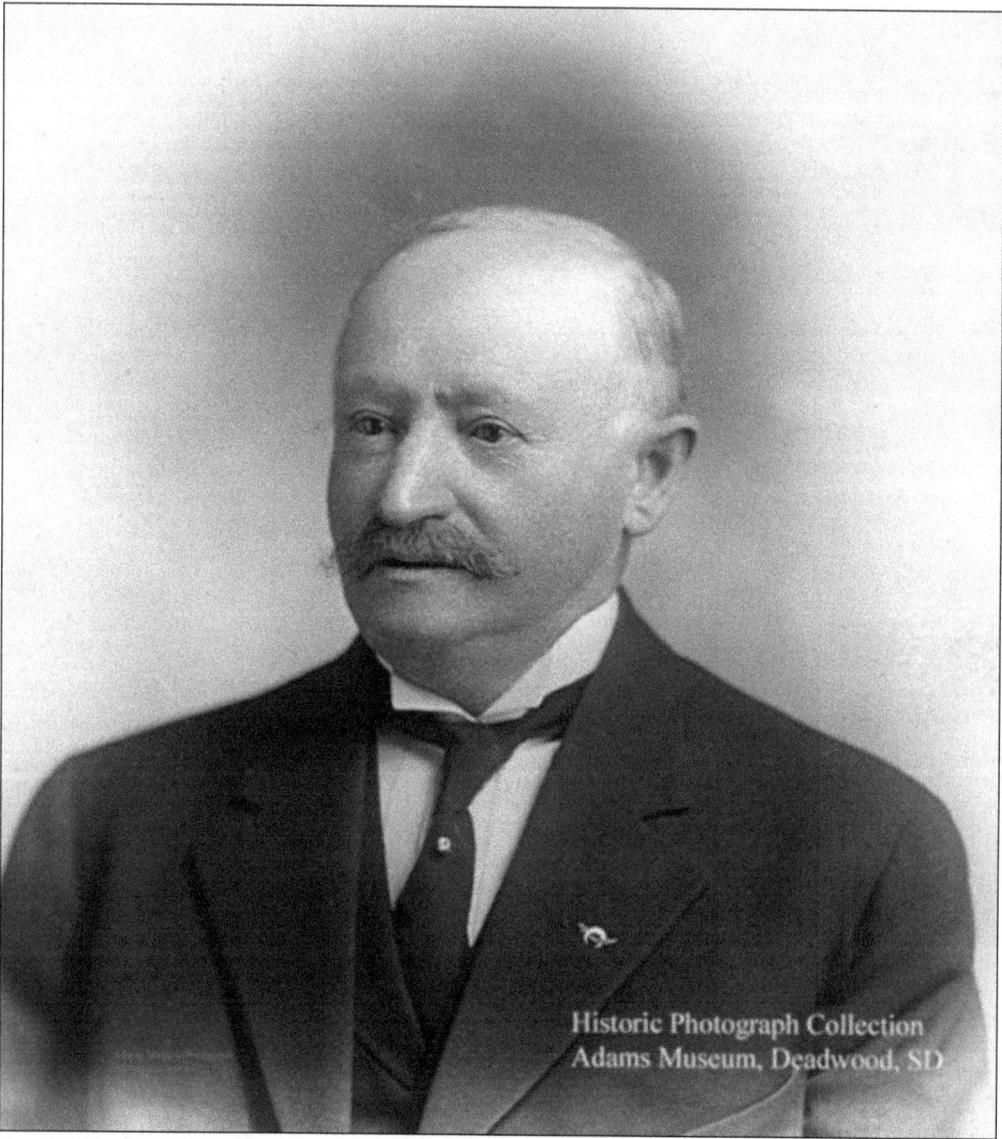

Charles Zoellner came from Germany in 1866. Zoellner went to Denver and then to Cheyenne, Wyoming. In 1876, he joined the gold rush to the Black Hills, arriving in Deadwood in March of that year. (Courtesy Adams Museum.)

In 1885, Zoellner returned to Germany where he "secured a bride," according to the *Black Hills Daily Times*. Charles Zoellner's young family is seen at right. (Courtesy Adams Museum.)

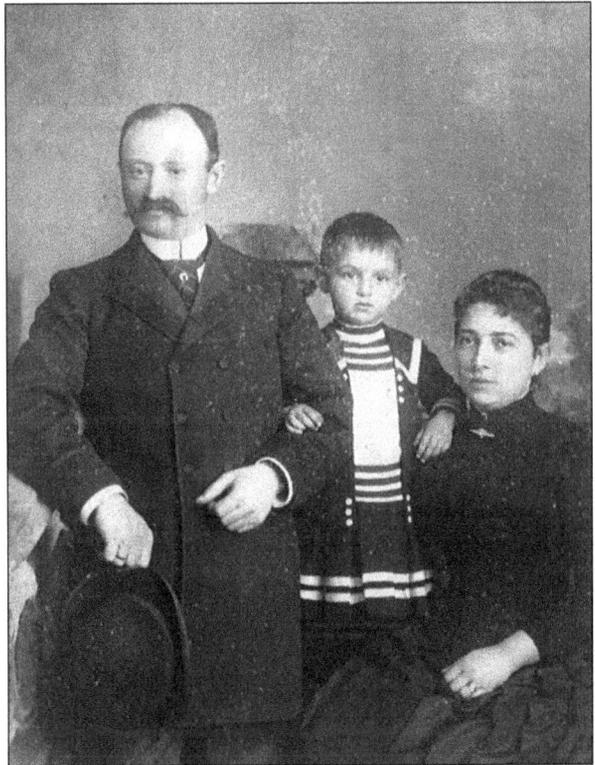

Charles Zoellner is seen riding in a Pioneers Day parade. Horses were a vital form of transportation. (Courtesy Adams Museum.)

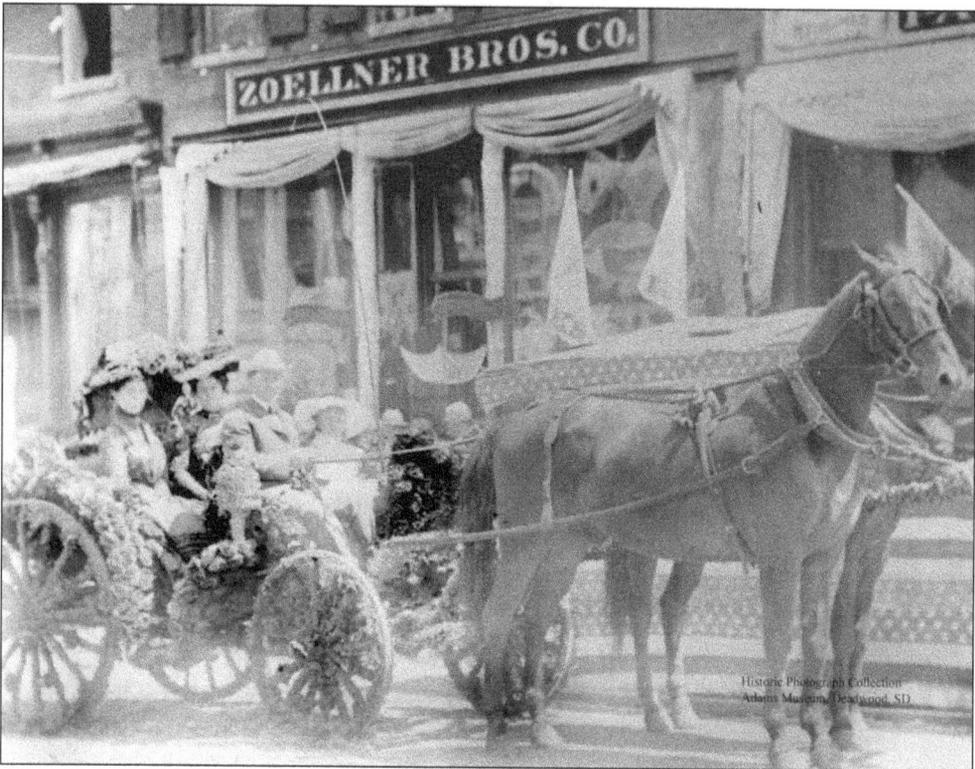

Charles's brother Jonas joined him in the Black Hills in the spring of 1877, and together they established a general store at Central City, halfway between Deadwood and Lead. In this photograph, a carriage with the Franklin women, Anna, Ada, and Mildred, passes by the Zoellner Bros. Co. in a parade. (Courtesy Adams Museum.)

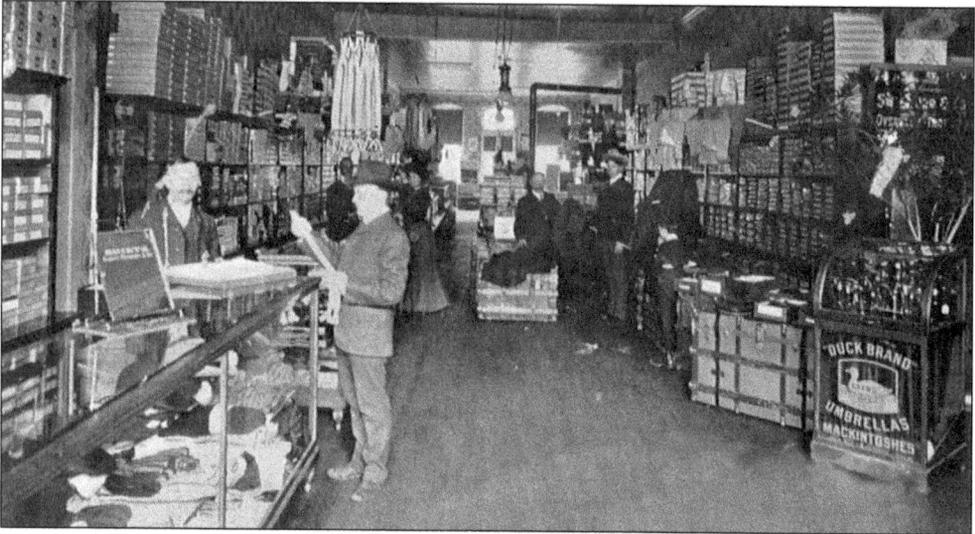

In 1899, Charles and Jonas opened their store in Deadwood, and the firm of Zoellner Bros. Co. became well known throughout the Black Hills. Jonas left Deadwood in 1912 to take over a business in Scottsbluff, Nebraska, and Charles became the sole owner of the Deadwood business. (Courtesy Adams Museum.)

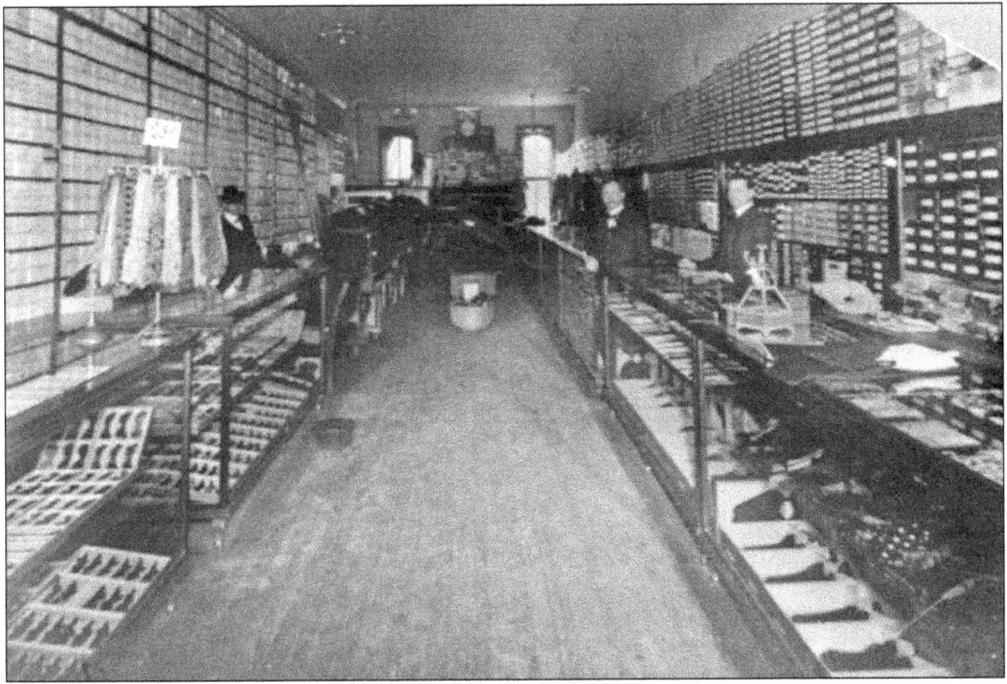

The interior of Zoellner's clothing store in Lead shows a variety of merchandise. They opened another branch of their clothing store in Spearfish in 1877. The Spearfish store suffered the same fate as so many early-day structures and was lost to a major fire. (Courtesy Adams Museum.)

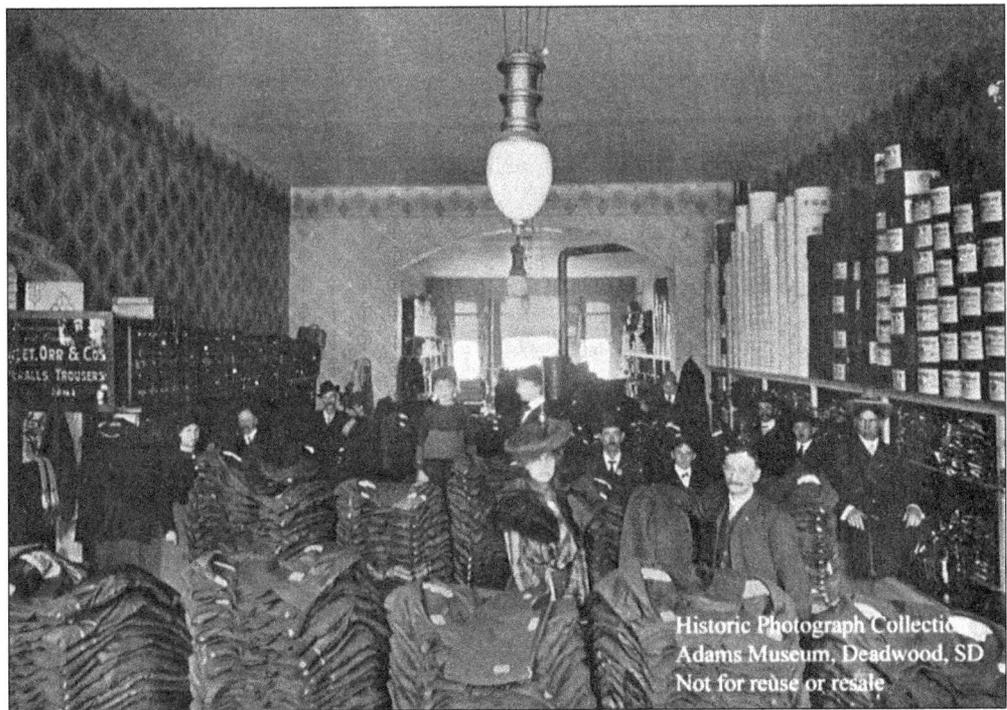

The Zoellner brothers rebuilt, restocked, and reopened the store, better than before. (Courtesy Adams Museum.)

Charles Zoellner's son (second from right) is seen on his pony with other children in front of the Franklin Hotel. The girl in the center may be Mildred Franklin. (Courtesy Adams Museum.)

Three

THE HOMESTEADERS

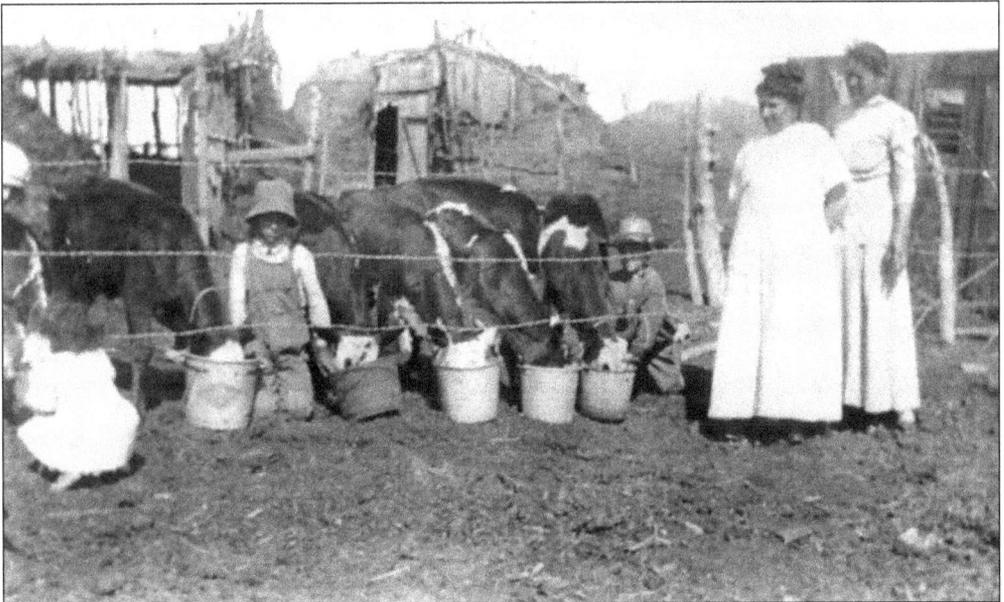

This photograph was taken on the Sinykin homestead in 1912. Ruth Sinykin peeks in from the left. Baby Cecelia Steinberg's back is to the camera, Cecelia's brother Benny Steinberg and Louie Sinykin feed the calves, and Fanny Sinykin Steinberg and Grandma Etta Sinykin look on. Passed by Congress in 1862, the Homestead Act encouraged development by allowing the homesteader up to 160 acres of free land. They had to build a structure, even a shack, and live in it for five years and develop the claim, a process called "proving up." Winters were wretchedly cold, summers unbearably hot, and the wind never quit blowing. Only 40 percent of all those who started the process were able to complete and maintain title to a claim. To Jews who were forbidden by law to own land in many other parts of the world, this was a very provocative offer. (Courtesy Diane Sinykin Small.)

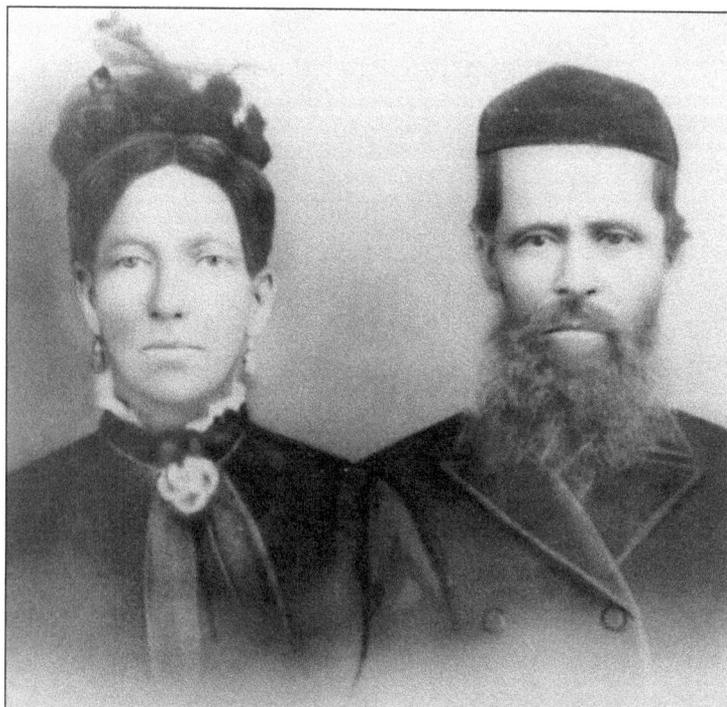

Harry and Etta Sinykin (the Americanized form of Sinaikin), newly arrived immigrants from Minske Kepulye, Russia, were among the 20 married couples and 18 single men who homesteaded in 1905 at the settlement in western South Dakota, about 40 miles north of Quinn, which came to be known as Jew Flats. The nearest town was Grindstone, comprising a railroad stop, a post office, a store, a white schoolhouse they still call "Big White," and little else. (Courtesy Diane Sinykin Small.)

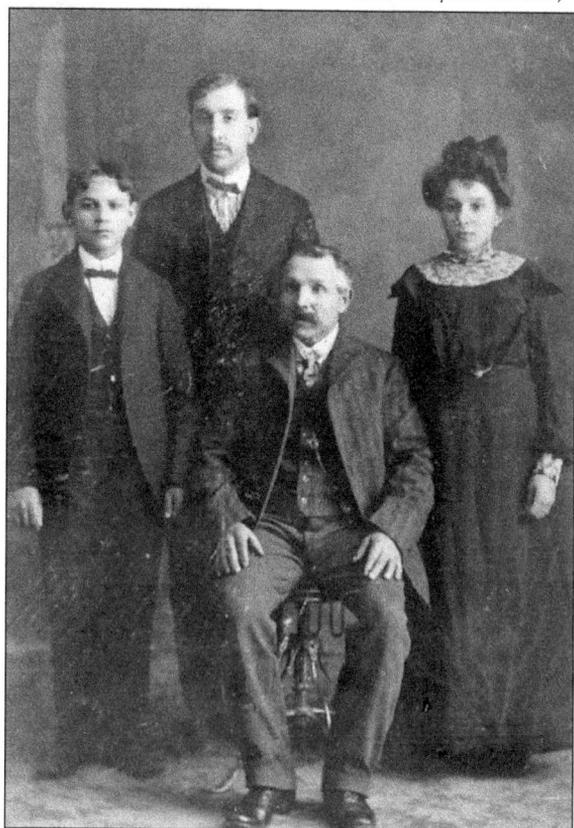

Immigration was usually a family matter, each one helping the other. In 1901, Harry Sinykin (seated) welcomed his brother Sol and Harry's children, 13-year-old Ted and 15-year-old Fanny, to the United States. They had come from Minske Kepulye, Russia, which was within the pale of settlement, meaning Jews were permitted to live on but not own land. These official restrictions and pogroms made life unbearable. The Sinykins came by steamship and then by train to Dell Rapids, South Dakota. (Courtesy Diane Sinykin Small.)

Etta Fanny Koval Sinykin is shown here in 1905. Upon her arrival from Russia with her three youngest children, this photograph was taken in New York City. Her older three children had come to the United States before her. Ted and Fanny arrived in 1901, and Jack (John was his given name) had arrived in 1903. Etta stayed with her sister Chaya for a month before leaving to join her husband in Sioux City, Iowa. After a year in Sioux City, they moved to the homestead on the barren prairie of western South Dakota, where her former "comfortable" life was about to change drastically. One example of this life-changing move was brought about by her unwavering need to follow the orthodox practices of her religion. Their homestead was located next to a running stream that served as a *mikveh* (bath), which was where she could follow the ritual of monthly purification by immersion in clear running water that religious women practiced. In the winter, when this stream froze over, Etta's daughters recall breaking the ice for their mother to immerse herself. Later on, Harry would build her an enclosed *mikveh*, one where she could bathe and be protected from the freezing temperatures and icy winds of a South Dakota winter. (Courtesy Diane Sinykin Small.)

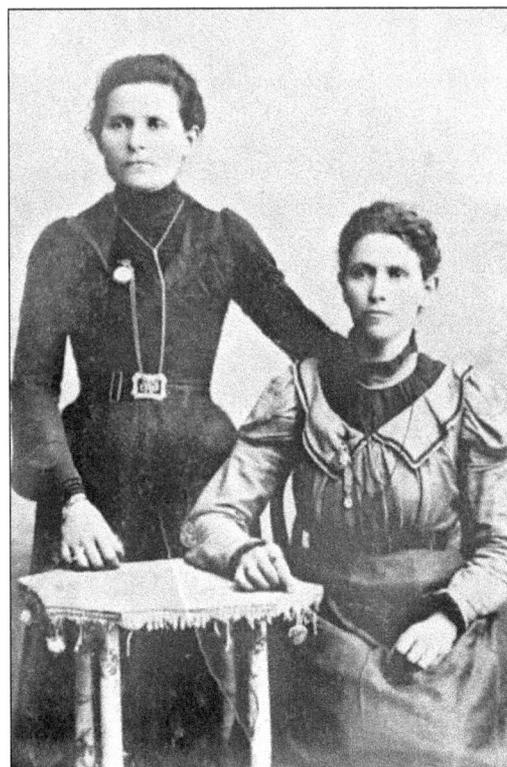

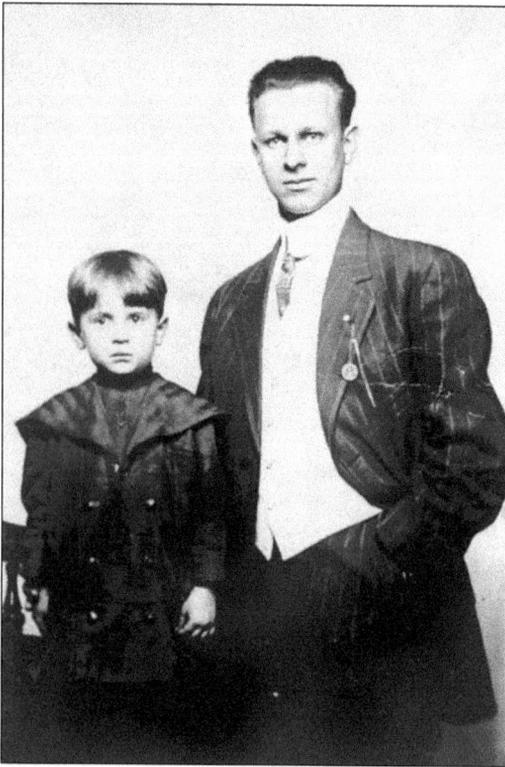

Here are Louie and his older brother Jack Sinykin in 1904. Louie and Jack both pursued a variety of careers in their lives. Jack was the first to train dogs to assist the blind in the United States. He started a foundation called His Master's Eyes in St. Paul, Minnesota. They trained the dogs and provided them to the blind. Over his lifetime, Jack trained more than 3,000 dogs. (Courtesy Diane Sinykin Small.)

Ted Sinykin (third from left) and his cousin Jake Kozberg (second from right) are seen at Ted's homestead in 1908 with other single homesteading neighbors. Ted's parents were Harry David Sinykin and Etta Fanny Sinykin. Jake's parents remained in Russia. (Courtesy Diane Sinykin Small.)

100

Neighbors are seen having a party at Grindstone, the town closest to the homestead, in 1910. (Courtesy Diane Sinykin Small.)

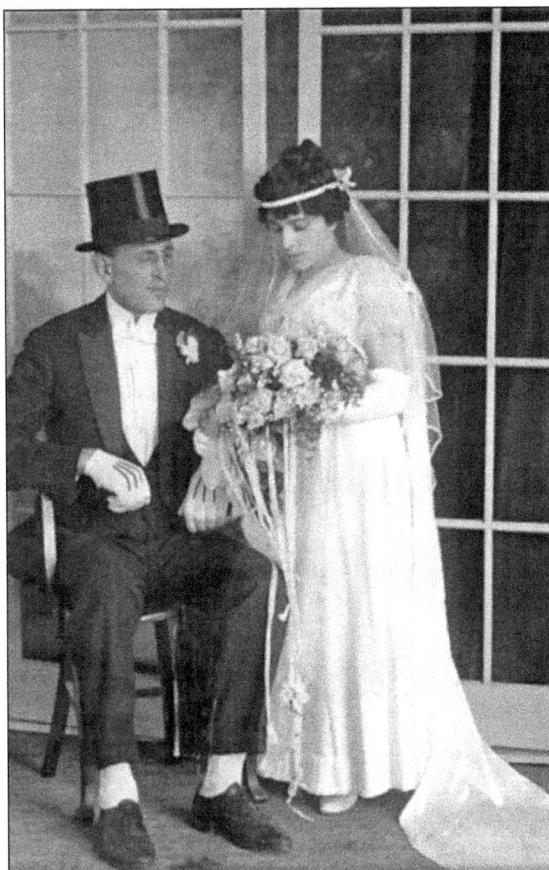

Rose Sinykin and Isadore "Izzy" Moskovitch (later Americanized to Marsh) are seen on their wedding day in 1916. Izzy was one of the original 18 single men who homesteaded at Jew Flats and was quite religious. (Courtesy Diane Sinykin Small.)

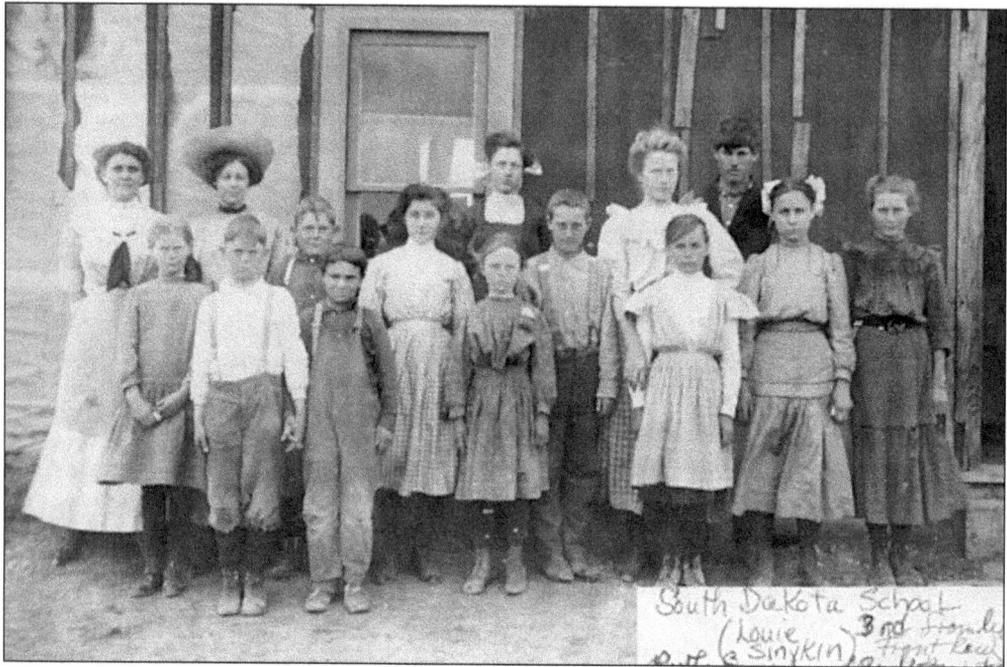

The Grindstone School in 1908 is pictured here. In the photograph above, Louie is the little boy in overalls in the first row, third from left. Sister Ruth Sinykin is the tall girl in the dark dress with white bib, located in the third row, center. Note the tarpaper siding over the wood frame structure. Below, Louie is the last boy on the right. (Both, courtesy of Diane Sinykin Small.)

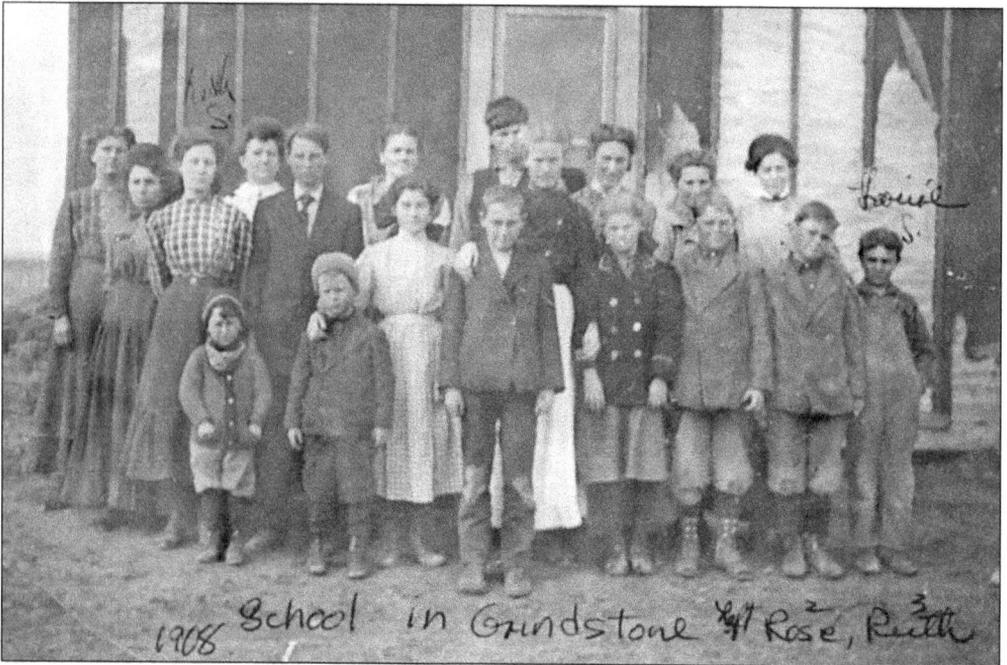

Ruth Sinykin Koval (center) poses with friends at her 18th birthday party in 1914. (Courtesy Diane Sinykin Small.)

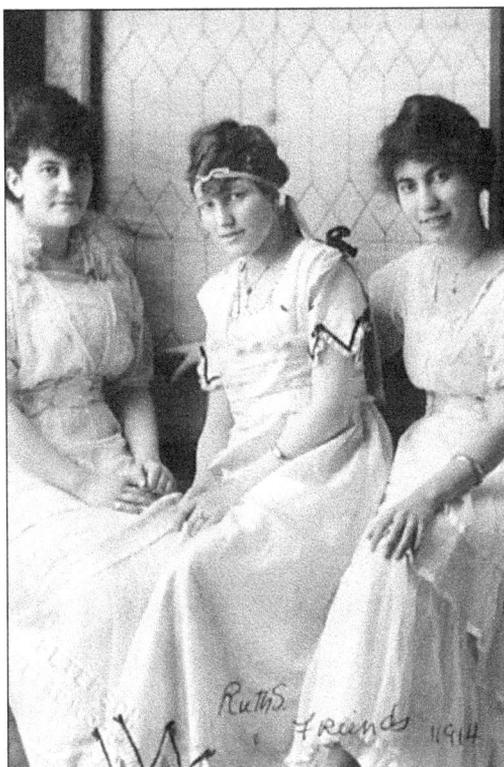

Piesha Koval, father of Etta Koval Sinykin, is pictured here in Russia around 1880. He was a blacksmith and had a dairy farm but was very well educated and made sure both his daughters could write, read, and speak Russian, Yiddish, and Hebrew, as well as being well versed in math, Torah, and Jewish law. (Courtesy Diane Sinykin Small.)

Jack Sinykin is pictured with Red Cloud in 1914. Out on the prairie, people got to know their neighbors. Some of the Jewish merchants who traded with the Indians, as in the case of Bailey Martinsky, who also homesteaded in western South Dakota, learned to speak Lakota, the language of the local Sioux people. (Courtesy Diane Sinykin Small.)

Harry Sinykin's brand certificate was issued in 1914. Cattlemen had to create a brand of their own. (Courtesy Diane Sinykin Small.)

ORIGINAL

No. 8109

State of South Dakota

Know All Men by These Presents:

That in accordance with Sections 2932 to 2947, inclusive, of Revised Political Code, 1903. Harry Sinykin of Minnehaha County

of State of South Dakota, is hereby granted

THE EXCLUSIVE RIGHT

to use the following Brand and Mark within this State for the purpose of branding and marking of live stock, to-wit:

S^H

on left hip of cattle

In Witness Whereof. We have hereunto set our hands and seals this 26 day of Aug, 1914

Lou (Bronco Lou) Sinykin is seen trick riding in 1915. Lou was an outstanding rider. Here he is on his way to compete at the Interior, South Dakota, rodeo for the national bareback-riding honors. (Courtesy Diane Sinykin Small.)

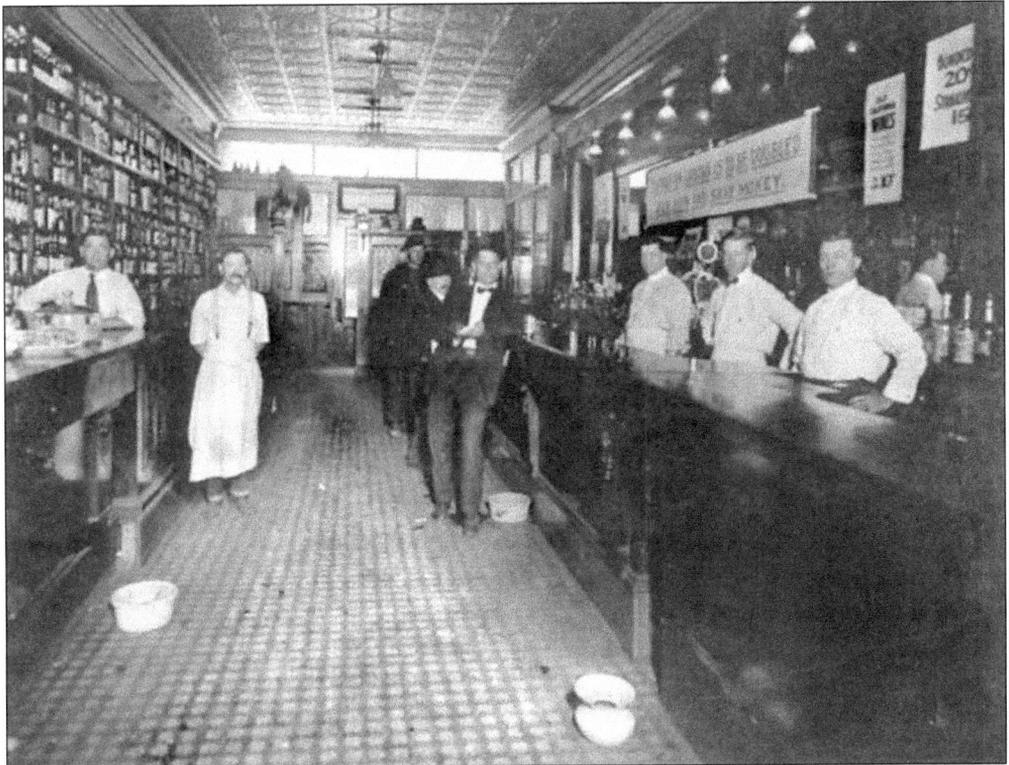

Jake Kozberg tried his hand at homesteading but decided life in the country was not for him. He did just the opposite and went to work in the Homestake Gold Mine, where he saved his money to start a saloon and liquor store in Lead, a surefire business success in the Black Hills. Pictured in 1915 is the interior of the Lobby Liquor House and Saloon in Lead. (Courtesy Diane Sinykin Small.)

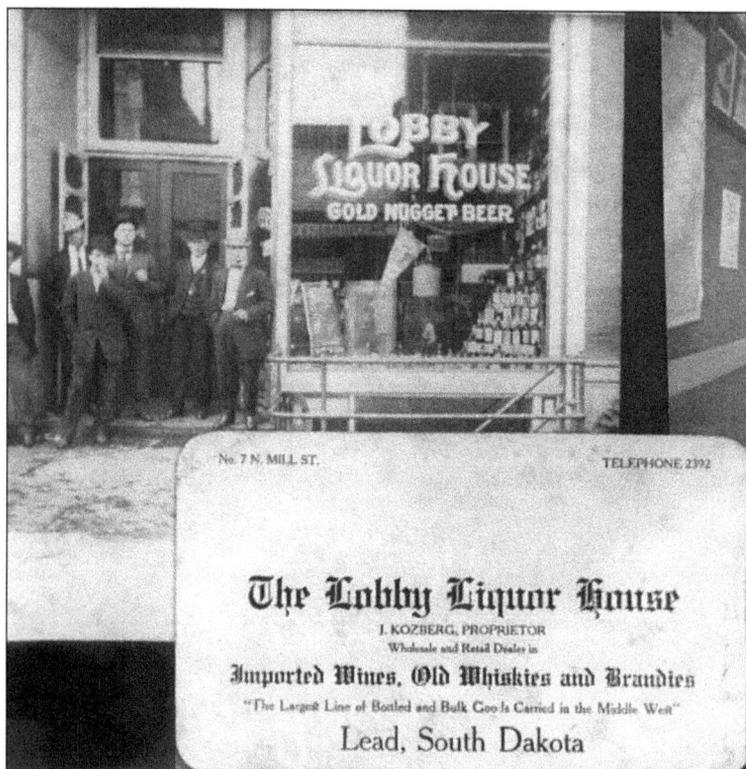

Here is the exterior of Jake Kozberg's Lobby Liquor House and Saloon in Lead in 1915. (Courtesy Diane Sinykin Small.)

No. 7 N. MILL ST. TELEPHONE 2392

The Lobby Liquor House

J. KOZBERG, PROPRIETOR

Wholesale and Retail Dealer in

Imported Wines, Old Whiskies and Brandies

"The Largest Line of Bottled and Bulk Goods Carried in the Middle West"

Lead, South Dakota

Kozberg's second establishment was the Lobby Liquor House and Saloon in Deadwood. (Courtesy Diane Sinykin Small.)

Ruth and Jake Kozberg (at right), with the help of two cheerful friends, are cleaning their upstairs apartment over the saloon in Lead in 1916. (Courtesy Diane Sinykin Small.)

Local midwife Etta Fanny Sinykin, while on the way to deliver a neighbor's baby, puts two of her granddaughters, Helen Marsh and Pauline Kozberg, in a wagon in 1917. (Courtesy Diane Sinykin Small.)

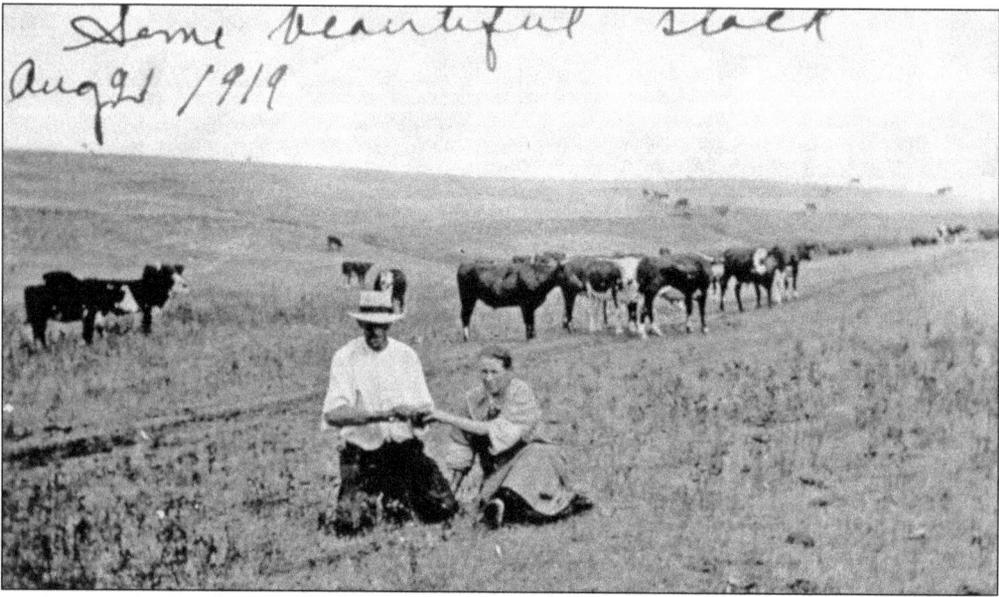

Izzy Moskovitch/Marsh and Etta Fanny Sinykin are shown in a field in 1919. They may have been picking wild onions. Though quite traditional, Izzy decided to Americanize his name to Marsh when he moved to St. Paul, Minnesota. (Courtesy Diane Sinykin Small.)

The outhouse, a two-seater, was the first thing to get shoveled out after a blizzard. Snow was a mixed blessing. It provided needed moisture for the crops, but it made life tougher and more dangerous in the winter. (Courtesy Diane Sinykin Small.)

Here is the Sinykin family in St. Paul in 1924. At top center is Louis, or Louie, as he was known. When this photograph was taken, he was still in law school at Minnesota School of Law. His career was suddenly disrupted by a serious accident in which he fell down an elevator shaft, fracturing his spine and causing him to drop out of law school. Louie's first wife was Florence, and they had three children together, Bill, Larry, and Diane. Unfortunately, Florence passed away. After a number of years, Louie met another woman, also named Florence, and he remarried. She was a loving stepmother and was very kind to the children. (Courtesy Diane Sinykin Small.)

The Sinykin kids, Larry, Bill, and Diane, all "cowboyed up" to sing over the radio. This photograph was taken at the Duhamel Studio in Rapid City. (Courtesy Diane Sinykin Small.)

Benjamin Strool was the Jewish founder of the town of Strool in Perkins County. The long-anticipated railroad link by the Milwaukee Road stretched across South Dakota, into southern North Dakota, and stopped in Hettinger. From there, a $3.50 trip by stagecoach brought the voyager and his family to this remote corner of northwestern South Dakota, and the nearest town was founded by, and named for, Ben Strool. (Courtesy Keith Carr.)

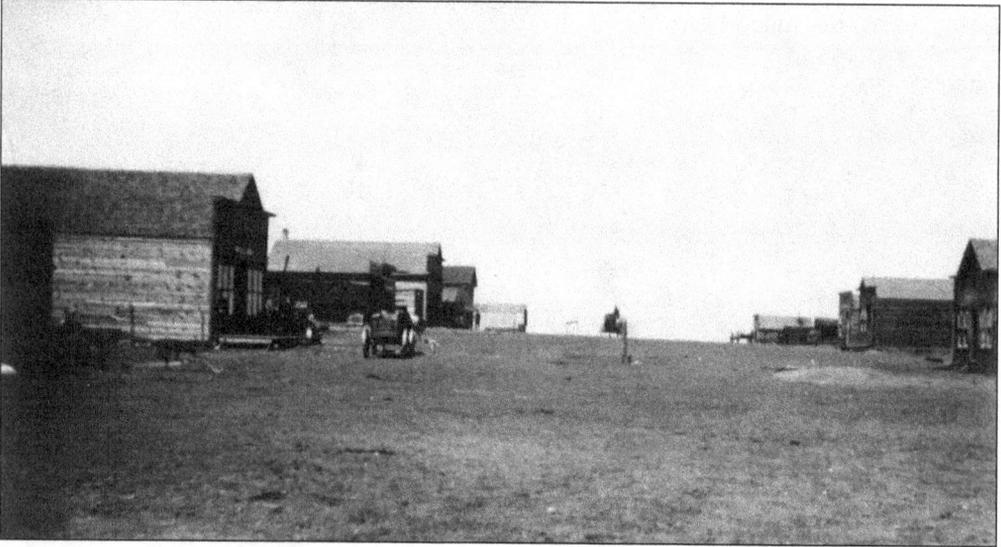

This is an arid grassland where fierce winters and hard-baked summers test the mettle of the most steadfast of homesteaders. Now and then comes a "wet year," when the rains fill the water barrels and dams. Rain brings hope and inspires the homesteader and his neighbors to stay on for one more year, to fix the fences and to build another shed. But the dry years outnumber the wet ones, and prospects grow dim. The 13th census of the United States, conducted in 1910, listed a group of Yiddish-speaking Jewish families in the Warthold precinct, northwestern South Dakota, whose place of birth was Russia. (Courtesy Keith Carr.)

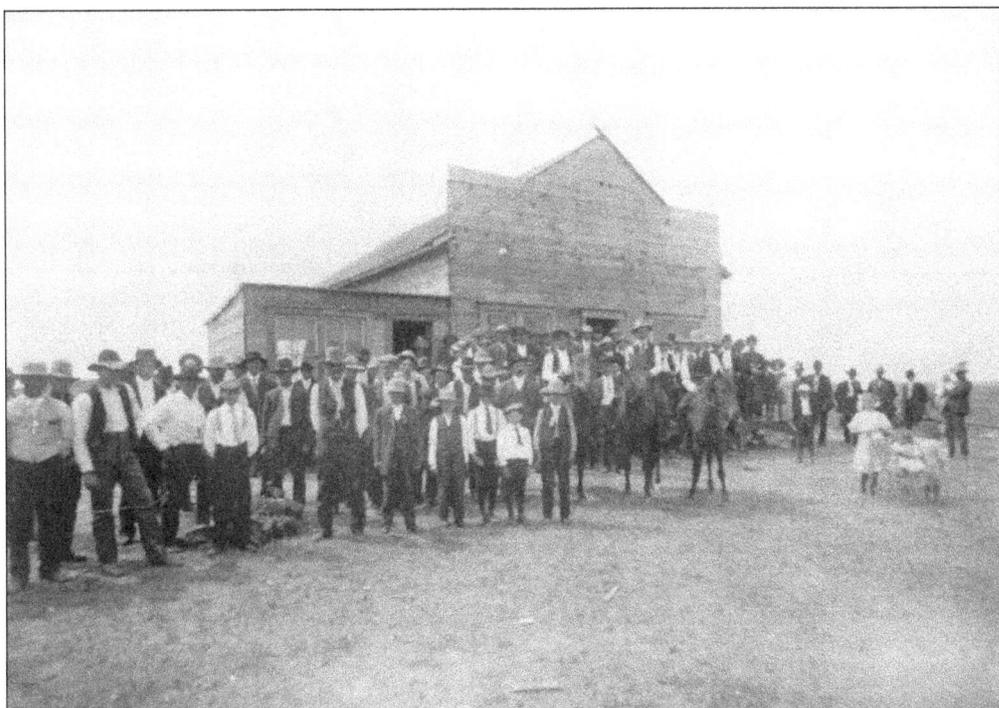

Neighbors gather at the Strool general store for a Fourth of July celebration. (Courtesy Keith Carr.)

This is the office of the pioneer newspaper, the *Perkins County Leader*. The false front gives the tiny, one-room cubicle the appearance of being somewhat larger than it actually is. After Ben Strool died, a dispute over money arose between the townspeople and Ben's absentee landlord widow who came to collect the rent. The people won by simply moving their buildings across the road. Their "new" town was named Prairie City, and Strool vanished. (Courtesy Keith Carr.)

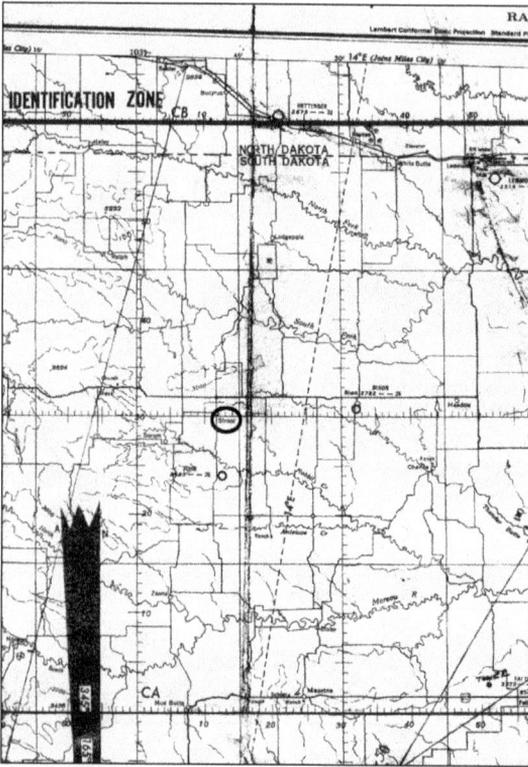

Strool is not a ghost town. Not even the dot that marked Strool on the aeronautical map of the northwest corner of South Dakota during the 20th century exists anymore. Strool is prairie once again. (Courtesy Norma Kraemer.)

Sam Bober received many awards in his lifetime. In 1966, Bober received an honorary doctor of science degree from South Dakota State University for his service to agriculture. Bober is a hero in Perkins County, which is where Sam and Rose Lee Stolar, his bride, homesteaded. While Rose was turning their homesteader's shack into a habitable home, Sam was planting, farming, learning, and experimenting with grain seeds. He developed seed varieties suitable for the harsh climate that are still in use today. His family had fled Russia when he was a teenager, and Sam loved America. In 1964, Sam Bober was appointed to the Agricultural Hall of Fame. (Courtesy Newell Museum.)

Four

RELIGION

The Torah is at the center of Jewish religious life, wherever religious Jews congregate. The Blumenthal (Deadwood) Torah now resides in the ark at the Synagogue of the Hills. A Torah must be in perfect condition, every letter legible and clear, in order for it to be useable. It can be kosher (ritually acceptable) for hundreds of years, but it takes expert preservation to keep it so. The Torah scroll shown here is partly unrolled. It contains the Five Books of Moses. A Torah is written in Hebrew characters on special parchment, with sections hand-sewn together, and lettered with specially made ink. It can only be written on by a *sofer*, a specially trained scribe. When read from, the reader uses a *yad*, or pointer, instead of touching the scroll with a finger, and the words should be chanted according to the markings on the scroll. (Courtesy Rocky Shropshire.)

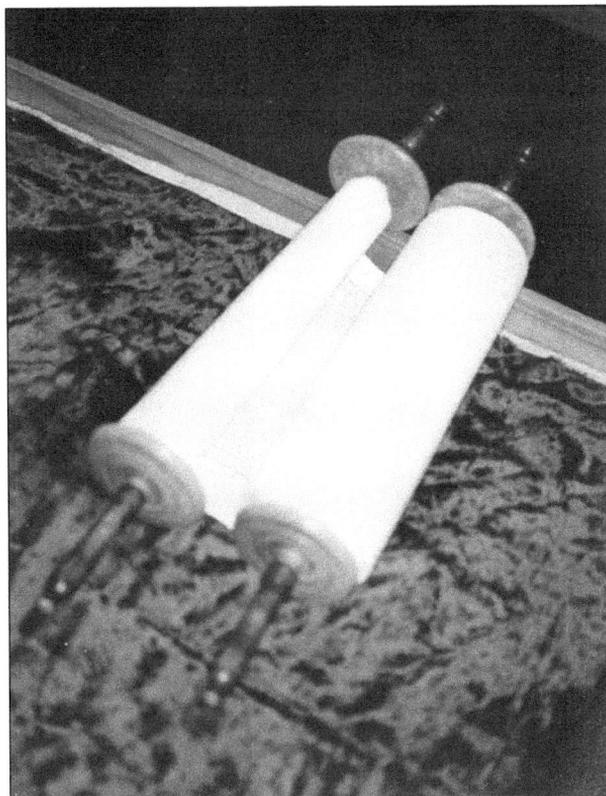

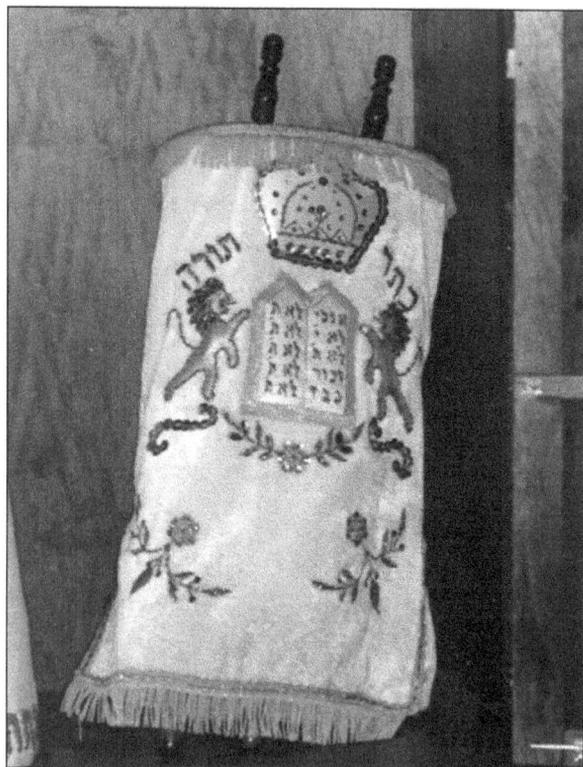

In 1888, the Black Hills acquired a Sefer Torah from which to read, pray, study, analyze, reflect upon, and seek guidance. This was thanks to the marriage of Ben Blumenthal and Frieda Lowenstein. Frieda's family provided her with the essential guidepost of the life of a Jew. All the Jewish people of the Black Hills have benefited from Frieda's gift of the Torah to their congregation. The Torah was read from on Sabbaths, on certain Jewish holidays, and at bar mitzvahs. Traditionally, one of the first activities of a Jewish community is formation of an organization. They would also need a burial society, a *Chevreh Kaddishe*, which translates to literally a "group of holiness." Deadwood's first *Chevreh Kaddishe* was placed in the hands of the Hebrew Benevolent Society, formed in 1879. (Courtesy Rocky Shropshire.)

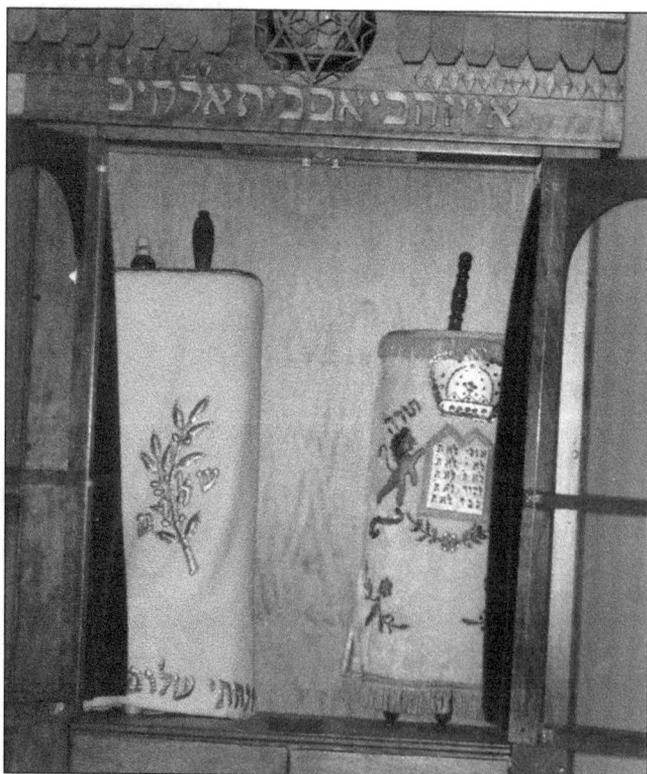

The Torah on the left is the Shalom (Ellsworth) Torah. The Torah on the right is the Blumenthal (Deadwood) Torah. (Courtesy Rocky Shropshire.)

This small scroll was created and inscribed on December 2, 1957, on the occasion of a gift of another Sefer Torah by a group of members of the Synagogue of the Hills. The donors included Blanche and Tess Colman, Julia Poznansky, Nathan and Ruth Horwitz, Myron and Sarah Rivkin, Mr. and Mrs. Bert Jacobs, Stanford and Ita Adelstein, Jack and Harriet Bober, Harold Glick, Julius Sanger, Capt. Abraham Wiseman, Mr. and Mrs. Max Ettinger, Dr. Rosenbaum, and others. (Courtesy Kenny Putnam, Image Up.)

A *ketubah* is a marriage contract with origins dating back to ancient times. It is usually written in fine Hebrew characters. It is essentially a promise that protects a wife from wrongdoing by her husband. This *ketubah* was written for Harry and Etta Fanny Sinykin, who homesteaded on the prairie north of Quinn, South Dakota, in the settlement known as Jew Flats. (Courtesy Diane Sinykin Small.)

Five

SOCIETY

The Society of Black Hills Pioneers, founded in 1889, aimed to be a social group, a "moral, benevolent literary association" to preserve the names and histories of those who were "really pioneers." The geographic area of residence for members included the counties of Lawrence, Meade, Pennington, Butte, Custer, and Fall River in South Dakota and Crook County in Wyoming. Initially, only those who arrived in or before 1876 were allowed to be members. The eligibility was later extended to allow membership to those who arrived before the railroad reached Deadwood, exemplifying just how significant the arrival of the railroad was to Deadwood and Lead. Charles Zoellner is seen in the center of the above crowd indicated by an arrow. (Courtesy Adams Museum.)

This image shows the laying the cornerstone of the new Masonic Temple in Deadwood in 1900. The existence of a synagogue belonging to the pioneer Jews of the Black Hills gold rush has been greatly debated over the years. There is no evidence to support that there ever was a brick-and-mortar edifice. However, from as early as 1879, there is a paper record of Jewish community and worship. Jews gathered for worship and to observe the holy days, and as the fraternal orders, such as the Masons and the Knights of Pythias, were compatible with Jewish moral and ethical views, it was not uncommon to find that Jews in small towns would congregate in the Masonic Temple or Knights of Pythias Hall. These were much in favor due to their atmosphere of freedom of thought and shared values. Therefore, the answer turns back on the question of how one defines a synagogue. If one defines a synagogue as a congregation of Jewish people, then the answer would have to be yes, there was a Jewish community that gathered for worship. (Courtesy Adams Museum.)

The Masonic Temple is shown under construction. In 1906, after Nathan Colman passed on, Sidney Jacobs assumed the role of lay rabbi, a position he held for the rest of his life. Sidney was as respected for his religious knowledge and leadership, as he was renowned for his outgoing personality and his generosity. When Sidney passed away, there was no layman to succeed him. (Courtesy Adams Museum.)

Historic Photograph Collection
Adams Museum, Deadwood, SD

In full regalia, Morris Stern is fourth from the right at Scottish Rite of the Masonic Lodge, Deadwood Chapter, in 1889. The Masonic Lodge occupied an active and prominent role in Deadwood's society. Sol Star was not very involved in the religious aspect of Judaism, but he was a highly active and involved Mason, having achieved the standing of Grand Master of the Deadwood Lodge. (Courtesy Adams Museum.)

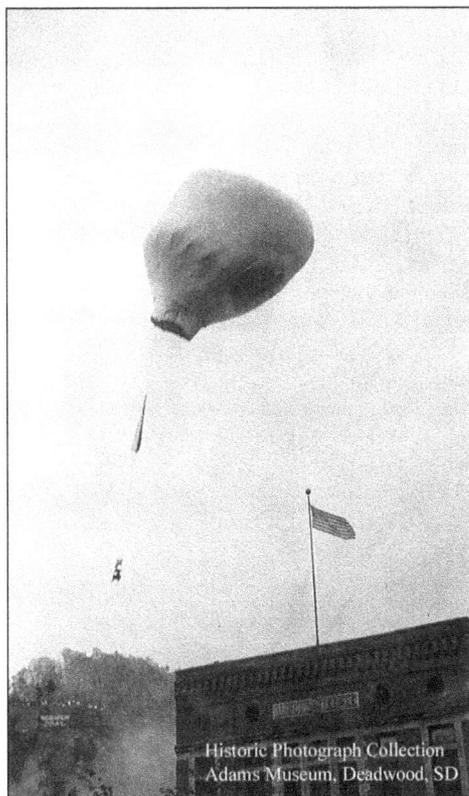

A balloon passes over the Masonic Temple. Eventually, the northern Black Hills' Jewish population of hundreds, as well as the general population of many thousands, diminished. The mines were playing out, and so were the jobs. There was less demand for provisions. The next generation sought better jobs and improved opportunities. The Torah was needed less and less in Deadwood. In the 1940s, it was taken to Rapid City and delivered to the home of the Morris Adelsteins. From there, it was taken to Ellsworth Air Base, where services were held until the 1990s. It now resides on the *bimah*, in the holy ark, of the Synagogue of the Hills in Rapid City. (Courtesy Adams Museum.)

Historic Photograph Collection
Adams Museum, Deadwood, SD

In the 1920s, a darker side of society arose when the Ku Klux Klan metastasized into the Black Hills. Sidney Jacobs's advertisements alongside the highways could find a KKK painted over "The Hub Store." There were cross burnings and intimidation, but their venom was mainly directed at the Catholics, whom they called "Papists." There was even an assassination of a Catholic priest, Father Belknap. The crime went unpunished, but everyone knew who had committed it. The Jews did not escape the Klan's deadly wrath. Signs were posted at the county line warning blacks, Catholics, and Jews to be across the county line by sunset or face the vengeance of the KKK. Oftentimes, when they paraded through the streets, individuals could be identified by their shoes beneath their white sheets, and some of the officials of local government and law enforcement were among the parade participants. In this photograph, the Klan parades up Sixth Street in Rapid City. Fortunately, the organization lost its appeal and declined by the 1930s. (Courtesy SD State Historical Society.)

Six

MOUNT MORIAH

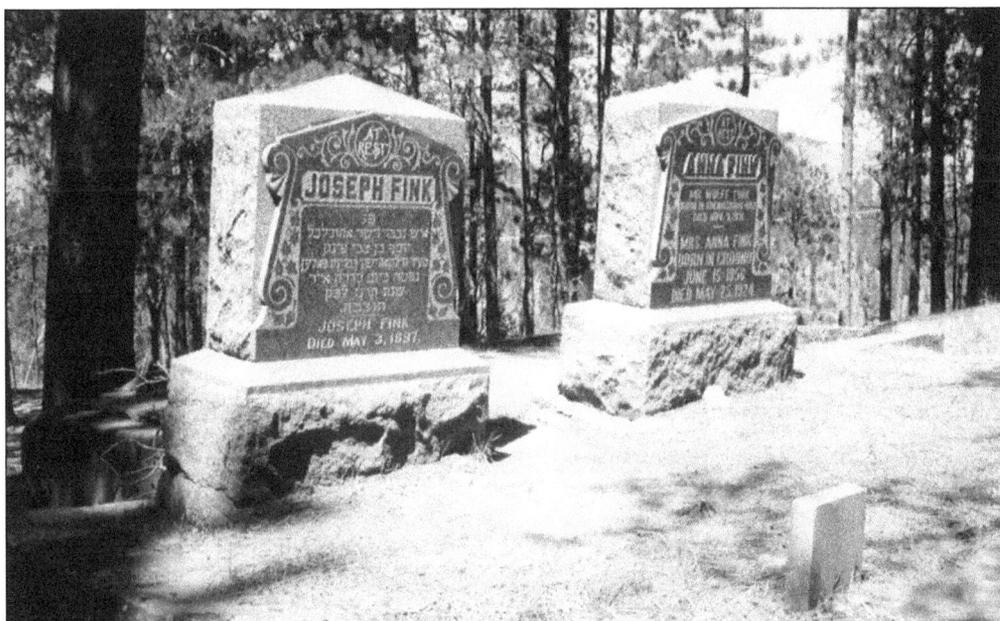

A cemetery can be a history book. The stones can tell stories about a community that might otherwise be lost to time. Like a journalist, the who, what, where, when, and why can be learned of its people and it can be passed on. The graves of the Fink family members, Joseph, Wolff, and Anna, who were highly successful in the jewelry business in Lead, are especially ornate and beautiful, engraved with Hebrew and English lettering and decorative scrollwork and patterns from nature. The stones tell that this family emigrated from Koenigsburg, Germany. Stones of several others buried here tell of this same origin. The Finks settled in Lead and were always involved in Jewish activities. In the summer of 1893, the Hebrew Benevolent Society, representing Deadwood's Jewish community, which at the time numbered in the hundreds, purchased an area of Mount Moriah for the sum of $200 to be used as sanctified burial ground. The cost of lots would be 12.5¢ per square foot. Some of the many Jewish pioneers who helped to develop and stabilize the town of Deadwood are buried in this section, which is called Mount Zion. (Courtesy Sihaya Reid.)

Here is Albert Bernard's grave. Sometimes there is nothing in archives or in books to tell that a particular individual or family participated in this pioneering experience. All that is left is a tombstone to tell that this Jewish person was part of this community. (Courtesy Sihaya Reid.)

Isaac and Charlotte Krainson share one gravestone. They can never be separated. They did have a baby boy for whom Felix Poznansky from Rapid City was called upon to perform a *b'rit milah*, a ritual circumcision. (Courtesy Sihaya Reid.)

Erma Fishel was one of the many casualties of early-day childhood illnesses. The Fishel brothers established a stationery, fancy goods, and notions business in 1892 called Fishel's Bazaar, which they operated until 1934. Adolph and his wife, Lala, both of whom died in 1940, as well as their baby daughter Erma are buried in the Mount Zion section of the cemetery. They were survived by one daughter. Louis Fishel, who never married and died in 1941, and Max Fishel, who died in 1955 at the age of 48, are also buried there. (Courtesy Sihaya Reid.)

There are several gravestones marked with the name Jacobs. They are not all necessarily of the same family. Simon and Dora, Sidney and Jennie, and Bert and Ruth Jacobs lie here, all of one family. Meyer, Morris, and Augusta Jacobs are buried in Mount Zion, as is Louis Jacobs. (Courtesy Sihaya Reid.)

Gusta Schwarzwald's monument is flanked by the graves of her daughter Theresa Nathan Aldrich and son Charles Nathan. (Courtesy Ann Haber Stanton.)

Ben Blumenthal 1859-1935
Mrs. Ben Blumenthal 1866-1927
Bertha Burstin 1880-1916
Isaac Cohn () – 1898
Nathan Colman 1850-1906
Mrs. Nathan Colman 1852-1939
Gustav Colman (son) 1879-1891
(4 yrs.)
Joseph Colman (son) 1888-1891
(3 yrs.)
Bertha Colman (daughter) 1878-1878
(infant)
Rosa Colman (daughter) 1882-1887 (5
yrs.)
Theresa Colman
Blanche Colman
Joseph Fink ()- 1897
Wolff Fink 1852-1931
Mrs. Wolff Fink 1856-1924
Adolph Fishel 1857-1940
Mrs. Adolph Fishel 1867-1940
Max Fishel 1853-1907
David Goldbloom 1841-1908
Mrs. David Goldbloom 1844-1899
Alfred Gutwillig
Harris Franklin 1849-1923

Mrs. Harris Franklin 1849-1902
Charles H. Hyman 1852-1914
Meyer Jacobs
Morris F. Jacobs, 1841-1897
Mrs. Morris F. Jacobs, 1839-1902
Louis D. Jacobs 1870-1903
Mrs. Louis D. Jacobs 1870-1944
Simon Jacobs 1853-1935
Mrs. Simon (Dora) Jacobs 1853-1931
Sidney B. Jacobs 1872-1934
Mrs. Sidney B. Jacobs 1879-1948
Jacobson 1862-1906
Mrs. Elizabeth Kiemer 1866-1946
Isaac Krainson 1852-1930
Mrs. Isaac Krainson 1864-1914
Sol Levinson 1859-1910
Joseph Levinson (son) 1887-1934
Hugh Margolin 1824-1933
Leo Nathan 1885-1918
Sam Schwarzwald 1851-1927
Mrs. Sam (Gusta) Schwarzwald 1863-
1942
Rosa Welf 1845-1899
Clara Zoellner 1859-1911
Charles Zoellner

The above names are taken from cemetery records. There were many more Jewish pioneers than the number of burials in the Mount Zion section of Mount Moriah Historic Cemetery would suggest. People like Jacob Goldberg's family spent most of their lives in Deadwood, yet they spent their retirement years on the West Coast and are buried there. Sol Star died in Deadwood, but he is buried in St. Louis. It gets even more difficult to justify numbers when there were unmarked graves from an earlier date. However, from cemetery records, the names and dates of birth and death that were available are listed in this table. Mount Moriah Historic Cemetery is now recognized as a National Historic Landmark, with its burials honored for posterity and the graves and pathways carefully tended, given due respect and remembrance. Blanche Colman said there were "hundreds" of Jewish people. It is customary when visiting a Jewish cemetery to leave a small stone at the grave as a sign that one has visited. It is a kindness, one that has been handed down through the generations. Walk softly, please, and remember these people with gratitude.

BIBLIOGRAPHY

Adams (SD) Banner

Alschuler, Al. "Colmans and Others of Deadwood." *Western States Jewish Historical Quarterly*: Judah Magnes Museum, Berkeley, July 1977.

Bennett, Estelline. *Old Deadwood Days.* Lincoln and London: University of Nebraska Press, 1928.

Bower VanNuys, Laura. *The Family Band: From the Missouri to the Black Hills, 1881–1900.* Lincoln and London: University of Nebraska Press, 1961.

Bye, John O. *Back Trailing in the Heart of Short Grass Country.* Everett, WA: Alexander Printing Company, 1956.

Colman, Blanche. "Early Jewish History of the Black Hills of South Dakota." Deadwood, SD, 1953.

Directory of Sioux City Jewry, December 1969.

Dr. Watson Parker, author, Black Hills historian, and professor emeritus of history at the University of Wisconsin, interviewed at the author's residence by author, October 1998.

Eastern Pennington County Memories. Wall, SD: American Legion Auxiliary, Carrol McDonald Unit, 1965.

Eka Parkison, researcher, genealogist, and Rapid City historian, interviewed at the Parkison residence, January 1998.

Fielder, Mildred. *Carbonate Camp.* South Dakota Historical Collections, undated.

George Moses, Black Hills columnist and historian, interviewed by author at Mount Moriah Cemetery, September 1998.

Goehring, Orlando. *Keeping the Faith: Bertha Martinsky in West River, South Dakota.* South Dakota History Bulletin.

Grafe, Ernest, and Paul Horsted. *Exploring with Custer: The 1874 Black Hills Expedition.* Custer, SD: Golden Valley Press, 2002.

Kingsbury, George Washington. *History of Dakota Territory.* Chicago, IL: The S.J. Clarke Publishing Company, 1915.

Klock, Irma. *Central Black Hills.* Pierre, SD: South Dakota State Historical Society, 1986.

———. *All Roads Lead to Deadwood.* Pierre, SD: State Publishing Company, 1978.

———. *Silver is the Fortune.* Pierre, SD: South Dakota State Historical Society, undated.

Fishman, William J. *East End Jewish Radicals: 1875–1914.* London: Gerald Duckworth and Company, 1975.

Kopco, Mary. *Adams House Revealed.* Deadwood, SD: Adams Museum and House, 2006.

Lawrence County Historical Society. *Some History of Lawrence County.* Deadwood, SD: 1981.

Lee, Bob. *Gold, Gals, Guns, and Guts.* Pierre, SD: South Dakota State Historical Society Press, 1976.

Libo, Kenneth. *We Lived There Too: In Their Own Words and Pictures—Pioneer Jews and the Westward Movement of America, 1630–1930.* New York: St. Martin's-Griffin, 1984.

Loomis, Thomas A. "The Holy Terror, the Uncle Sam and the Golden Reward: In the Shadows of the Homestake." *Matrix: A Journal of the History of Minerals.* 10.3 (1991).

McClintock, John. *Pioneer Days in the Black Hills.* Norman, OK: University of Oklahoma Press, 1939.

McLaird, James. *Hard Knocks, a Life Story of the Vanishing West, by Harrry (Sam) Young.* Pierre, SD: South Dakota Historical Society Press, 2005.

Mills, Rick. *Railroading in the Land of Infinite Variety.* Hermosa, SD: Battle Creek Publishing Company, 1990.

Moses, George. *Those Good Old Days in the Black Hills.* Rapid City, SD: *Rapid City Journal*, 1981.

———. "The Sunday Column." *Rapid City Journal:* 1972–1985. Deadwood Public Library Index of Historical Newspaper Archives.

www.oldstonehouse.com

New York Times

Parker, Watson. *Black Hills Ghost Towns.* Athens: Swallow Press, 1974.

———. *Gold in the Black Hills.* Lincoln and London: University of Nebraska Press, 1966.

———. *Deadwood, the Golden Years.* Lincoln and London: University of Nebraska Press, 1981.

Parkison, Eka. *Rapid City Pioneers of the 19th Century.* Rapid City, SD: Rapid City Society for Genealogical Research, Vol. 2 (1997).

Pechan, Beverly. *Deadwood, 1876–1976.* Charleston, SC: Arcadia Publishing, 2005.

———. *Keystone and its Colorful Characters.* Keystone: Permelia Publishing, undated.

Postal, Bernard. *A Jewish Tourist's Guide to the United States.* undated.

Rachel Calof's Story, Jewish Homesteader on the Northern Plains. Bloomington and Indianapolis: Indiana University Press, 1995.

www.rapidcityfoundersparkplaza2@blogspot.com

Rathbun, Janet D. "All Roads Led to Strool: The Rise and Fall of One Man's Town." www.realsouthdakota.com

Rezzato, Helen. *Mount Moriah, Kill a Man—Start a Cemetery.* Rapid City, SD: Fenwyn Press, 1989.

Robinson, Doane. *Encyclopedia of South Dakota.* Pierre, SD: 1925.

Rochlin, Harriet. *Pioneer Jews, A New Life in the Far West.* Wilmington: Houghton-Mifflin, 2000.

Russel Frink, historian for Mystic, South Dakota, interviewed in Mystic by author, September 1998.

Ruth and Nathan Horwitz, elders of the Synagogue of the Hills, interviewed at the Horwitz residence by author, October 1990.

Sarah Niederman Alschuler, niece of Blanche Colman, interviewed at the Alschuler residence by author, April 1999.

Schloff, Linda Mack. *And Prairie Dogs Weren't Kosher.* St. Paul. MN: Minnesota Historical Society Press, 1996.

www.searchroots.com

Shaff, Howard. *Paving the Way: The Life of Morris E. Adelstein.* Keystone: Permelia Press, undated.

South Dakota Department of History, Report, and Historical Collections. Pierre, SD: South Dakota Historical Society, Vol XXXI (1962), 333–334.

South Dakota History Bulletin, Winter 2006

South Dakota Magazine

Stanford M. Adelstein, president of Synagogue of the Hills, interviewed at the author's residence by author, June 1998.

Strain, David. *Black Hills Hay Camp.* Rapid City, SD: Dakota West Books and Fenske Printing, 1989.

Toms, Donald. *Flavor of Lead, an Ethnic History.* Lead: Lead Historic Preservation Commission, 1992.

Trupin, Sophie. *Dakota Diaspora, Memoirs of a Jewish Homesteader.* Lincoln and London: University of Nebraska Press, 1984.

Wagner, Sally Roesch. *Daughters of Dakota, Schooled in Privation.* Yankton: Self-published, 1991.

Wolfe, Mark. *Boots on Bricks, Walking Tour of Historic Downtown Deadwood.* Deadwood, SD: Deadwood Historic Preservation Commission, 1996.

Visit us at
arcadiapublishing.com

www.ingramcontent.com/pod-product-compliance
Lightning Source LLC
Chambersburg PA
CBHW050640110426
42813CB00007B/1870